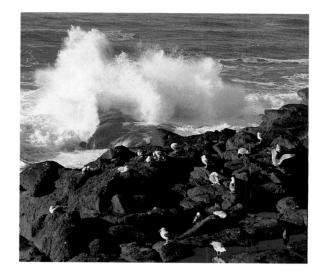

OREGON IV

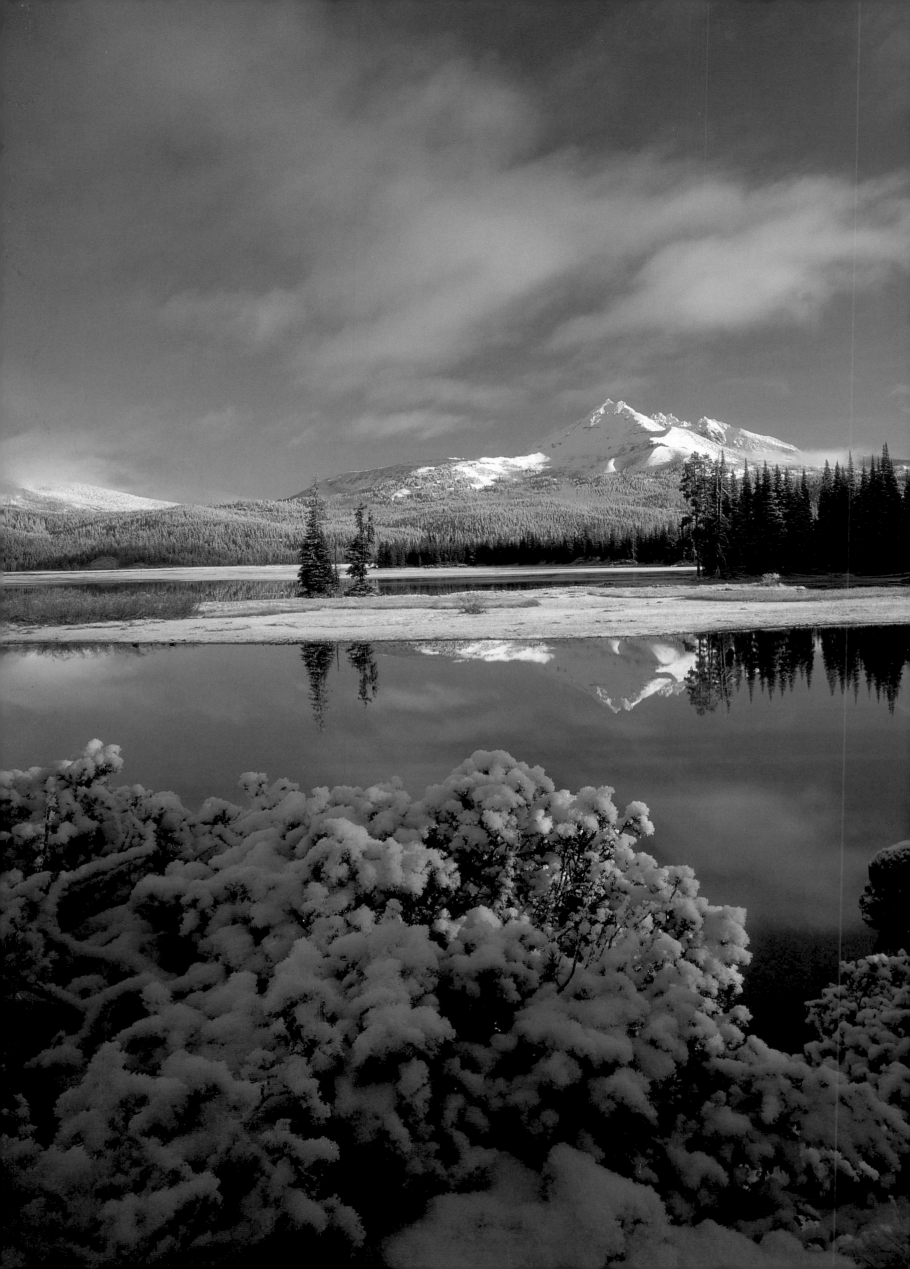

OREGON IV

PHOTOGRAPHY BY RICK SCHAFER

ESSAY BY CRAIG LESLEY

GRAPHIC ARTS CENTER PUBLISHING®

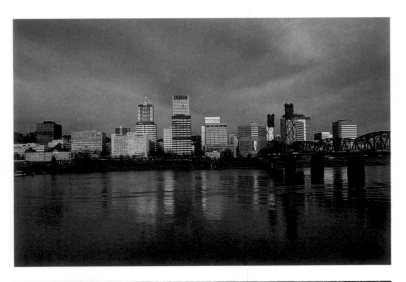

Photographs © MMII by Rick Schafer
Essay © MMII by Craig Lesley
Book compilation © MMII by
Graphic Arts Center Publishing®
An imprint of Graphic Arts Center Publishing Company
P.O. Box 10306
Portland, Oregon 97296-0306
503-226-2402
www.gacpc.com

QUOTATION CREDITS

The quote on page 108 is by Edwin T. Reed, from *Into the Promised Land,* 1942, published by the Oregon State College Cooperative Association, Corvallis, Oregon. All other quotes were published by Graphic Arts Center Publishing Company and are © by the publisher: page 34 is by Kim Stafford, from *Wind on the Waves,* 1992; page 60 is by Jonathan Nicholas, from *On the Oregon Trail,* 1992; page 74 is by Harriet A. Loughary, from her 1864 diary, quoted in *On the Oregon Trail,* 1992; page 90 is by Fred Beckey, from *The Cascades,* 1982; and page 124 is by Carl Gohs, from *Oregon,* 1968.

Library of Congress Cataloging-in-Publication Data
 Schafer, Rick.
 Oregon IV / photography by Rick Schafer ; essay by Craig Lesley.
 p. cm.
 ISBN 1-55868-687-8 (hardbound : alk. paper)
 1. Oregon—Pictorial works. 2. Oregon—Description and
 travel. I. Title: Oregon 4. II. Title: Oregon four.
 III. Lesley, Craig. IV. Title.
 F877 .S328 2002
 979.5—dc21 2002003189

President: Charles M. Hopkins
Associate Publisher: Douglas A. Pfeiffer
Editorial Staff: Timothy W. Frew, Ellen Harkins Wheat, Tricia Brown,
 Kathy Matthews, Jean Andrews, Jean Bond-Slaughter
Production Staff: Richard L. Owsiany, Joanna Goebel
Designer: Robert Reynolds
Cartographer: Ortelius Design
Digital Prepress: Color Technology, Inc.
Printer: Haagen Printing
Bindery: Lincoln & Allen Co.

Printed and bound in the United States of America

◁ ◁ Crashing wave, Rocky Creek State Wayside, central coast
◁ Sparks Lake and Broken Top, from Ray Atkeson Memorial
△ △ △ The Willamette River, Hawthorne Bridge, and Portland
△ △ Shepperd's Dell Falls, Historic Columbia River Highway
△ Two barns and an alfalfa field, Wasco County lowlands

CONTENTS

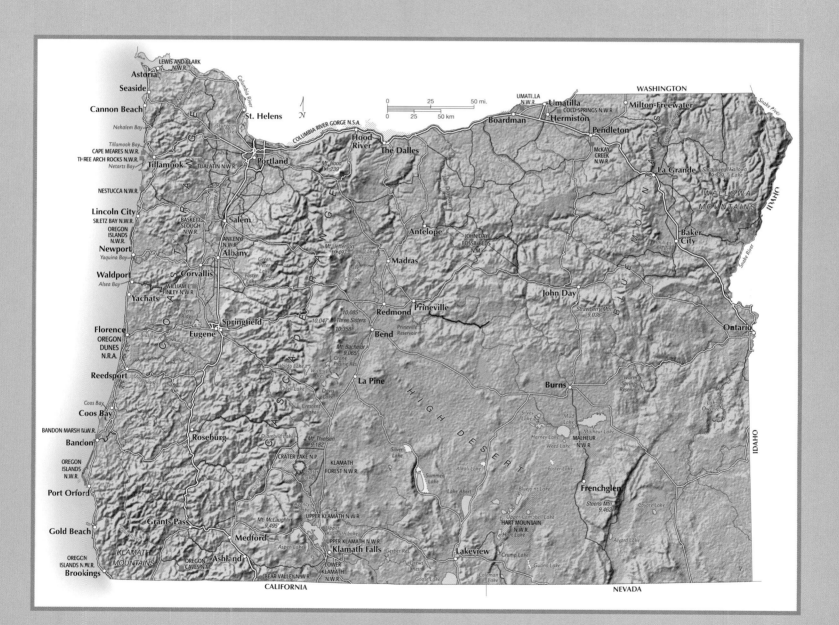

To my children, Lorae, Mitchell,
Brett, and Jackson, who continually
show me new ways to look at the world.

—Rick Schafer

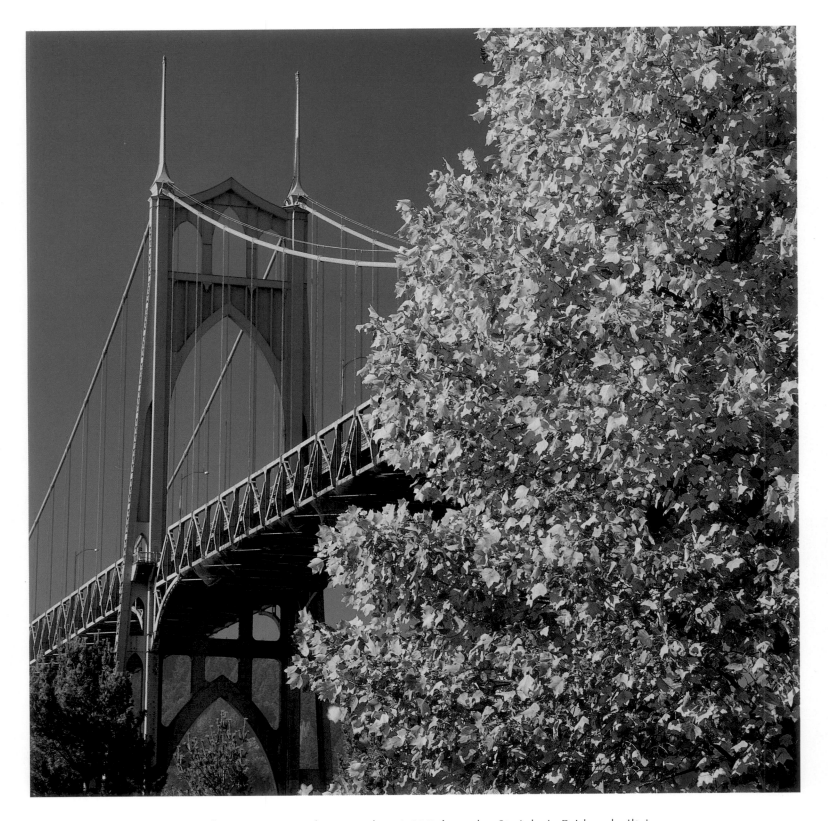

△ With a main span that stretches 1,207 feet, the St. John's Bridge, built in 1931, crosses the Willamette River. ▷ Douglas-fir *(Pseudotsuga menziesii),* the state tree, flourishes here in the Columbia River Gorge National Scenic Area. ▷ ▷ Mount Jefferson reaches 10,495 feet above sea level. This view is from the headwaters of the Metolius River near Camp Sherman in the Central Cascades.

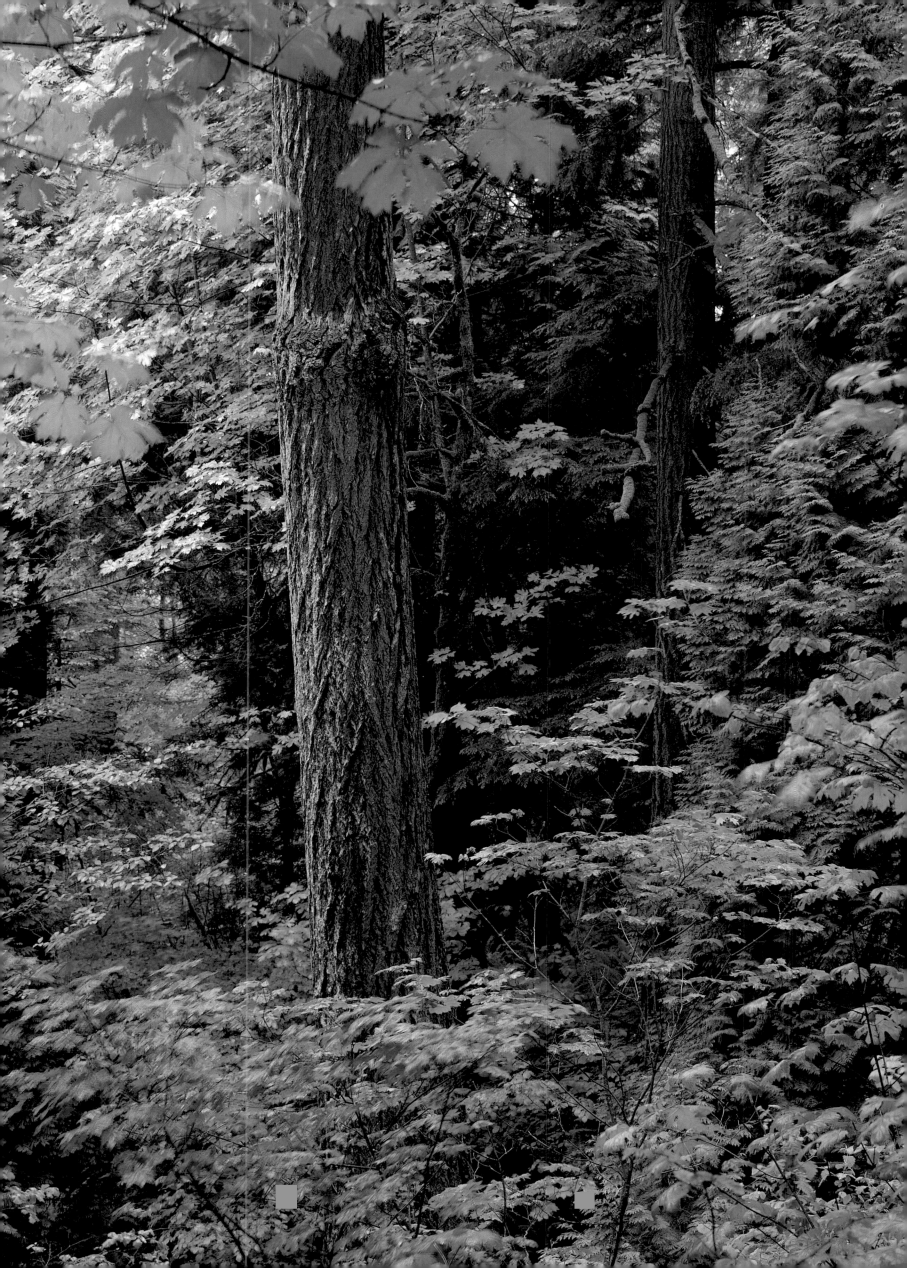

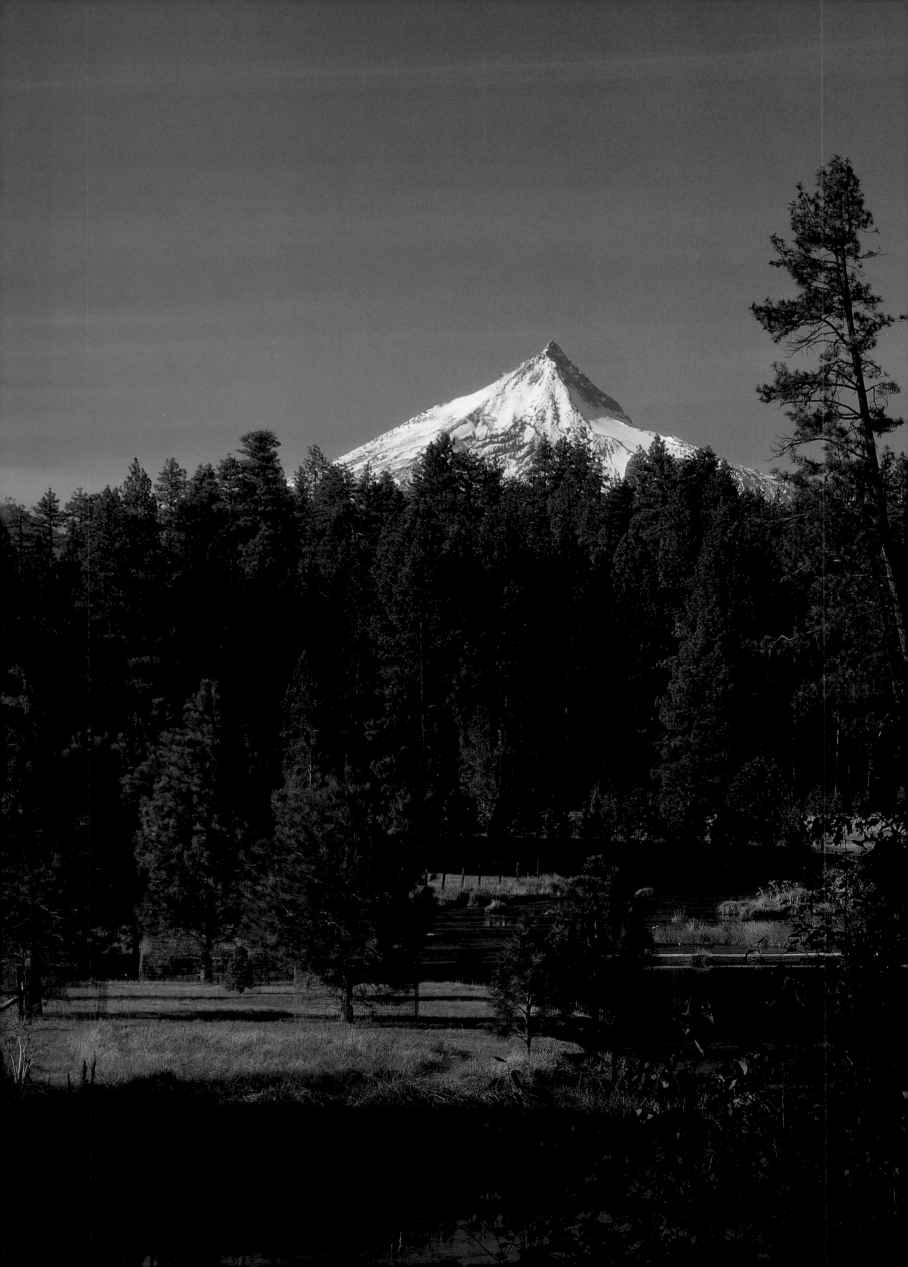

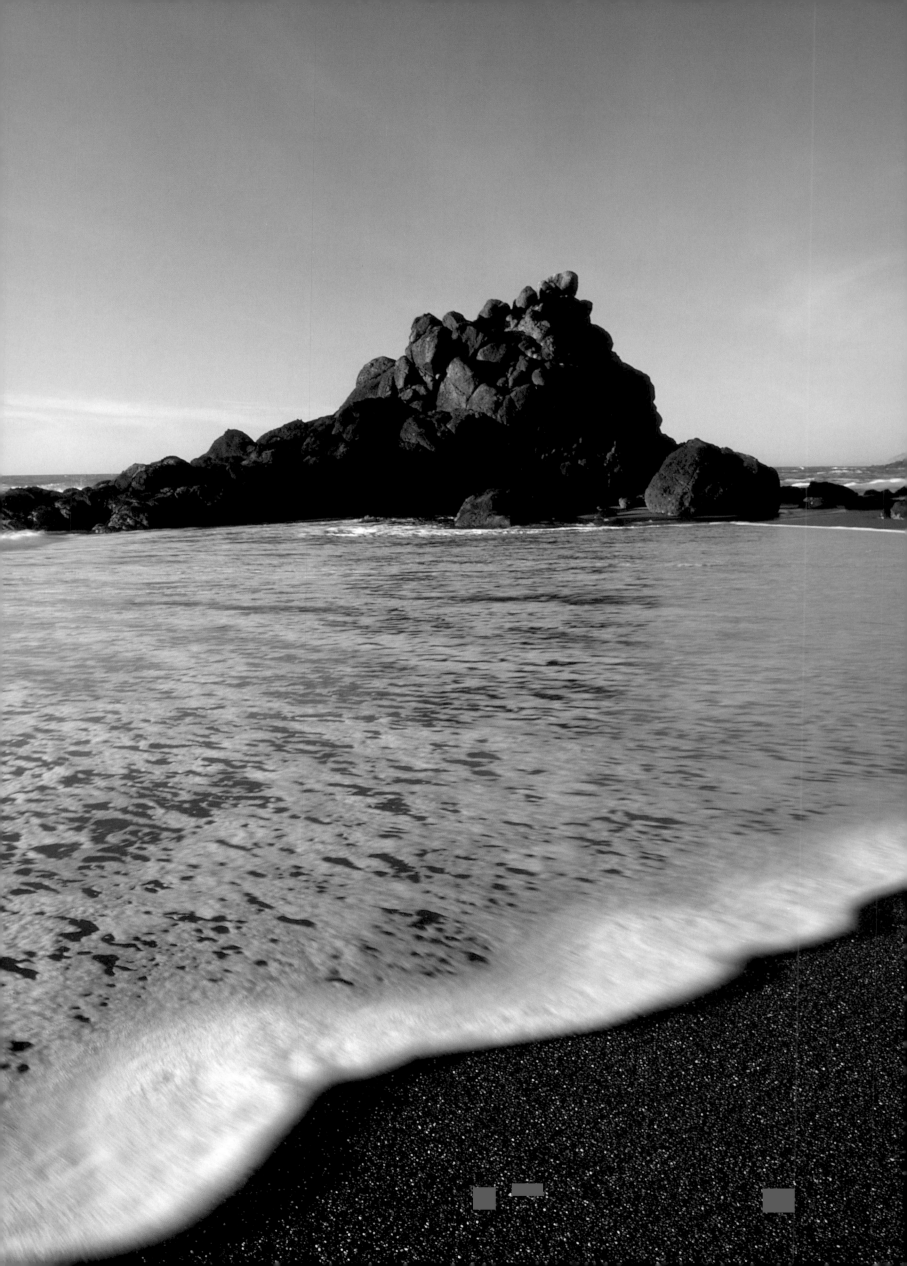

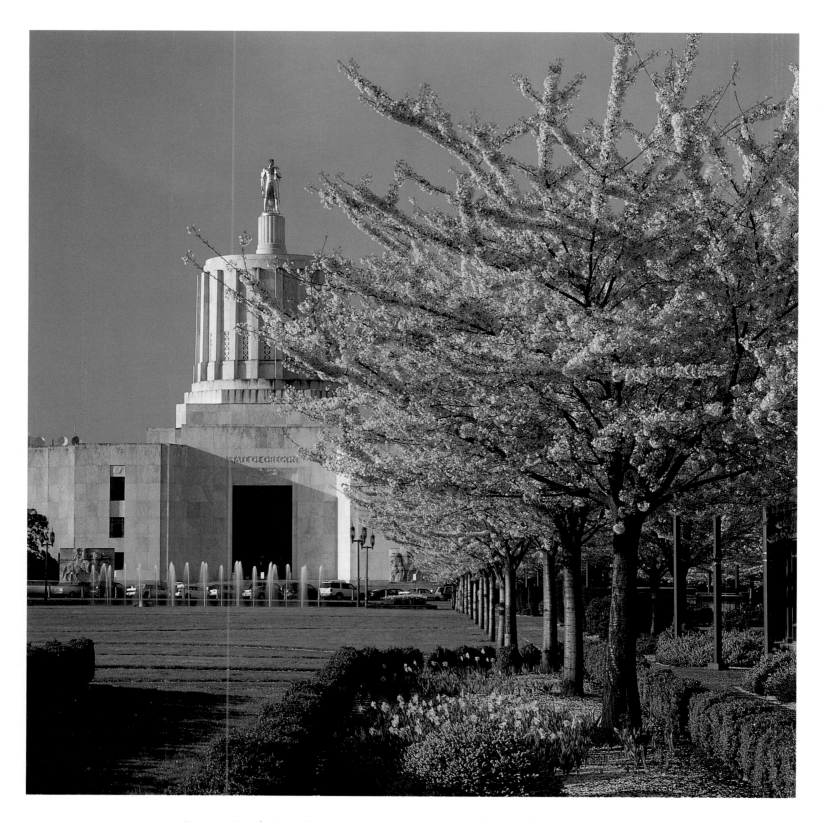

◁ Fogarty Creek State Recreation Area is one of the best bird-watching and tide-pooling sites on the coast. △ The "Golden Pioneer" has topped the rotunda of Oregon's capitol in Salem since the building's completion in 1938. Created by Ulric Ellerhusen, the gold-plated, hollow statue is twenty-three feet high and weighs eight and one-half tons. A 121-step, spiral staircase leads to the base of the statue.

11

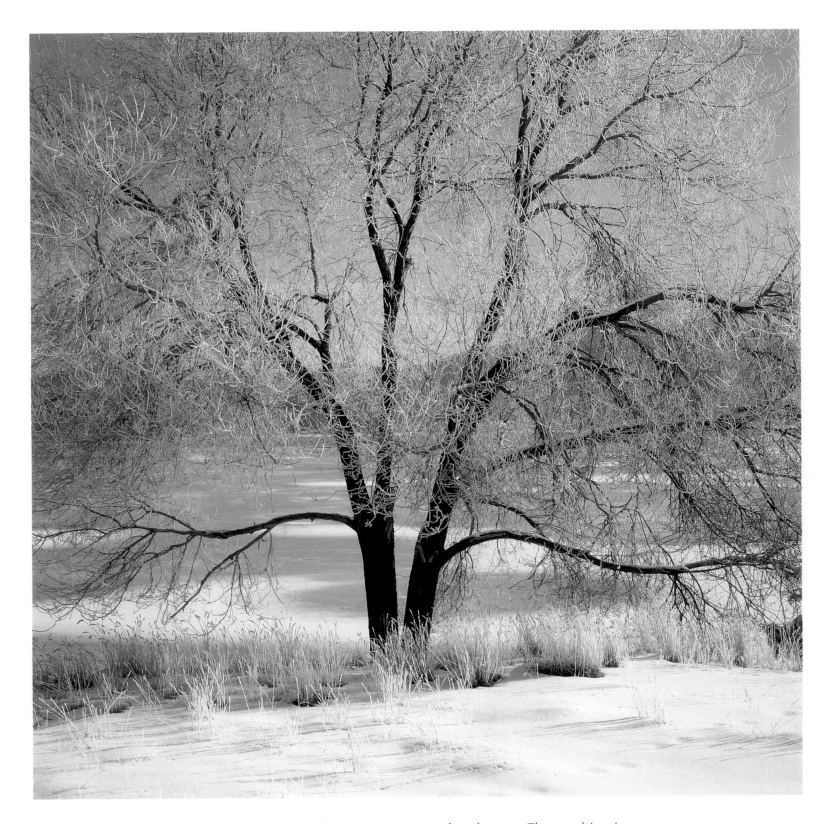

△ Hoar frost occurs when water vapor, or fog, freezes. The resulting ice can coat everything—including trees, such as this graceful one in Jefferson County—touching each twig and blade of grass with magic to create a virtual fairyland.

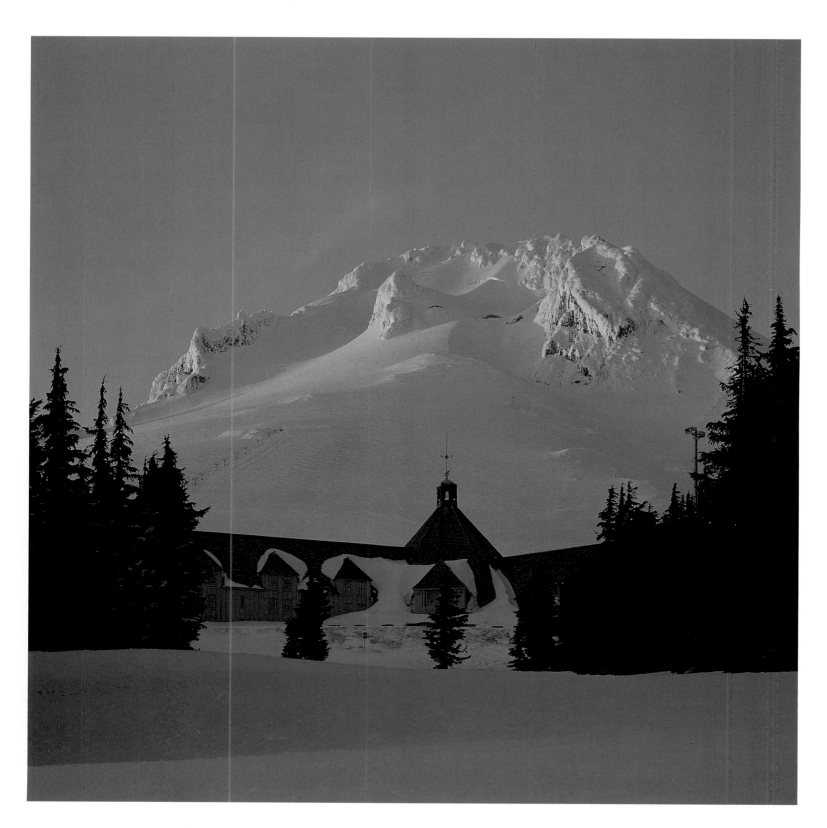

△ A 1930s WPA project, Timberline Lodge was dedicated in 1937 by President
Franklin D. Roosevelt. Situated at six thousand feet on the south slope of Mount
Hood in Oregon's Cascade Range, the lodge is now a national historic landmark.

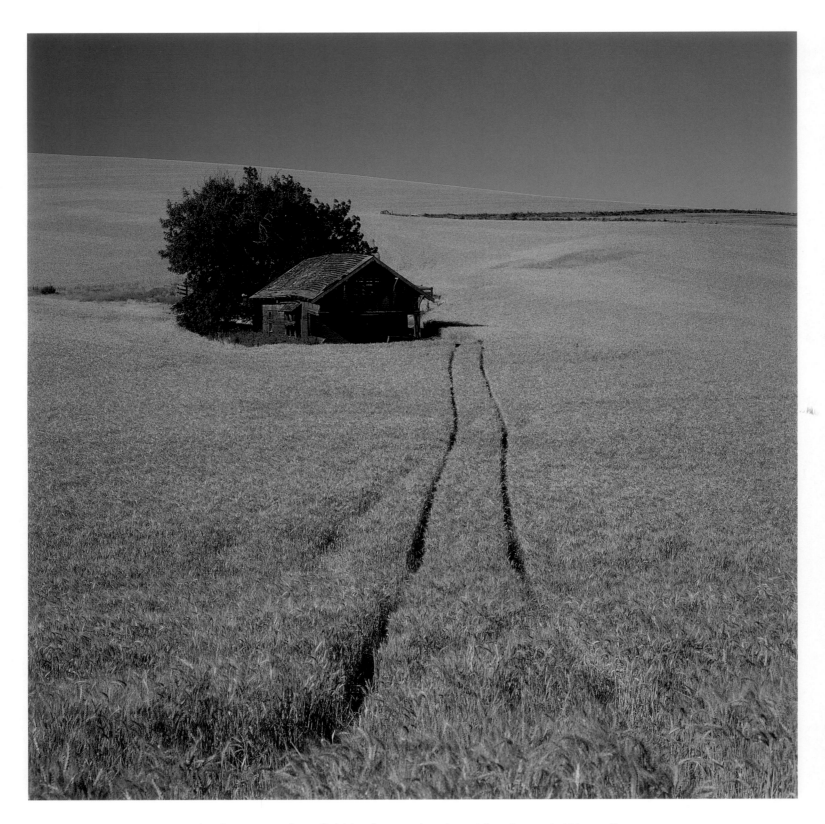

△ Wheel ruts in a wheat field lead to an abandoned farmhouse in Wasco County. Early settlers, often undercapitalized, abandoned their homesteads because they were unable to survive several years in a row of heavy drought, or even simply because they could not stand the isolation or needed to move closer to schools. ▷ Evergreen trees line lava beds along the McKenzie-Santiam Scenic Byway.

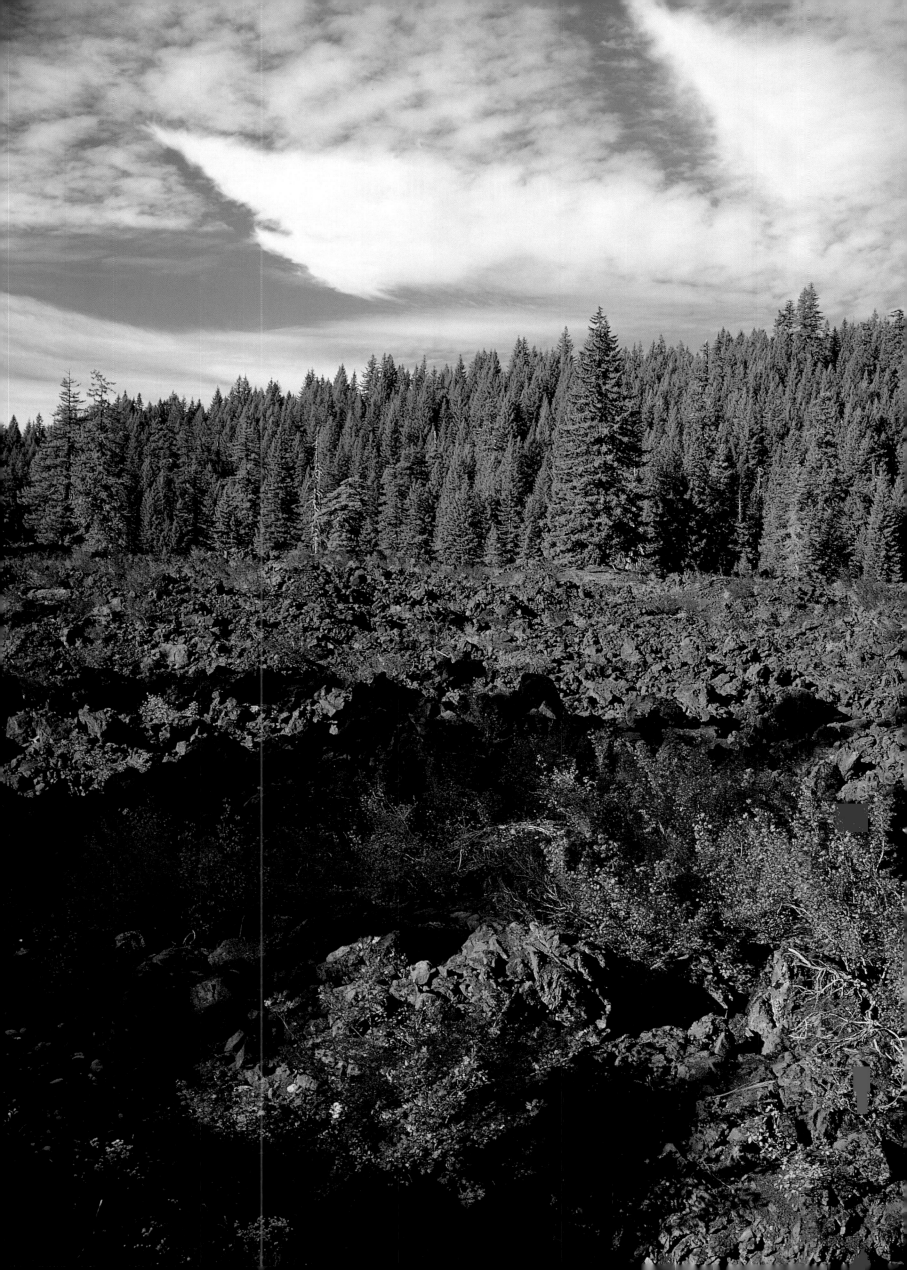

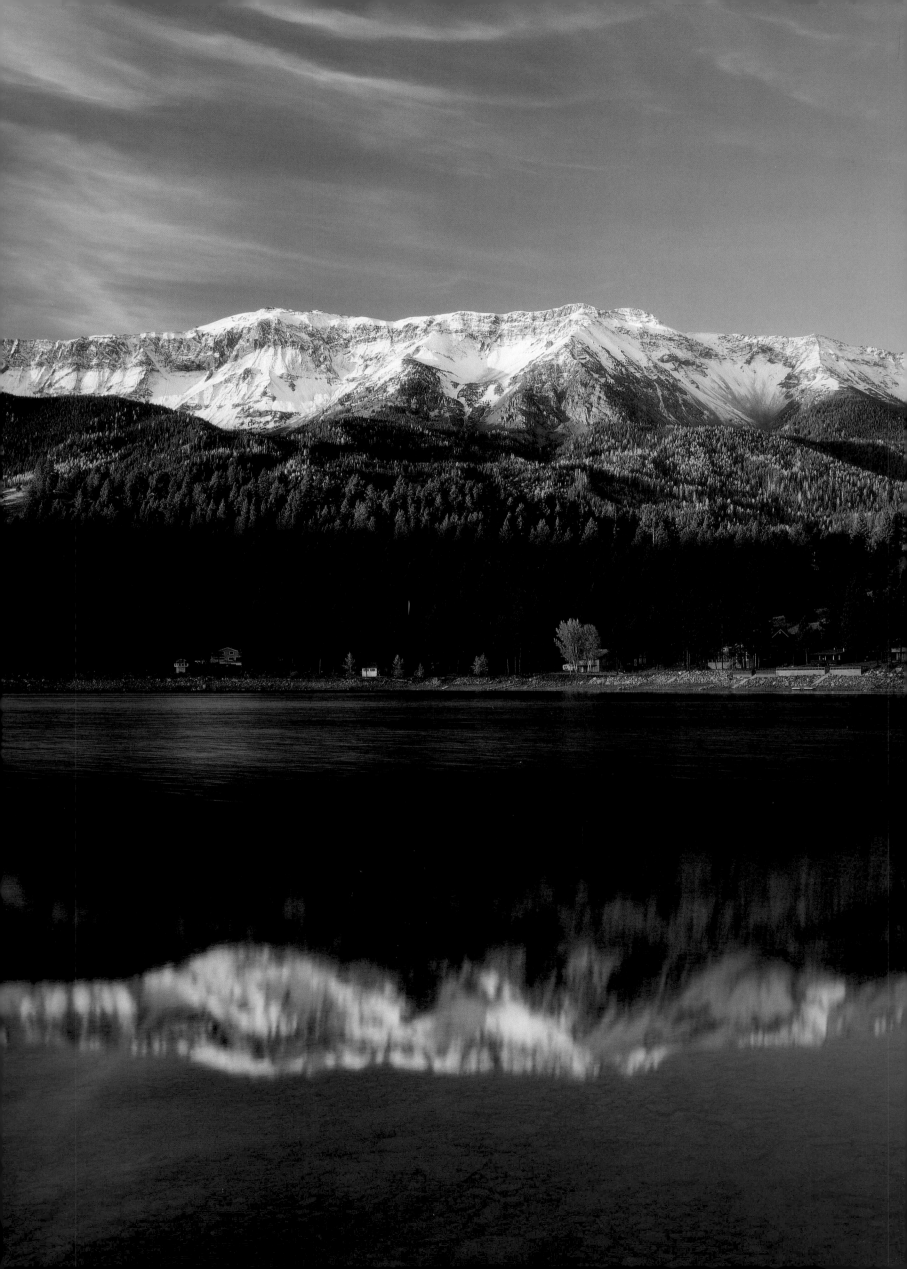

OREGON
LANDSCAPES

HEADING WEST

∿

I began writing *Winterkill* in Amherst, Massachusetts, because I missed Oregon deeply and needed to conjure the magical landscapes of home. New England is charming, a fine place to visit, but it's not Oregon. I longed for spectacular mountains—Cascades, Elkhorns, Siskiyous, Wallowas. Sagebrush, juniper, ponderosa—the whole of Oregon's high desert pulled at my heart like a lodestone. I remembered the dramatic capes of Oregon's spectacular coast, the long stretches of deserted beach south of Coos Bay, and coastal streams teeming with salmon.

Oregon's inland rivers kept rolling through my imagination, and I recalled fishing them stretch by stretch much the way Nick Adams remembers fishing Michigan's Big Two-Hearted. Hemingway said he had to leave Michigan to write about it, but I found I had to return to Oregon. Eventually, I featured the Deschutes and Columbia in my novels. I pictured chunky redsides rising for a Rhoda Special near Trout Creek or sipping a Renegade below White Horse. I wanted to see Tidewater barges filled with wheat and wood chips steering down the Columbia. Celilo Falls was gone, drowned by backwaters from The Dalles Dam, but I had grown up with that venerable fishery, and I wanted to watch the people dipping for salmon in the old style from the platforms at Sherars Bridge, Willamette Falls, and the Narrows.

I wanted to hear gritty, hardscrabble place-names. Puritan New England lacked sites named Devil's Elbow, Wagontire, Three-Fingered Jack, and Jawbone. I missed the rowdy dust of rodeos, the tan-faced, quick-smiling cowboys and cowgirls, the calloused hands of ropers, and the bravado of bull riders.

Perhaps I missed Oregon's neighborliness most of all. I wanted groups that gathered to build footpaths around Portland parks, one shovelful of bark dust after another. I longed for slow-talking ranchers, elbows jutting from pickups, discussing alfalfa cuttings and Certified Angus Beef. I missed the strangers who pitched in during times of crisis—fires and floods—and those rural breezy geezers with Cenex caps leaning back in chairs, gossiping about anyone headed for the city.

I longed to see elk shouldering through deep green timber high in the Wallowas, and I wanted to follow the riot of wildflowers from the lower Columbia Gorge into the higher mountain elevations as summer months slipped by.

So I wrote about Oregon in Amherst, and when that writing wasn't enough, I pointed my pickup west, thankful for the slanting sunlight on my face. I came home.

THE DALLES

∿

My Oregon begins in The Dalles with the rushing Columbia River, Celilo Falls, and cherry trees. In those days, I lived with my grandparents who ran a modest rooming house just off Lincoln Street. My grandfather Oscar Lange worked as a typesetter for *The Dalles Chronicle,* a small-town newspaper that kept in touch with the heartbeat of the Oregon country. He also distributed the paper to all the delivery boys, including me, once I reached the age of eight and was capable of carrying the weighty paper satchel up the steep streets. He nicknamed me "Skook," Chinook jargon for a strong spirit.

I became fascinated with my grandfather's stories of early settlers on the Oregon Trail. They rested in The Dalles, one of the last stops on the Trail, then decided whether to continue down the Columbia through treacherous rapids or trek the arduous Barlow Trail with its heartbreaking hills and wagon-busting slopes. I knew the fertile Willamette Valley was their goal, Oregon City or points south where they could farm, orchard, or raise cattle with the support of Dr. John McLoughlin who outfitted countless settlers from his Hudson's Bay headquarters.

However, the Willamette Valley, where two-thirds of Oregon's population now resides, remained a mystery to me. We stayed close to The Dalles. My grandfather's excursions took us up Fulton Canyon to spot deer and raccoons, east to the Deschutes where he caught fish and I didn't, to Fifteen Mile Creek gathering watercress for my grandmother's spring tonics, out to Dufur for the threshing bee. And always to Celilo Falls to watch the Native Americans fish for salmon.

The roomers gave me a hankering to see more. Two were railroaders for the Union Pacific who covered the Western states and spoke fondly of colorful railroad towns including Wishram, Huntington, Pocatello, and Rock Springs. Most of the others were young men who worked on The Dalles Dam, one of the many dams touted by the Army Corps of Engineers for inexpensive power, cheap irrigation, and flood control.

Two mighty forces a stone's throw upstream from The Dalles were on a collision course. Celilo Falls had been the gathering place for thousands of Northwest Indians who came every

◁ *Wallowa Mountains and Wallowa Lake*

spring and fall to fish for salmon, the staple of their diet. Here the great river narrowed down to a series of chutes and falls. As the salmon moved upriver to spawn, the people caught them in hooped, long-handled dipnets when the fish were in the basalt chutes or attempting to leap the falls.

Shaky wooden platforms extended over the churning waters. The people stood on the platforms, some anchored by safety ropes, holding the long dipnets steady by bracing the pole handles against their chests and shoulders. They wore rubber boots and rain gear to keep from getting soaked by the mists rising above the falls, and they smoked their pipes upside down to prevent the mists from putting out the tobacco.

The returning salmon rose out of the water like silver ribbons as they leaped the tiers of the falls. When the fish swam into the hoop-shaped nets, the Indians hauled them out and brought them to the waiting women who clubbed the salmon as they flopped against the twine webs. Later, they ate the plentiful salmon, sold some to tourists, dried many to last through the long winters.

But the gathering involved more than fishing. Warm Springs, Yakama, Wasco, Nez Perce, Umatilla, Walla Walla, and many other tribes traveled to gamble, gossip, feast, brag of hunting exploits. Fishing and gathering to celebrate the salmon's return defined their way of life.

As a child watching the building progress on The Dalles Dam, I couldn't grasp the concept that the dam's backwaters would inundate what remained of the falls after engineers had blasted away sections of rock to enhance river navigation. The river seemed too powerful to stop, and the falls had been there longer than anyone could remember.

Some of the people like Chief Tommy Thompson never cashed their checks from the federal government, believing that if they didn't take the money, everything would be okay. But when the engineers closed the floodgates on the dam, Celilo drowned, and the mighty roaring river became a hushed, giant lake. In the process, a way of life was destroyed. The Indians felt the most pain, but everyone lost when Celilo fell.

Progress? Ironically, today the talk focuses on the removal of dams, the restoration of salmon runs. And for those of us who love the Western environment, Celilo presents a cautionary tale. Landscapes can be destroyed, rivers altered. The territory most of us believe we have inherited can be stolen away.

I recall my grandparents' roomers gathering across the alley with other dam builders for a beer and barbecue the day they closed the floodgates on the dam. My grandparents did not join in. "Let's stay at home, Skook," my grandfather said. "There's not all that much to celebrate."

While my grandfather focused on upstream events, my grandmother, mother, and aunt Grace concentrated on the profusion of wildflowers downstream from The Dalles. Their excursions began in March when legions of grass widows blossomed on the beautiful hills near Rowena, Memaloose, and Mosier. These were harbingers of spring, and my grandfather dutifully drove the old curvy highway to the purple-covered grassy plateaus west of town so we could all enjoy the beautiful spectacle.

Ralph Waldo Emerson wrote, "The earth laughs in flowers," and certainly this proved true in the giddy blooming outside The Dalles. After the purple expanse of grass widows, the hills laughed with yellow bells, prairie stars, chickweed, larkspur, deer's head orchid, and Indian paintbrush. I was fascinated by the names and kept repeating them in a kind of chant as my relatives identified and wondered at species after species. However, I was terrified of the death camas because my grandfather told unsettling stories of pioneers confusing it with camas, the staple root in the Indian diet, and dying agonizing deaths after eating their mistakes.

In May we celebrated the western blue flag and yellow flag, both members of the iris family. "Look at that wild Irish," my grandfather joked, but echoing him, I pronounced the name wrong for years. When the lupine and balsam root joined in the merriment, my eyes ran with colors.

Although today I can identify only two dozen or so of the varieties that populate the East Gorge, I junket once or twice each spring to marvel at the wildflowers along this stretch. I feel the ghosts of my relatives smiling close by.

MADRAS

I spent two years in the late 1950s making America safe for democracy by keeping a vigilant eye out for enemy planes— North Korean– and Russian–piloted MiGs that might be threatening Oregon's interior near Madras. Tuesdays and Thursdays after school, my friend Tub Hobson and I stood on the flat roof of the Madras Fire Department scanning the horizon for hostiles.

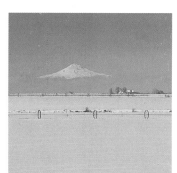

With the naked eye, and a single pair of cloudy binoculars traded back and forth, we repeatedly swept all four quadrants, taking no chances enemy planes would sneak by us to attack Culver, Gateway, or God help us, open fire on Madras itself. Our Boy Scout leader had warned that even seemingly harmless places like Metolius were prime targets, given the fact that they grew and stored potatoes there. He told of starvation during the Irish potato famines and how Stalin starved the Ukrainians by taking away their potatoes. Now our enemies threatened Central Oregon's spuds. I was convinced by the leader's speech, but Tub was more skeptical.

"Hairballs," he whispered.

In spite of our best intentions, strict discipline faltered in about an hour. By that time my eyes stung from staring over Mount Jefferson, Mount Bachelor, Three-Fingered Jack, and the Three Sisters, roughly the directions of North Korea and Russia, if you drew a line toward infinity.

Tub slugged me hard in the shoulder. "Don't rub it," he challenged.

His fists were bigger than mine and he already had grown the beginnings of a moustache.

"I think I felt a mosquito," I said but didn't rub it, even though my shoulder hurt like hell.

"I can throw farther than you can," Tub said.

"Not unless the bears come out of the woods."

"Betcha I can."

Dozens of rocks, some large as apples, mysteriously appeared on the flat composition roof before we manned each shift. We figured other high schoolers, probably the "hoods," threw them up in a night ritual. Our task was to throw them off—aiming for the city fire department's pumper truck parked in a gravel backlot half a block away.

My shoulder remained sore after Tub's slug, but I limbered up and selected a baseball-sized rock. To gain momentum, I ran toward the roof's edge, then flung the rock hard and high. It clanged off the truck's water tank.

Imitating the voice of a baseball announcer, I spoke: "Tub Hobson rounds third and Lesley makes the throw from deep center field. It's going to be awfully close, folks, but he's called out at the plate. What a major-league throw!"

"Pure blind luck, you throwing that far." Tub spit on his right palm, wound up, and threw with a mighty oomph.

The rock fell short.

Cupping my hand behind my ear, I asked, "Did you hear a clunk, Tub? Maybe I'm getting deaf."

Disgusted, he thrust his hands in his pockets and shrugged. "Hey, no kidding. How come you always outthrow me, Lesley? You got smaller arms and skinnier shoulders." He seemed genuinely puzzled.

"Physics," I said.

"Physics?"

"Remember, you got a C in Mr. Johnson's physics class and I got an A. Momentum and thrust, Tub. Angle of trajectory. Keep that in mind."

"Weenie Arm!"

In that five minutes or so while we goofed off, I suppose a plane or two could have snuck by unnoticed, but fortunately, they didn't.

What did fly across the Madras skies during our watch? A yellow biplane cropduster, numerous magpies, a confused pheasant that wandered into town and dodged sparse traffic. Closer to the earth, we also spotted a few wobbly drunks escorted by the police from the Shangrila Bar to the city lockup, where they idled until their red-faced wives reclaimed them.

Thank heaven no enemy planes threatened Madras on our watch. In those days, the city police car had no radio (tight budget), so if an emergency occurred, Madge Frudgett, the dispatcher, lit a red beacon light on top of the firehouse. The light was visible from anywhere in Madras—except the dark, smoky bars. When he saw the light, Herb Vibbert, the officer on duty, would stop at a house, ask to borrow their phone, and call in to see what was happening. All of this took time.

While Tub and I were freezing in the winter, baking in the summer, the light flashed only a few emergencies, but most were routine: stolen bicycles, cows breaking through fences, pregnant women going into early labor. Whoever spotted the flashing light first got to punch the other volunteer squarely in the shoulder, say, "Don't rub it," then add, "Do you see any enemy planes, Horseface?"

Most shifts were uneventful outside of the throwing and punching. For the last hour of the shift, I gazed toward the snowcapped beauty of the Cascades—the jagged crest of Three-Fingered Jack, the rugged beauty of Broken Top—and I'd dream of catching brook trout later in the summer and hiking alpine meadows filled with wildflowers.

Shifting my eyes, I'd watch the sunlight glinting off the tin potato shed roofs at Metolius and realize they did make ideal

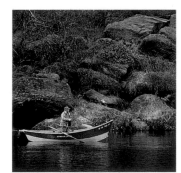

targets. Strengthened by my resolve to complete my duty, I'd stare hard at the sky another twenty minutes until black dots danced before my eyes.

Finally, Madge would crunch out onto the gravel parking lot to announce that our shift was over and invite us for cookies and Kool-Aid in the dispatch room. We descended the shaky ladder while two more eager Civil Air Patrol volunteers headed for the roof.

After scarfing the drinks and sticking extra Snickerdoodles into our pockets, Tub and I made our way toward separate homes, confident we had kept Madras safe for another three hours. We parted at the county jail where sad-eyed men gestured out the bars, begging smokes.

"See you tomorrow, Bacteria-Breath," Tub said.

"Same to you but more of it," I answered. I sauntered home, secretly pleased with his friendship and confident that any major-league scouts visiting Madras would covet my throwing arm. Once again, Tub and I had guaranteed that Central Oregon was safe from invaders.

Many years later, when the Metolius potato sheds finally did collapse, no one could discern a reason. Old age, gravity, saboteurs. No potatoes had inhabited the sheds for years, but a few transients had been reported taking up residence.

Earl Cordes, Jefferson County fire chief, drove out the five miles in response to a call from the sheriff's office. According to the story featured in the *Madras Pioneer,* Cordes yelled into the collapsed building (a dangerous mess), but got no response. "So far I've received no reply," he told the paper. "So they're either unconscious, dead, or not there."

I wonder what became of the so-called transients. Perhaps they were saboteurs, following sinister orders from a foreign power. Were they agents from Cuba, North Korea, the former USSR?

Maybe Cordes is right. "Unconscious," "dead," or "not there" implies no one is threatening Central Oregon, but I'm not so easily convinced. Growing up with full knowledge of the Red Menace, I know how sneaky those Commies can be. Even now, they could be hiding in seed carrots, the bluegrass fields, or lurking in the mint—just waiting for us to lower our guard.

THE DESCHUTES

Oregon's blue-ribbon trout streams are legion, and their names roll off the tongue with a poetic cadence: Umpqua, Metolius, Crooked, Rogue, Deschutes, Siskiyou, Grande Ronde. Still, the Deschutes is the queen, and her reputation as well as the thunder of her rapids stir many hearts across the continent and beyond. Buckskin Mary, Whitehorse, Boxcar, Sinamox, Sherars Falls get a fisherman's blood racing. To my mind, nothing compares with the blue-green beauty of the Deschutes in May or June, the fragrance of mock orange along the riverbanks, that wonderful smell of water in the dry basalt canyon heat.

As the Deschutes is legendary, so, too, was my uncle Oscar Lange of Madras who ran Oscar's Sporting Goods and the Deschutes River Guide Service for twenty-seven years. Oscar wanted to catch fish, and usually he returned with a cooler full, so the dudes he took fishing could brag to their families and business partners. For *The Sky Fisherman* I used both my uncle Oscar and the town of Madras liberally, blending in a few details from Maupin, Baker City, and my home town of The Dalles. The novel is set in 1957, the same year the Russians scared the dickens out of us with Sputnik, and Tub Hobson and I stood our vigil for the Civil Air Patrol.

In those days, the Deschutes was uncrowded. We expected to see only four or five other boats in a day. Today, it gets a ton of traffic. In 1974, I was fishing Michigan's Pine with a friend. It was so crowded that we had to time our fly rod casts between the flotillas of canoes that passed by, filled with exuberant and careless Michigan State students. I remember thinking smugly that the Deschutes would never get overused like that, but sadly it has, and now it's choked with state rules and regulations.

Ironically, the widespread popularity of the Deschutes struck me when I was in New York City. My editor surprised me with the copyedited version of *The Sky Fisherman* manuscript crowded with the queries and notes of the fastidious copy editor, who has the tedious job of poring over the pages, making certain everything is correct. For all their usefulness, copy editors usually hail from east of the Alleghenies and don't know about many things Western, including place-names, distances, railroad terms, fishing paraphernalia, Native American customs. The Western writer is responsible for these "esoteric subjects." Even so, a copyedited manuscript is like gold, and I had no briefcase large enough to hold the six hundred pages. I had to make certain the manuscript was secure both for the time I was in New York, and again when I flew back to Oregon.

I had spotted some rugged Filson bags at a New York fishing store, so I headed there, clutching the precious manuscript

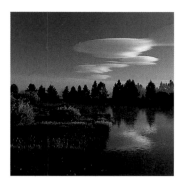

held together by only two thin rubber bands. On the way, taxis tried to clobber me and scatter the pages across midtown Manhattan, but I made it safely.

The clerk immediately spotted me as an out-of-towner and inquired about my business in Manhattan. I talked a little about writing, and when I informed him I had just finished a novel on the Deschutes, his eyes glazed and he rummaged a map from beneath the counter. Beaming as he unfolded the map, he said, "I'm heading to the Deschutes next week. Can you show me some of your favorite spots?"

Before me lay a map of the river. Mecca Flat, Whiskey Dick, Grey Eagle, Whitehorse, Buckskin Mary, and other place-names swam before my eyes, and my knees slacked with homesickness. "You'll want to stop at Whiskey Dick," I said. "The river guides put up a plaque there to honor my uncle Oscar."

I leaned over and started to explain more, then caught myself. No reason to give away the secret places my grandfather, uncle, and I had discovered by fishing seriously over seventy years. For a moment, I thought of twilight on the river, 1957—the year the novel takes place, the scent of my grandfather's pipe tobacco on the evening breeze, the perfect float of a dry fly.

"It's a magical river," I said. "Lots of terrific fishing." And I showed him a dozen spots out of Oregon hospitality, but I held the very best places in my heart.

WARM SPRINGS

Artist and maskmaker Lillian Pitt grew up on the Warm Spring's Reservation, but her mother's people came from the Oregon side of the Columbia River Gorge. Her clay images honor the pictographs, petroglyphs, and legends of her ancestral home, as well as places on the reservation including Simnasho and Tenino. Now she divides her time between Warm Springs and her Portland gallery Kindred Spirits.

In addition to celebrating her ancestors and the places of her background, Lillian's work shows an affinity with the natural world. She has made anagama figures of eagle, badger, hawks, skunk, deer, and other creatures. After forest fires destroyed Western forest animals and their habitat, Lillian turned to a series of animal spirit figures to help keep the spirits alive. She noted, "Usually there is only a 50 percent success rate in that wood-fired kiln, but this time every forest critter survived the three days of intense firing and the week of slow

cooling. I felt it was a gift from the fire as a promise of Mother Nature's persistence to keep things in balance."

Lillian's raku and anagama works include silver and copper, shells and feathers. as well as other natural materials. Her work features masks, totems, drypoints, and installations. Whistling spirits, the legendary Stick Indians of the Columbia Basin and Plateau, sparked the idea for my novel *River Song*. According to the legends, people who are lost in darkness, fog, or smoke in remote reservation locations might hear the whistling "night bird" songs of the Stick Indians. If the person is good, the whistling leads to safety; if bad, it leads to destruction. My hero Danny Kachiah is spiritually lost and needs the Stick Indians to guide his journey toward redemption.

Lillian once described herself as "a project of my people" and her many artworks honor them. Oregon writer Barry Lopez pointed out that Lillian's work is part of a "boundless creation" outside of linear time. He added, "She can only make that object because her grandfather is talking to her from long ago, and wild celery is talking to her now, and she is walking a man [Lopez himself] along the river of her youth, and recalling for him the ways in which she is alive."

RICHARDSONS' ROCK RANCH

Richardsons' Recreational Ranch, located fourteen miles north of Madras, features world-famous rockhounding. Each year more than fifty thousand people visit the ranch and rock shop; seventeen thousand of those carry picks, shovels, and other digging equipment out to the agate, jasper, and thunderegg beds.

"Sometimes in the summer we get so many rock hounds digging that the ones on their way out to the beds have to grab the equipment from the ones driving back," Normadell said. Her people have been on the property six generations, and she keeps watch over the agate shop the way a Navy cook oversees his mess hall. She and her husband, Johnny, offer advice to the rock hounds as they fill out digging permits, pass out equipment, help a husband select agate earrings for his wife, and identify the composition of the thunderegg, Oregon's official state rock.

Explaining its origin to a wide-eyed grade-school girl, Johnny held the two halves of a beautifully cut and polished thunderegg. "This started as a homely mudball a volcano threw out when the Cascade Mountains were being formed. Originally,

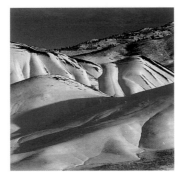

it was hollow. Then over the eons, water carrying silica and minerals oozed into the gas cavities, forming this beautiful blue-black agate inside. When she's polished she's almost as purty as you are."

In addition to thundereggs, enthusiasts can dig moss agate, jasper, and Oregon sunset and rainbow agates. At one time the Richardsons also had plume agate beds, the most notable in the world. In total, four thousand acres of their ranch lie open for digging. While most finds occur under easy digging conditions, some of the rarest agates reside in rugged flows of volcanic rhyolite. The Richardsons call this pick and shovel work "hardrock mining."

The rock shop itself, half the size of a school gymnasium, is filled with curiosities from around the world. One of the rarest is an elaborate vessel made from red amber found only in Crimea. Others include ammonite shells from Morocco. These resemble huge snail shells; the largest weighs 248 pounds. "That's my petrified escargot," Johnny kidded. He pointed to a petrified eel from the Oregon desert and petrified predawn redwood.

"Here's my aquarium." He proudly indicated the shop's showpiece. "You never have to change the water or feed the fish. Best hobby I ever had." The fireplace-sized slab of sandstone contains thousands of petrified freshwater herring, so that many of the fish fossils lie superimposed. The slab is truly an awe-inspiring fossil record.

To study everything at the rock shop takes a couple of hours. Outside, huge piles of rock from every corner of the earth cover the ground. A sign reads, FOR SALE OR SWAP. Inside, the back room displays fifteen hundred baseball-style caps advertising regional businesses—everything from backhoeing to water witching. Johnny pointed out that three thousand additional caps are stored away so they can rotate the display. Tugging at his own cap bill, he quipped, "All these caps used to cover a heap of rockheads."

One area of the shop is devoted to exhibits of speartips and arrowheads dug from the ranch itself and the wider Oregon country. These include large heads for spearing deer and elk as well as tiny, delicate but lethal, birdtips. During the Fourth of July weekend, as many as two hundred flintknappers occupy the ranch and demonstrate their skills.

Two of my friends, the Warners, recently visited from Michigan. They had waited more than thirty years to see the Oregon country. I asked them to prioritize the places they wanted to visit. Of course, I was thinking of the Oregon coast, Crater Lake, the Cascades. Both Bob and Mary Ann shook their heads vigorously. "We'll get to those later." Mary Ann pulled a rockhounder's guide from her bookbag. She flipped through the pages and pointed. "Richardsons'," she emphasized. "More than anything else we want to see Richardsons'. Maybe I can trade them Lake Michigan Petoskey stones for Oregon agates."

PORTLAND

Seattle writer Ivan Doig once waggishly remarked in the travel section of the *New York Times* that while Portland was a fine city to live in, he wouldn't want to visit there. This was during the '70s just after a national magazine cited Portland as the most liveable city in the United States. Doig's point at the time was that Portland was fine for families and people who knew its routines, but the city lacked nightlife for conventioneers, more than one major-league sports team, an active art scene. Of course, much of that has changed, and Portland has become a major city while maintaining a small town feel and family atmosphere.

About the time Doig wrote his phrase, Harold and Wilma Smith moved to Portland from Jackson, Mississippi. Harold had served a tour in the Navy, and a job with the Army Corps of Engineers brought him to Portland. As a Navy man, he liked the fact that Portland was a port, and he enjoyed trekking the waterfront. Harold also found the climate temperate, contrasting with Mississippi's heat and humidity.

"We found out you could have so much fun for free," Wilma said. "The Rose Gardens and Peninsula Park were beautiful. We watched the airplanes from Marine Drive, attended all the parades, explored Sauvie Island, picnicked in Blue Lake Park. We loved visiting the zoo and Oaks Park. Sometimes we went up the Columbia Gorge to Multnomah Falls, fed the fish at Bonneville hatchery, and wondered at those giant sturgeon. In Hood River, we ate delicious fruit."

The Smiths bought a family home near Alberta Park and added three more to Oregon's population. Tommy, the oldest, has graduated from Oregon State with a degree in construction engineering management. Reggie earned a communications degree from Portland State University. Sherena attends Benson and is ranked the number five triple jumper in the state. Quintessential Oregonians.

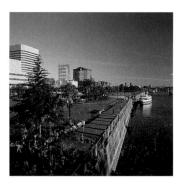

The Smiths also love the ambiance of their Northeast Portland neighborhood. "We thought about moving when the family expanded, but we stayed near Alberta Park," Wilma explained. "Sometimes we walk up to Whitaker School. Everyone is friendly, and I like the fact each house has its own character. Yards, too."

"People are individuals," Harold said. "If they want a bright pink house, they have a bright pink house. Chartreuse is okay, too. People are unique. Maybe you want lawn ornaments. That's okay. They express individuality, not conformity."

This last statement makes me think of the legendary Oregon mavericks, Wayne Morse and Tom McCall. Somehow, I think they'd approve.

"One year, when Wilma was pregnant, we switched vacation plans from Yellowstone to Oregon," Harold said, "just because we didn't want to wander too far from home. And we had a fabulous time at the Oregon Caves and Crater Lake. We did a lot of walking, seeing spectacular sites. When I first saw Crater Lake, I was impressed like nothing before. 'I'll come back here,' I vowed to myself."

"We attended two Scandinavian festivals," Wilma added. "One in Junction City and a second in Astoria. Everyone in Astoria chuckled when we claimed to be from Sweden. We were the only African-Americans attending."

The Smiths came to Portland to stay. Harold has now retired from the Army Corps of Engineers, and Wilma works as a nurse practitioner/clinic manager for the Multnomah County Health Department. She is one of two women African-American nurse practitioners in Oregon.

Active in their Maranatha Church of God, the Smiths are also spreading the "gospel of Oregon" to acquaintances across the country. Wilma tells this story:

"One time we hosted an assembly from the Church of God in Christ. They were pentecostals from other parts of the country. We took them up the Gorge and they were awe-struck by the beauty of the river and mountains. Somewhere near Bonneville, they got out of their cars and started jumping up and down, shouting and praising God for all the beauty. Some were even singing, 'Thank you, Jesus, for all this majestic scenery.'"

ASHLAND

In 1935 Angus Bowmer and other Ashland visionaries decided to celebrate the Fourth of July with two plays by Shakespeare. Convinced Shakespeare might not turn a profit, they hedged their bets by scheduling boxing matches in the afternoon. However, Shakespeare packed more punch than the pugilistic fights for artistic local residents, and the Oregon Shakespeare Festival was born. Today, half a million people attend the plays during a season. In addition to Shakespeare, the Festival produces classic comedies such as *The Man Who Came to Dinner* and *Charlie's Aunt* as well as contemporary works including *Wit* and the controversial *God's Country*, which deals with white supremacy.

On my first visit to Ashland, I had a ticket for a matinee performance of *Oedipus the King* featuring Todd Oleson, my high-school drama coach, as Tiresius. Athough I had taught the play three times and considered it a good starting point for a drama course, I didn't believe it would actually work as a production. The masks, the choral strophes and antistrophes, the esoteric Greek allusions—all suggested it was good to study as literature but difficult to perform as theater. And each time I had taught the play, my students remained cool, in spite of my enthusiasm.

Nonetheless, I was buoyed because my favorite high-school teacher (and a fine actor) had landed a key role, and I looked forward to his portrayal of that powerful but reluctant prophet.

My bubble burst when I saw dozens of yellow school buses—both high school and middle school—parked in the lot. Suddenly, I imagined a performance marred by groaning students whispering and fidgeting for ninety minutes. I didn't need to drive five hours for this mess, I thought. Inside the Angus Bowmer Theater, my worst fears materialized. Throngs of teens chatted, flirted, punched each other's shoulders. Considering retreat, I realized the evening performances were sold out. I was stuck.

Imagine my surprise when the curtain rose and the students hushed. Not a peep. The role of Oedipus had fallen to a six-and-a-half-foot actor who commanded the stage. His performance riveted the audience. When Todd appeared as Tiresius, wound with pale trailing rags, the tension between the two was spellbinding. Oedipus's power and privilege, his kingly statements, were countered by the prophet's dire predictions. Tiresius's words twisted and fluttered like frightened birds.

For the first time, I understood the play. Events happened so quickly, I realized why Oedipus might brush off the prophet's warnings and listen to his troubled queen, Jocasta. Glancing around the audience, I saw the high schoolers paying equally

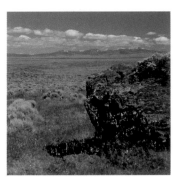

close attention. As the play finished and the tragedy uncoiled, my heart felt seared. Catharsis.

Before the evening performance, Todd and I had dinner in one of Ashland's outstanding restaurants and browsed the plentiful antique stores for carved duck decoys, one of my passions. Throughout these activities, the play stayed with me, and I kept praising its merits. At last, Todd produced a ticket for that night's performance.

The night crowd was different: men in suits, women in designer dresses, tweedy professors, blue-haired elderly women. But the play was equally engaging—until a peculiar event brought the production to a halt.

After Oedipus learned the truth about his birth, that he had murdered his father and married his mother and brought a plague upon Thebes. After he blinded himself and staggered out of the castle to face the citizens. After he asked Creon, his brother-in-law, to bring forth Ismené and Antigone, both Oedipus's children and siblings, products of his incestuous relationship. Finally, after all these tumultuous and horrible revelations, there came a moment of respite and solace when Oedipus tenderly held his children and asked Creon to care for them.

At that very moment toward the end of the production, an elderly woman lurched to her feet and pronounced loudly, "I'm eighty-six years old and I'm not going to watch any more of this filthy, trashy story."

The performance on stage stopped, but the woman's continued. The acoustics were great in the six-hundred-seat theater. As she gathered her coat and cane, the audience heard every mutter deriding the play's perversity. It took her maybe two minutes to exit the theater, but she never stopped talking. It seemed a lifetime. When the door slammed, the show went on. Somehow, the players picked up and found the ending.

"We were dumbstruck," Todd said later. "What a woman. She absolutely stole the show!"

OREGON DESERT

~

Fort Rock, a crescent-shaped volcanic cone rising from the windswept Oregon desert, brings shivers to visitors because it is hauntingly beautiful and surreal. The spectacle evokes ages past when swamp and marsh occupied today's desert. Artifacts discovered in nearby Fort Rock Cave demonstrate a Native American culture that flourished more than ten thousand years

ago. Staring at the geological wonder, I recognized my own brief life span, the transient nature of civilization.

Fort Rock sandals, well-known in the archaeological community, testify to the long-ago inhabitation. Large spear points indicate the big game once present as do ancient sharpening tools including elk antlers, deer antlers, hammer rocks, and obsidian—all part of a hunter's "tool chest." However, when the first white settlers arrived in the 1800s, they found only a few northern Paiute people who used small arrow tips suitable for rabbits and birds. The big game had vanished along with the marshes, swamps, and forests.

The giant inland lake had disappeared as well. Still, net weights and other fishing artifacts testify to its presence, as does the fossil record. Most impressive of all is Fort Rock itself. Volcanic rims of the cone crater rise three hundred feet from the desert floor, but one large expanse is missing, forming the crescent. Scientists have determined that this vacant side was worn away by the wave action of the large inland lake. Still, looking at the gray-green desert sagebrush, I had to use an active imagination to conjure a lake filled with canoes and fishing nets.

As shadows lengthened and the evening air cooled, coyotes began to cry in the great basin, a lonely, desolate sound. A great horned owl called. Putting on my sweatshirt, I thought of the spirit quest the Paiute people took, journeying far into the desert, often for as long as five days. They followed a ritual of fasting, prayers, and singing, while waiting for the guardian spirit—deer, rattlesnake, owl, or wind—to make its appearance. By closing my eyes and listening, I could hear the old songs carried by the night wind.

After leaving Fort Rock, I traveled to the small town of Christmas Valley, a planned retirement and leisure-time community based on a Christmas theme and the timeless beauty of the desert. Street names include Holly and Tinsel, Donner and Blitzen. The area has several good motels, restaurants, and a golf course. Artists, miners, writers, and "genuine characters" make up the town's population. Two colorful general stores offered me a chance to stock up food and water for more desert exploration.

When most out-of-staters think of Oregon, they picture the beautiful Oregon coast, old-growth forests, rushing trout streams, and the Cascades. The Oregon desert and high plains hold their secrets a little closer perhaps. Growing up in Eastern Oregon has given me a love for desert exploration. The sage

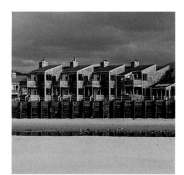

flats don't look as though they hold much wonder, but if I get out of the car, I can see the distinct yellow of wild buckwheat, purplish blue penstemon, crimson Indian paintbrush, and delicate mariposa lilies. Wildlife abounds on the flats: antelope, deer, rabbits, hares, several types of rats including the colorful kangaroo rat. Predators and scavengers make a good living. These include sharp-tailed hawks, turkey buzzards, and the ubiquitous coyote. In speaking of Montana, the wonderful writer James Welch mentions his love for the remote stretches of Highway 2, where motorists race toward North Dakota at eighty miles an hour. Jim insists they'd see a lot if they'd stop the car and walk around a little. The same holds true for the Oregon desert.

In addition to Fort Rock, three other mysterious places lie within easy driving range. Hole in the Ground rests eight miles to the north. This incredible geological phenomenon is a steep-sided hole about a mile across and three hundred feet deep. At first appearance, the hole looks like a meteor crater similar to the ones found in Arizona. However, more likely it's a large volcanic formation resulting from recent lava flows being propelled by gases from deep within the earth. These "blowouts" have also formed some of the lava tubular caves within the area. A number are deep enough to form perpetual ice formations. This ice within the desert creates a paradox, and the caves themselves attract area spelunkers.

The Lost Forest, another desert paradox, testifies to the evidence that the desert once was a rich marsh and forest area. The current Lost Forest of ponderosa pines, some over five hundred years old, lies at the east end of Christmas Lake basin. Seeing the Lost Forest, I thought "mirage," because an extensive pine forest doesn't belong in the desert. Yet this one exists and fascinated my shirttail relative Dick Berry who did his Ph.D. dissertation on the forest for Oregon State University. He concluded that at the time the marshes and lakes covered the region, large forests occupied the hills, and this present forest was a holdover from prehistoric days. The peculiar mix of volcanic rock and sand holds moisture from what little rain falls, and the forest thrives under "impossible conditions." Anyone attracted to desert anomalies will enjoy the delightful isolation and surprise the Lost Forest presents. But carry plenty of water.

As I approached Crack-in-the-Ground, the desert wind carried gusts of cool air, and the hot smells of sage and sand shifted to dark, moist odors of caves and cellars. Faint tire tracks through the sand led to a volcanic fissure that opened like a deep jagged wound in the landscape. The crack seemed wide at the start, but narrowed as I progressed. In places I could touch both sides with outstretched arms, and I had to scramble up and over rugged jumbles of basalt as the crack wound two miles through the desert. In some places the fissure dropped to ninety feet, and the blue desert sky all but disappeared. Gazing upward in wider places, I caught the flit of a magpie, the lazy drift of a sharp-legged hawk.

When my sweat cooled, I put on a sweatshirt and thought perhaps I should have brought a flashlight. But surely it won't go that deep, I reassured myself. Still, the irregular basalt walls transformed into goblins and monsters. I thought of snakes, falling rocks, a broken ankle, actual desert dangers but more likely formidable than fatal. Perpetual ice formed in some of the deepest locations. Early settlers used the ice to make ice cream, to cool their meat and cheese. Comforting thoughts.

Finally emerging into sunlight once again, I blinked hard, relaxed, and put on my sunglasses to avoid the harsh glare. My cooler in the car held beer and sandwiches. In Christmas Valley, a short drive away, modern air conditioning provided relief from the intense heat. Even so, a chill remained. After traversing the crack, I felt the desert's mystery in my bones.

THE SOUTHERN COAST

I pore over maps. I love the colorful names of towns, including Bonanza, Scappoose, and Winchester. The evocative names of Deschutes Rapids—Whitehorse, Boxcar, Buckskin Mary—stir my imagination. Sometimes names get too tidied up. Hardman used to be called Raw Dog, Yellow Dog, or Dog Town; Drewsey had the moniker "Gouge Eye" because of the wild fights. Small towns make good names for characters in novels including Culver, Flora, and Riley from *The Sky Fisherman*.

Knowing maps can also prevent mistakes. In the winter of 2001, I headed for a splendid writers' conference sponsored by Southwestern Oregon Community College's satellite campus in Gold Beach. With two hip replacements, driving gets a little wearisome, so my plan was to fly to North Bend, rent a car, and drive to Gold Beach, stopping in Bandon for a book signing and Port Orford for the view. For my money, Southern Oregon's coastline along 101 is among the prettiest in the world.

On the Horizon commuter plane, we enjoyed bluebird weather. Near North Bend, as the plane descended, we flew

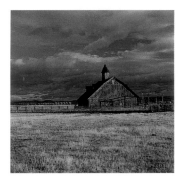

over sandy shore, green beach grasses, and deep blue Pacific. Spectacular scenery. However, two seats ahead of me, a woman became extremely agitated.

"What is that down there?" she demanded. "What on earth is that?" Her voice grew strident and she gesticulated wildly.

The steward unbuckled his seatbelt, walked down the aisle, and rebuckled in the seat across from her. "Can I help you?"

"What's all that sand doing down there? What lake is that?"

"That's the beach and the Pacific Ocean," he said in soothing tones.

"Where's the mountain?" she demanded. "I don't see any mountain. I'm going skiing this afternoon."

Slowly, I began to realize that her destination was Bend, not North Bend. A Massachusetts native, she had assumed towns came in clusters as they do back East. Hadley, North Hadley, and West Hadley are within pitching distance of one another. However, in Oregon, we name our cities with far more imagination. Although I'm certain she didn't ski that day, I hope she enjoyed the fabulous Oregon coast.

Before leaving the North Bend/Coos Bay area, I drove to Sunset Bay State Park where large sandstone bluffs and ocean rocks blend into a fine vista. Shore Acres State Park features gigantic rock cliffs gouged with pits and caves from the frenzied water crashing against the barrier and rising hundreds of feet into the air. Here winter storms are phenomenal, especially in February. Once the private grounds of the Simpson lumber family, Shore Acres is now famous for its luxurious botanical gardens featuring varieties from across the world. Nearby, Cape Arago State Park offers a photogenic lighthouse and sea lions lounging on offshore islands.

My next stop was Bandon for a book signing in the old downtown. Cranberry capital of Oregon, Bandon has become a charming tourist destination, and I was pleased at the turnout, surprised that some people had traveled from Eugene to attend the reading and then enjoy that stretch of coast. The burgundy cranberry bogs, both north and south of Bandon, were pleasing to the eye, and the dried cranberries I purchased were delicious.

The Beach Loop features large offshore rocks, a variety of monoliths, some rising like stone needles, others resembling heads and faces. In season, yellow gorse blooms cover the beach slopes. Azaleas, dogwood, and lupine offer a variety of beauty.

The Sixes River tempted me with legendary stories of salmon and trout. But I had promises to keep farther south. Still, I couldn't resist stopping in Port Orford, a picturesque village, for delicious clam chowder and halibut fish and chips. Drowsy, I parked at Battle Rock State Park, surveying the spot where Captain William Tichnor's men made a stand against hostile Natives in 1851. Port Orford is a charming, hardworking town, and I recall that my wife and I spent several days relaxing there after finishing a lengthy revision of *Winterkill*. The hot summer sun and brisk ocean air revitalized my soul.

Gold Beach is the jump-off place for the jet boat excursions up the Rogue. Tourists can choose the sixty-mile round-trip to Agness or the longer one to Paradise Bar. Along the way, one can see elk, wild turkeys, deer, mountain sheep. Zane Grey popularized the river with his writing and roughneck drinking episodes, and he used Gold Beach as the setting for one of his novels. At the well-stocked local bookstore/coffeehouse, I bumped into a filmmaker who was doing a project based on Grey's work.

The town itself contains good restaurants, resorts, a well-stocked, old-fashioned sporting goods store, river museums. Every winter it hosts the writers' conference where the workshops are inexpensive, the writers accessible.

Fifteen miles up the Rogue, I tried some winter steelhead fishing and got a ferocious strike on my flourescent orange Hotshot. Lou Giottonini served as my guide and ace photographer. After a photo opportunity, we released the twelve-pound buck, a wild and beautifully colored fish. I sent copies of the photo to all my fishing buddies, chiding them about the "runts" they settled for in other parts of the country.

BAKER CITY
~

BEEF. IT'S WHAT'S FOR DINNER.

The sign hangs over Danny and Sue Freeman's kitchen stove. They raise Certified Angus Beef—no hormones, no growth enhancers, no antibiotics—just wonderfully flavored, top-quality marbled beef, the kind that appeals to Oregon's health-conscious consumers.

The Freemans have ranched three generations in Baker County. In 1908, John Quincy Freeman headed west from Idaho

and homesteaded 160 acres. Tough times and drought plagued the landscape, and as fellow homesteaders starved out around him, J. Q. cinched his belt and added water to the stew. He gritted out the bad years and eventually took over sixteen other homesteads. The land passed from J. Q. to his son Joe and on to Danny and his brother.

Ranching is still hard work. "We never have a boom or bust," Danny said. "Baker's a nice place to live but a hard place to make a living." He explained that Joe worked at the Grange, "a salary job," in addition to ranching. Danny's wife, Sue, runs a beauty parlor out of their home. "She provides the cash flow."

Hard work aside, the spectacular view, one of the best in the state, must be worth a small ransom. From her neat-as-a-pin beauty shop, Sue can view the Eagle Cap Wilderness area. Looming to the west, the Elkhorn Mountains display steep, forested slopes and scenic snowcaps. Native to Eastern Oregon, Sue grew up in LaGrande and studied cosmetology in Pendleton, home of the woolen mills and world-famous Pendleton Roundup. "I like Eastern Oregon," Sue noted. "There's a nice atmosphere and a sense of community. I just wish winter was two months shorter."

Danny looks like a rancher. Wide shoulders, a bright smile, and blue eyes crinkled at the edges. In college, he won the National College Rodeo Association's bareback title. He also worked as an extra in Western movies. "I was on top of the world," he said. "Nothing could stop me. And then I got drafted."

This was the height of the Vietnam war when nearly every lottery number came up. Dodging the draft would never occur to Danny. He did twenty-one months overseas as an infantryman, packing a radio through Vietnam. "Man that sucker was heavy. Twenty-seven pounds of first-class target on my back."

After finishing his tour, Danny returned to Eastern Oregon and never wanted to leave Baker County. "I put my seat on a tractor and watched the mountains. I fed the cattle, stacked hay, and watched the mountains. Except for a trip to Boise, I never left the county for eight years."

Now fifty-six and four times a grandfather, Danny has learned ranching wisdom along the way. "I'm getting smarter instead of tougher; at least I hope I am. I figured out it's all hard work and you need help. These days, I just keep track of the cattle and get another guy to cut alfalfa and bale hay."

For a while, Danny and his brother ran an upland game preserve on their ranch, catering to wealthy patrons who wanted to shoot pheasants and take a turn at acting out the cowboy life, but it became too difficult to put up with the city dudes' demands.

Now Danny returns to his rodeo roots and old cowboy skills by team roping at Jackpot events in Oregon, Washington, and Arizona. "They handicap it now, so you've got a chance, even when you're an old geezer," he said. "I don't golf or fish, and roping is a lot of fun, but I'm not as fast as the younger guys. When they tease me about my slow times, I tell them, 'I like the sport so much, I go slow.' Danny offered a wink and that easygoing grin. "Roping keeps me out of the rocking chair, and I don't want to play bingo until I have to."

While cattle make up the contemporary riches of Baker County, at the turn of the century gold was king. As prospectors and miners sought gold throughout the area, frontier towns sprang up like wildflowers. Then after the gold played out, the towns became deserted. Some like Granite and McEwen have a few inhabitants remaining, but most are genuine ghost towns. Auburn, Bourne, Greenhorn, and Clarksville are inhabited only by the wind. It's difficult to believe that the weathered buildings were once part of cities that held as many as five thousand people and boasted newspapers, saloons, hotels, and whores.

Gold-rush treasures are on display at Baker City's U.S. Bank. The lobby features gold coins, gold dust, pea gold, and the famous Armstrong Nugget found by George Armstrong in 1913. The single nugget weighs 80.4 ounces and is worth more than thirty thousand dollars. The sight of it is enough to afflict a sane person with gold fever.

MONUMENT

Like the Freemans, Cora Stubblefield is in Eastern Oregon for the long haul. Laughter crinkled Cora's eyes when I asked her how far she had traveled away from Monument. The question caught her off balance.

"Well, George and I got married in Idaho. We took off to Payette because you didn't have to wait three days like you did in Oregon."

A schoolgirl's happiness lighted Cora's face, and I imagined the winding backroads they traveled in 1941. Payette would have seemed like a long journey.

"How far have you traveled in the last ten years?"

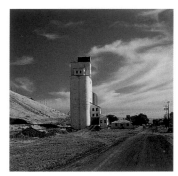

Her face sobered. "Walla Walla. George was in the Veteran's Hospital with cancer."

Cora was born in Monument and attended Top School in a settlement named for one of the cowboys, a "top hand." Top had twenty-three families, a store and schoolhouse during the 1920s. In 1956, she started working two hours a day as clerk in the Monument Post Office, and she became officer in charge in 1978, then postmaster from 1981 until the present time.

The post office now has 142 boxes and serves as a gathering place and information center when people come in to pick up mail. Cora knows all the regulars by first name, asks about their children and crops, passes on the latest news. The post office, Boyer's Store, and the Senior Center are Monument's main gathering places, although the Elkhorn Tavern has its regulars as does the Presbyterian Church where Cora serves as an elder.

"What was the most unusual item you ever got at this post office?" I asked her.

She put up her hands. "Oh my. That would be bees. We got several hives shipped in and the bees was just a-leaking out. We had to clear out the post office until they settled down some. Those bees were on their way to the Kimberly orchards. Going to pollinate the peach and apricot trees. They got some apples over there, too."

She and George raised five children, and all five stayed in Monument or close by. Perhaps it's the scenery. The mountains and rock formations provide stunning beauty as does the Middle Fork of the John Day River, which rushes past the Stubblefield's small ranch house and pasture.

"You don't get rich here but you get by just fine," Cora claimed. "That's why the kids have stuck around. There's ways to make money. Back in the forties, I was raising chickens and selling the eggs at Boyer's Store for a dollar a dozen. By the time Christmas came, I had paid off the store bill and had money left over for candy." She closed her eyes, remembering. "That candy was a treat. Mostly we got staples like flour and sugar."

"What about meat?" I asked. "Isn't that expensive?"

Her voice lowered a notch. "Well, George was a good shot." She shrugged. "The deer were coming down off the mountain to eat our alfalfa."

George's mother, Mattie, ran a rooming house during Monument's heyday when the sawmill was running and the town swelled to over two hundred people. "She kept a sober eye on that place," Cora said. "No drinking allowed. I guess you could say she was a little stern, but with Mattie, you always knew exactly where you stood."

Cora noted that in Mattie's day, Indians used to come through town to dig roots and pick wool off the barbed wire fences. "Thousands of sheep were in the country then and they had these big drives right through town. The Indians would take that fence wool to make blankets and shawls. They were sure thrifty that way—could live off the land."

The day I interviewed Cora was an unusual day for Monument because roaring wildfires had surrounded the town and rumors of evacuation circulated through the post office. More than four hundred firefighters were camping out at the shady city park and on the high-school football field. National Guardsmen had arrived from McMinnville and were helping to fight the fires. Inmate work crews from the Snake River, Powder River, and Columbia River Correctional Facilities were also on hand to lend support. Volunteers brought fire trucks and tankers from Corvallis, Albany, Brownsville, Monroe, Gladstone. More arrived each hour.

As Cora and I talked, a firefighter from Brownsville stepped in to mail a postcard to his family in the Willamette Valley. He looked tired from the long drive and explained that he was scheduled to head to the front lines at eleven o'clock that night. "We drove a long time because we didn't know quite how to get here," he admitted. "Monument's a little out of the way. Sure is pretty country, though. I bet it's usually a lot quieter."

Of course, bad things other than fires have happened in Monument. Cora recalled a young couple who went out for a midnight swim and drowned. "They had two little children. A friend and I took care of them until their grandparents came down from Top."

Cora complimented Monument's sense of neighborliness. "Let's say one of your neighbors got hurt when he was putting up his hay. Everyone would pitch in to help him out. The women from the church would take over food and the men would get the hay in. Same thing if someone had a fire and their place burned down. In about two weeks, you'd have a house raising."

I gestured at all the fire trucks outside. "That's kind of being neighborly, in a broader sense, don't you think?"

She nodded as she went back to sorting mail. "You're right. Sometimes we get awful mad at the people in the Willamette

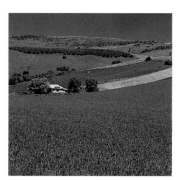

Valley because they pass laws about predators and grazing that pretty much seem to ignore our needs. But today they're really helping us out."

FISHTRAP

Each July, some of Oregon's best writers and their Western counterparts gather at the old Methodist church camp near Wallowa Lake to discuss common themes about the West and share their writing. At a Portland Writers' meeting in 1988, Rich Wandschneider made the suggestion that a conference should take place away from Interstate 5, and he offered Wallowa County. "It's more or less the same distance from Portland, Boise, Seattle, and Missoula," he pointed out. "We can attract a lot of great writers from all over the West, bring them to Oregon." His words proved prophetic.

Even as Oregon is blessed with photographic landscapes, the state also has an abundance of talented writers. Moreover, the well-known writer and Nez Perce historian Alvin Josephy, who divides his time between Joseph and Connecticut, offered to bring some of his good friends from the publishing houses of New York—just to enrich the stew a little.

The idea caught on. Many easterners were attracted to this remote, spectacular landscape called "Little Switzerland." Over the years editors from Knopf, Houghton-Mifflin, St. Martin's, and Picador have attended. So have reviewers from the *New York Times* and the *New Yorker*.

The gathering itself proves to be as egalitarian as a pot of beans. High-school scholarship students and community members can discuss their ideas with major editors and speakers over lunch, coffee, or the nightly campfire.

"All of the issues that affect the West also play out in Wallowa County," Rich noted. "These include water use, the environment, toxic waste removal, fire, Native American claims, and grazing. Fishtrap gives us all a chance to put our heads together."

The Fishtrap event attracts some of Oregon's top writers year after year: Molly Gloss, Ursula K. LeGuin, Barry Lopez, Kim Stafford, Kathleen Tyau, and George Venn lead workshops regularly. Scholarship recipients include upcoming Oregon writers Robert Stubblefield and Geronimo Tagatac. *Oregonian* columnist Jonathan Nicholas usually attends the event with his wife, writer and novelist Vivian McInerny.

Over the years Rich has added to the Fishtrap offerings with a winter Fishtrap based on themes including "Fire,"

"Downwind, Downriver," and "Generosity and Justice." In addition, selected writers can spend time at a retreat along the Imnaha River or in the recently purchased Coffin House including the Alvin Josephy Library.

According to Rich, the great harvest of Oregon writers depends in part on the magnificent Oregon landscape. "When you've got the Pacific Ocean, the Columbia River, old-growth forests, and the Wallowa Mountains—well, you just have to write about them."

The timbered slopes, pristine Wallowa Lake, and the rugged Wallowa Mountains demonstrate the truth of his words.

THE WALLOWAS

Every November in the early 1980s, I drove more than four hundred miles to my uncle Oscar's elk camp in the Wallowa Mountains. By the time I started going to camp, the hunters were pretty old, in their sixties, and slowing down. The elk were safe, I figured, and that was fine with me. I didn't intend to kill elk, but instead gather stories for my first novel *Winterkill*, which occupied my mind day and night.

Driving to the Wallowas provided much of the fun. The scenery along the Columbia was always spectacular, and when I pulled away from the river, I enjoyed the sight of the harvested wheatfields close to Hermiston and Pendleton.

I took a deep breath when I started climbing Cabbage Hill into the beautiful Blue Mountains. The depth of snow and road conditions helped me gauge the likelihood of snow in the Wallowas, the treachery of the roads closer to elk camp. In La Grande, I walked around a little to enjoy the crisp cold air, and my spine began to tingle. Once I turned north on Highway 82, the country grew heartbreakingly beautiful.

I passed Alicel, Imbler, Elgin, the steep Minam Grade. Here I once saw a black Ford Crew Cab towing a pink Cadillac convertible up the grade in a blinding snowstorm. The top was down. The Cadillac bristled with rifles and held four sizeable men wearing gray and black cowboy hats, passing around bottles of hooch as an antidote to the cold and snow. The two hunters in back had their feet propped over the front seats, and I recognized fancy cowboy boots—ostrich and kangaroo, maybe. I saw all this in the quick seconds we passed one another, and I was awestruck at the pure outrageousness of the spectacle. I tried to read the license plates partially

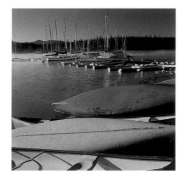

covered with dirty snow. Arizona. I figured they'd been road hunting with the top down and somehow it stuck. The Caddy featured a deep crease from the driver's side front panel to the rear. Pitch was visible in the crease, and I guessed they had slid off the slick road at one point and greeted an outstretched tree limb.

The memory of the scene kept me chuckling through Wallowa and Lostine. In Enterprise, I filled the pickup with gas, ordered a to-go cup of coffee, and studied the historic Wallowa County Courthouse. The rugged Wallowa Mountains loomed in the night, their peaks revealed by glimpses of moonlight through the clouds.

Eight miles to Joseph and then a stop at Wallowa Lake, whose waters rippled black and silver in the moonlight. To the west, the timbered slopes seemed to rise from the lake, and ahead, Chief Joseph Mountain stretched toward the dark sky. A short walk brought me to a stone monument, twice the height of a man. Tall sentinel spruces surrounded the monument. A swinging gate placed between two posts held a sign.

GRAVE OF OLD CHIEF JOSEPH
Maintained by Wallowa County Junior Women's Club

I thought hard then about Old Joseph and how he had welcomed the settlers into the valley. His son Chief Joseph had been forced to leave his homeland in Northeast Oregon to join the reservation Nez Perce in Lapwai, Idaho. But along the way, some of the young warriors killed white horsethieves, an act that precipitated the Nez Perce War.

With fewer than a thousand people, Young Joseph led a chase through Idaho, Montana, and nearly into Canada, before the U.S. Cavalry stopped him in the Bear Paws seven months later, and he gave his famous "From Where the Sun Now Stands, I Will Fight No More Forever" surrender speech copied down by Lt. C. E. S. Wood from Oregon. That speech is still studied in classrooms today for its rhetoric and gallantry; and Joseph's retreat is studied at West Point for its daring and cunning.

From Joseph, I drove forty miles farther east to the small settlement of Imnaha. The Imnaha General Store-Café-Bar was once owned by one of the original Sons of the Pioneers. On one trip I had purchased a tape with "Ghost Riders in the Sky," "Cool Water," "Tumbling Tumbleweed," and other Western favorites.

At Imnaha, I turned the pickup straight up the Imnaha River. By this time it was after midnight and pitch black, but I kept going, knowing the warm tent and old hunters waited twenty-seven miles up the river at a place called Indian Crossing. In the morning, I could see the Upper Imnaha Valley with its looming ponderosa pines and steep basalt canyons. This place was one of my favorites in all of Oregon. I passed a camp named Ollokot for Joseph's brother, the last Nez Perce killed in the Bear Paws, and I thought hard again about this territory's history and who really had the right to occupy it.

My uncle Oscar's large canvas tent sat under a lodgepole pine, its back to the Imnaha River. The face cord of wood was about a third of the way used up, and I realized the hunters had been up here camping for a week. Oscar's H & H Magnum stood just outside the tent, its barrel covered by wax paper and a rubber band to keep it from filling with snow.

Quietly, I unrolled my sleeping bag on an empty army cot, using a small flashlight to find my way inside the dark tent. Three old friends were sleeping, burrowed deep in their bags, wool stocking caps covering their heads. Howard Maw always came up several days early to make camp and chop wood. A baker, he brought delicious huckleberry pies in special wooden boxes so they wouldn't get crushed. Assout Jones got his moniker after a horrible fire in a Burns bar. When the place went up in flames, the back door was locked and he couldn't get out, so he put his head and chest inside the ice machine in order to breathe. His legs and buttocks were burned and scarred, but he lived.

My uncle stopped snoring and opened his eyes as I prepared for bed. "Good to see you, nephew," he said. "We need some fresh legs."

The canyons we planned to hunt the next morning provided some of the most spectacular scenery in the West. They were so long and deep, Howard had once remarked, "You got to look twice to see the bottom." Their names evoked the West: Black Horse, Beaverdam, Gumboot, Little Skookum. I preserved all these places in *Winterkill* because of their poetry. Even as we hunted that last year, the U.S. Forest Service was changing all the colorful names to numbers. Sadly, today only a few weathered signposts carry those magic names.

Heading upcanyon after a huge breakfast of steaks, eggs, and potatoes, we clung to steep, winding logging roads. Deep snow

forced my uncle to chain up all four wheels of his lumbering Dodge Powerwagon. "Good day for tracking," he said, referring to the falling snow. Inside the truck, the smells of wet wool, coffee, and gunmetal meant serious hunting.

We dropped Assout and Howard at a saddle where Black Horse Canyon met Little Skookum. Assout took his hatchet and chopped away at a deadfall fir stump until he found a pitch seam. Then he took out two stubby white candle butts from his Filson plaid coat pocket and lit them with a wooden match. He set these in the cut so the flame tips touched the pitch. Once it started, the wood ignited and the warming fire burned hot within a few minutes.

"You'll be cold by the time you get down this canyon, nephew," my uncle said. He checked the sky. "Snowing harder. High as your rump by noon."

Forty minutes later, he dropped me off at the head of Black Horse. The idea was for me to drive the elk downcanyon toward Howard and Assout. One might think the warming fires would scare the elk, but they didn't. The animals were used to burning after lightning strikes. My uncle cautioned me not to go too fast or let the elk double back. "Stay about a third of the way down the hill," he said. "And watch the far side of the canyon for movement."

When he drove away in his brown Powerwagon, I watched the red winking taillights and the exhaust cloud. After the truck had disappeared, I started down the snow-blind canyon. The far side seemed obscured by a white curtain. Closer, I saw bitterbrush patches, jackpine thickets, and huge fractured granite boulders. Tough going, I thought. And it was.

An hour later, I was sweating so hard I took off my stocking cap; steam rose from my head. I took an "elk hunt special" out of my rucksack. This was a cheese and peanut butter sandwich, a combination that provided a lot of energy.

Farther down the canyon, the snow was deeper, and wind had piled waist-high drifts under the lodgepoles. I had to buck through. Whenever I paused to rest, the sweat chilled, and I looked forward to Assout's warming fire, but that was still a long way off. By midmorning, the wind picked up, blowing the falling snow into my face. I kept studying the canyon bottom and opposite slope, but no sign of elk. In past years, another hunter had always walked the opposite slope, and it had been comforting to see an occasional glimpse of red-and-black plaid coat. This year we were two hunters short. Harvey Rhodes had cancer and Walt McCullough had passed away. I missed them. Their absence added to the sense of isolation.

I paused to eat a chocolate bar. The bar was brittle from being frozen, and pieces of it fell into the snow. Studying the opposite canyon slope, I thought I saw movement in the thick bitterbrush, but it might have been falling snow, a trick of light. Then I saw movement again where the bitterbrush met a jackpine thicket, and my chest tightened. I knelt beside a young pine tree, peering through the lower branches.

The movement coalesced into shapes. Elk were moving stealthily along the south slope of Black Horse. They were so quiet they seemed like brown ghosts gliding against a background of snowy hillside and basalt rimrock.

I rested my rifle on the lowest branch, scoping the elk. "Cow, cow, can't tell, cow, can't tell," I muttered, and then they were into the jackpine thicket and out of sight. I wondered about the two whose heads I hadn't seen. Probably cows. By this time of the season, the bulls held far back, letting the cows move ahead, the first to confront possible danger. I sat another ten minutes watching for bulls but none appeared.

The snow let up and I saw patches of blue above the Imnaha, more patches across toward Idaho. In ten minutes the sky cleared enough to view the gleaming Seven Devils Mountains. What country! I marveled.

When I stood, I saw the magnificent elk, a large bull trailing the cows but higher on the south slope. I watched in awe as he moved in and out of deep timber. I didn't raise my rifle, but followed his movements with the naked eye as he made his way downcanyon. Then I had a moment of fear that he might be shot by Assout or Howard as he approached the warming fire. I wondered if I could chase him over into Little Skookum, the next canyon, away from danger. I started walking fast, making myself clearly visible on the next stretch of open ground.

He saw me and, alarmed, started running for the canyon's rim. I smiled with satisfaction, thinking he'd get clear. Then a chunk of basalt spurted below the running elk, and I heard the deep barking *karunk, karunk* of my uncle's H & H Magnum. Somehow, Oscar was on the hilltop above and slightly behind me. One more *karunk* as the elk approached the top. All three bullets had whined past and I didn't hear any *chunks*, the sound a bullet hitting flesh makes. My uncle had stopped shooting as the bull ran out of range.

Then I heard my uncle call my name, a faint cry from a great distance.

I didn't want to shoot the elk, but I knew this might be my uncle's last hunt in the Wallowas. I slipped off the safety and rested the rifle on a limb. I didn't want to let my uncle down. Conflicting thoughts raced through my mind as I squinted at the elk through the scope. The crosshairs settled on his broad shoulders for a second, and I could have fired, but I held. Just before he broke over the top, I fired well behind him, and pulverized basalt broke away in a small quick puff. "Keep running, you bastard," I muttered.

As I waited a few minutes, I wondered if my uncle would hike down toward me or head back to the truck. I didn't want to move and reveal my exact position. I knew I had a great angle at the elk and could have fired off several clear shots, if willing. When the truck engine started, I felt relieved, knowing I'd have about an hour to polish my story.

The three men were drinking coffee by the warming fire. My uncle's eyes widened as I rested my rifle against a tree.

"I shot at one helluva big bull," he said. "Didn't you see him up there? You were a lot closer than I was, but I just heard you fire off one round."

I took some coffee Howard offered and had a sip before answering. "I didn't see him right away; I was stuck in the jackpines. When I heard you shooting, I busted out quick and got off a snapshot. Then he was gone."

My uncle shook his head. "Stuck in the jackpines." He paused. "That shot was terrible, nephew. Way behind him. You better sight that rifle in better."

On the way back to camp, the men talked excitedly about that bull, how he might stop in Beaverdam, two canyons over. They planned on tracking him the next morning. I kept pretty quiet since my story had been lame. My uncle knew full well I'd been hunting long enough to stay clear of jackpine thickets. But he didn't say anything else. And I figured his remark about sighting in the rifle was his way of showing he understood: I didn't have any desire to kill elk. And I was grateful for his generosity.

That night after a king's feast of top sirloins, salads, baked potatoes, and huckleberry pie, the men were mixing 7-Up with whiskey. The fire sang and Howard told his story about shooting an albino elk up near Stinking Water.

"White as snow!" he exclaimed, "like a ghost lost in a snow-storm." He sipped his drink. "I saw a glistening pink eye and

the rattling dark horns. I swear, I didn't know if I was seeing a ghost elk. For a minute I wondered maybe someone had shot me, and I was dead and seeing things."

"If you were dead, you'd be seeing hot red elk, not albinos," Assout said. "And there won't be any snow where you're going."

"He was a long way from the road," Howard said. "By the time we'd dressed him and quartered him, then carried him to the truck, it was way past midnight."

My uncle checked his watch. "Nine thirty," he said. "Past time for another piece of huckleberry pie. I've got to load in some fuel if we're heading up Beaverdam early tomorrow." He took a couple bites of his second wedge of pie and wagged his fork at me. "Well, nephew, I guess it's a good thing you're such a lousy shot. That elk today was pretty far up. We'd probably be lugging him out still, instead of eating this pie."

Wherever that big elk went, it wasn't Beaverdam. So much snow fell that night, tracking was impossible the next morning. The old men huddled near the new warming fire, and I snowplowed down through the canyon, but it was such tough going, I got stoved up and couldn't move at all the following day. I hope that elk is still roaming free, and I see him often in my imagination.

Before the next season, Assout went into a convalescent home after falling with a broken hip, and Howard decided he was too tuckered to face the rugged Wallowas. My uncle spent the last few seasons hunting Dry Mountain over toward Burns and the tall timber above Tygh Valley.

Now, anytime I go to the Wallowas, or the November nights chill and late-autumn winds blow, I remember those elk camps—the storytellers gathered around campfires, their words rising like sparks into the dark night sky. I'm thankful the stories came to me, and I was able to include most of them in *Winterkill* and my other work.

Stories bind us together in this wonderful community and landscape we call Oregon. Every year, more storytellers gather at Fishtrap and Cannon Beach and Yachats and Gold Beach and other conferences, making certain the tradition goes on. Many wonderful stories honor the people and the places of Oregon. Who knows where the next great stories will appear? We must listen carefully for new and powerful voices.

▷ *Sunset over the Pacific Ocean, Oregon coast*

COAST

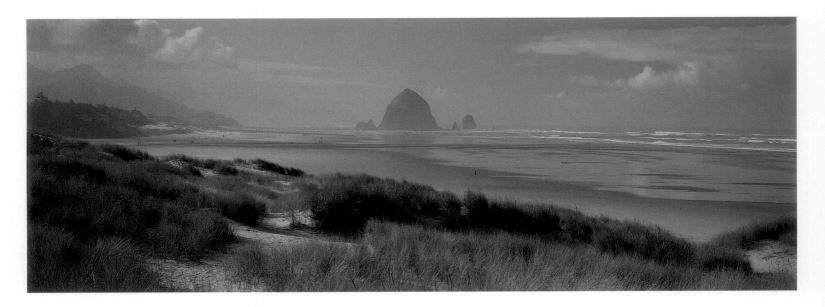

The waves and the wind have a kinship I've not seen

anywhere else. The wind spins past the headland,

and the waves lurch and boil. When I smell salt there,

I understand. You taste what's given, and be grateful.

—Kim Stafford

△ Haystack Rock, Cannon Beach
▷ The Needles, Cannon Beach

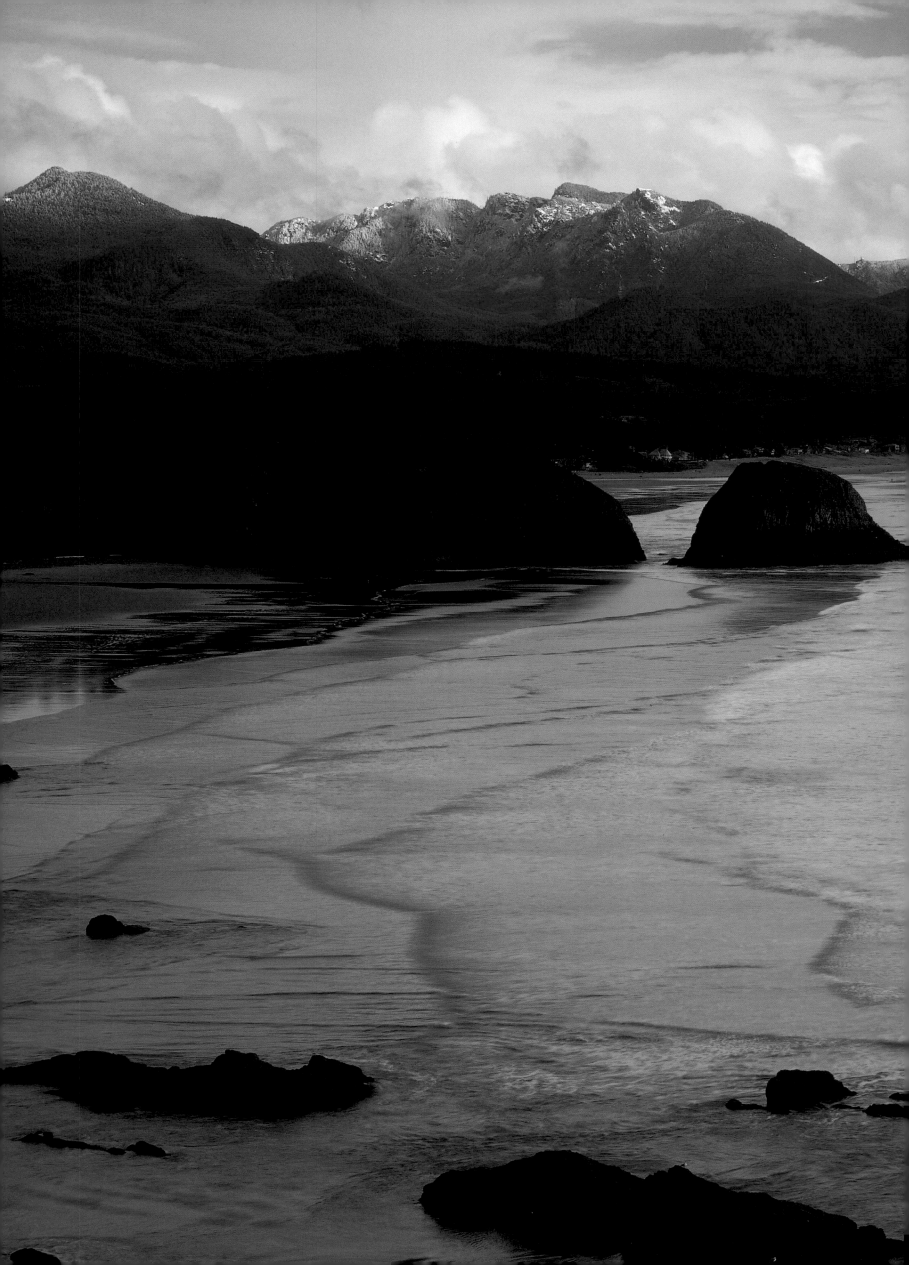

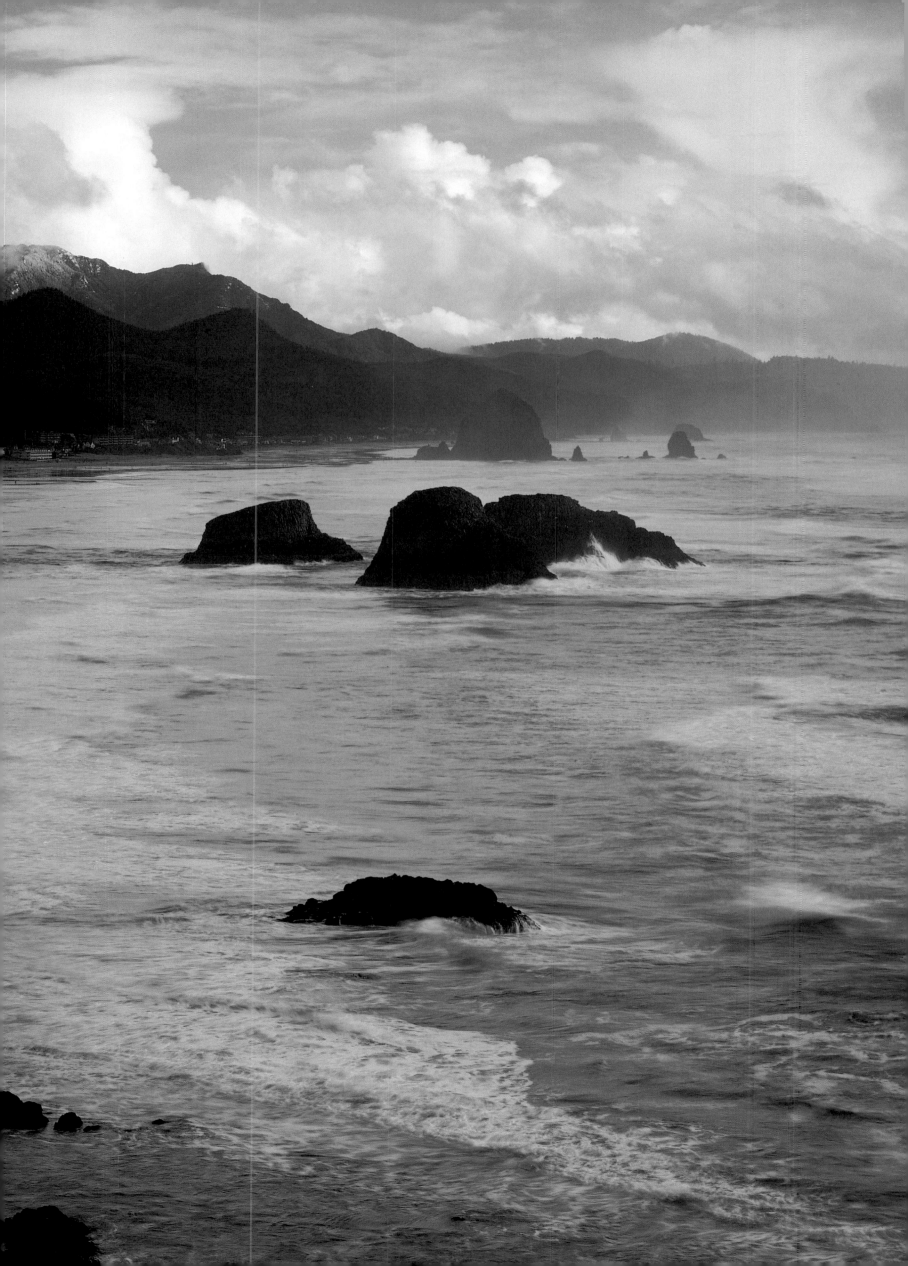

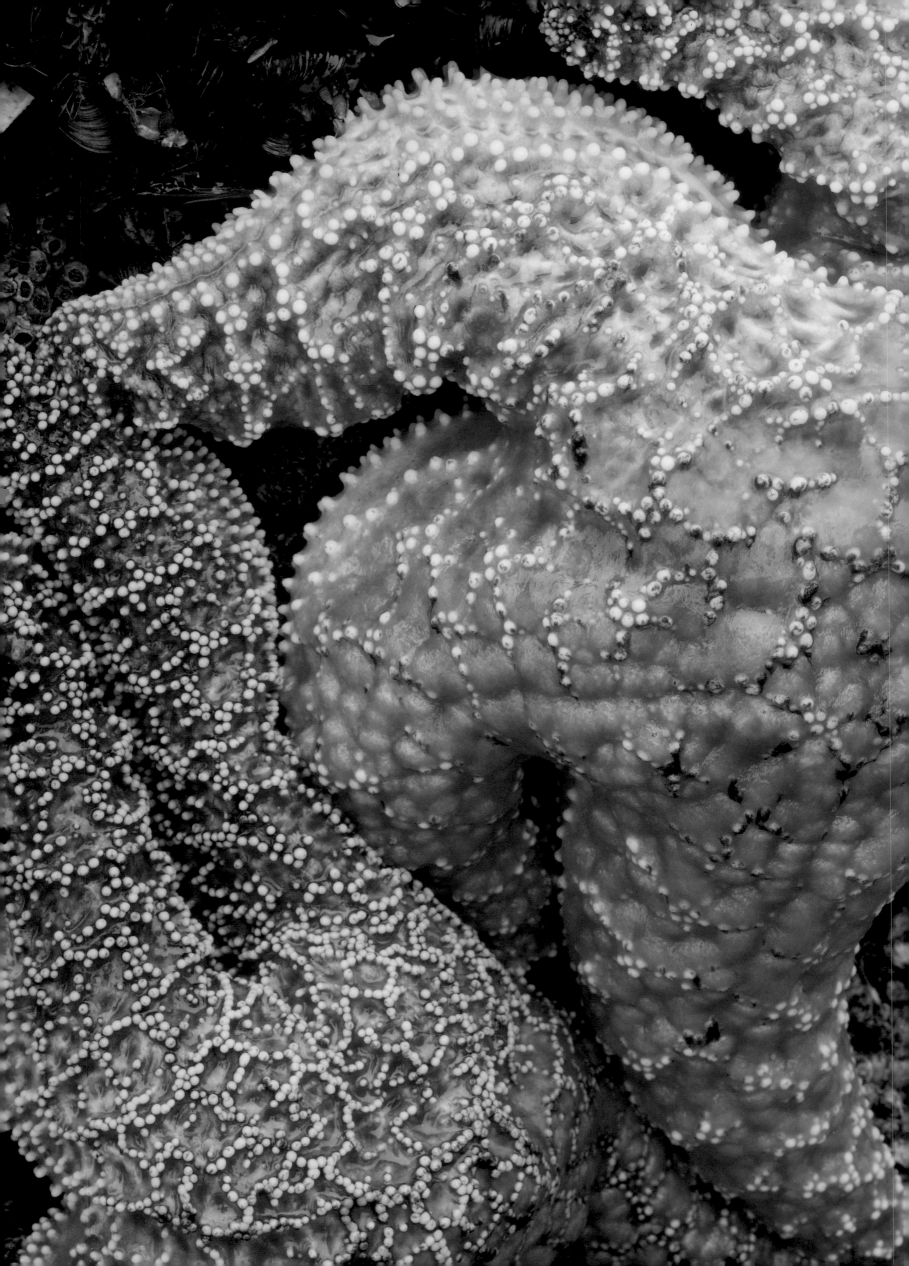

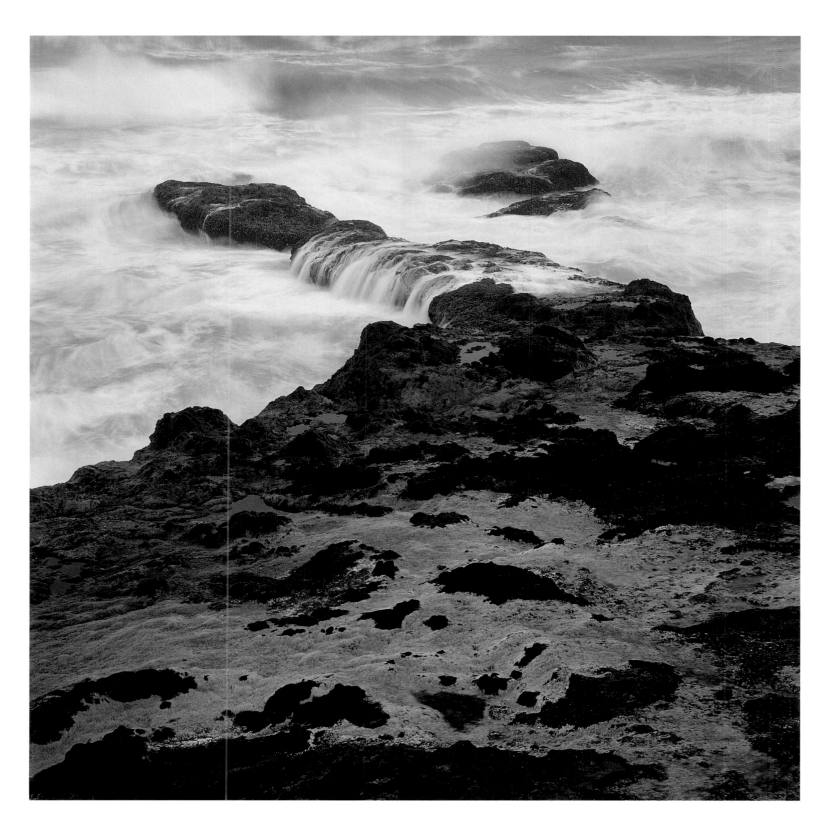

◁ ◁ Haystack Rock (235 feet high) is barely visible through the mist in this view of Ecola State Park and Cannon Beach. Neahkanie Mountain, dusted with snow, rises beyond the shore. ◁ Starfish, barnacles, and blue mussels cling to rocks near Cannon Beach. Barnacles, free-swimming as larvae, are permanently fixed as adults. △ Surf crashes onto the rocks at Yachats Wayside in Lincoln County.

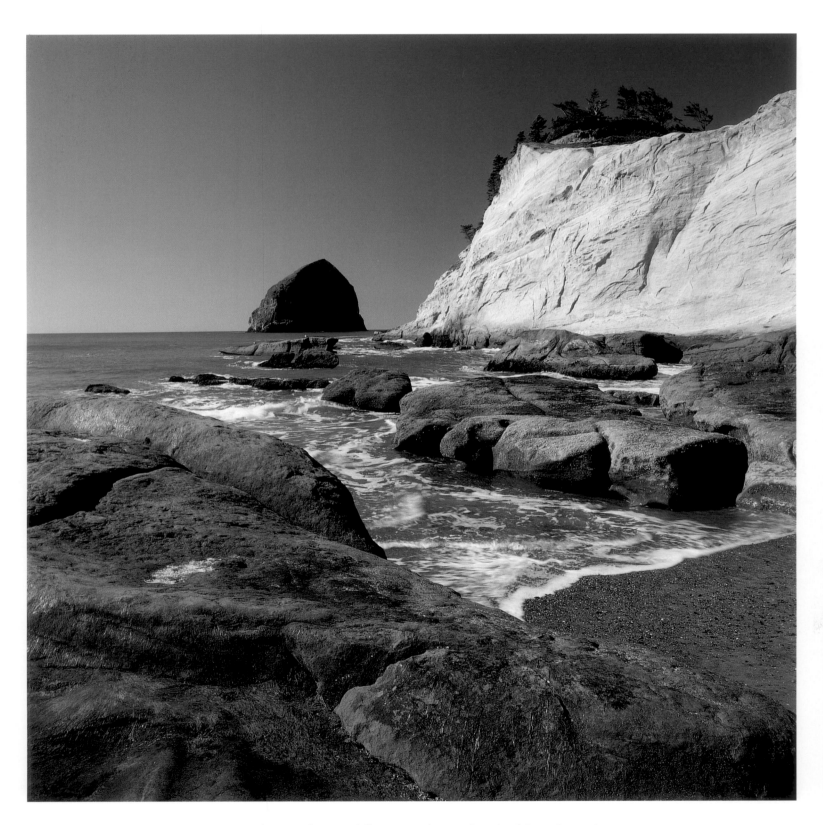

△ Cape Kiwanda's sandstone cliffs, rising about a hundred feet above the ocean, set off the "other" Haystack Rock near Pacific City. Besides spectacular waves, the cape provides great hang-gliding and kite-flying opportunities. The name *Kiwanda* probably comes from a Nestucca Indian chief who was a local celebrity.

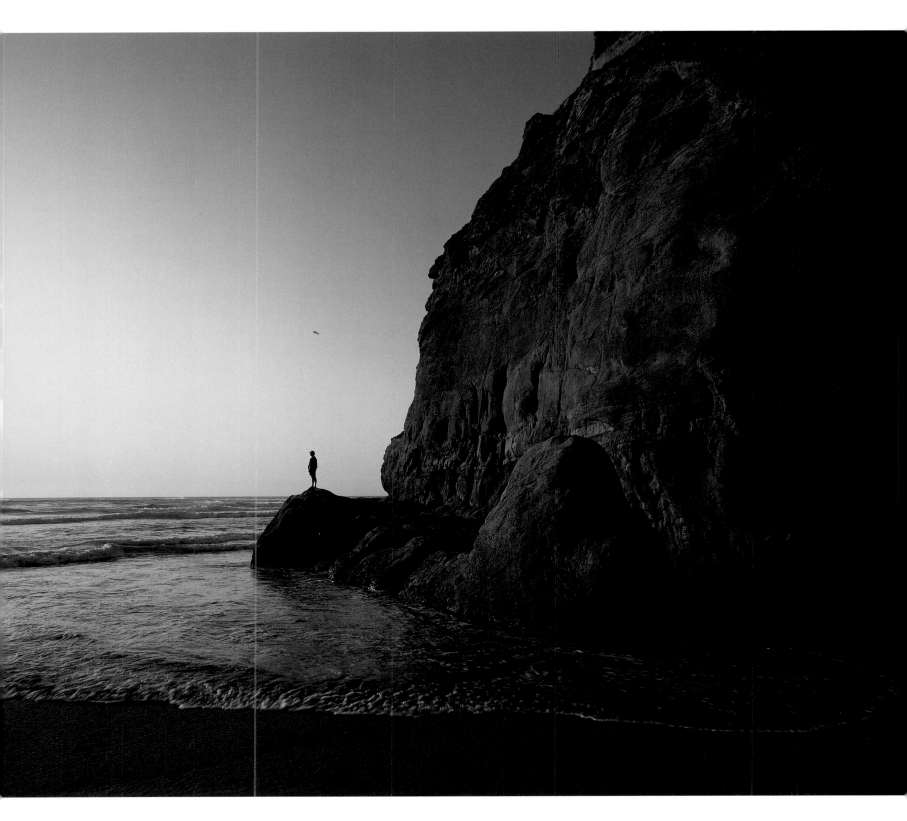

△ Hug Point is a small wayside off Highway 101, south of Cannon Beach. Stage-coaches and, later, automobiles used to travel on the beach before the Oregon coast highway was completed in 1936. Hug Point's rock ledge was hewed out to became part of their "road." Now, it's a great place for sea-watching, walking, and exploring the two caves around the point—but only during low tide!

△ The town of Cannon Beach offers almost as much interest and variety to visitors as do the ever-changing moods of the ocean itself. Here, colorful hanging baskets vie for attention with "open" and "espresso" signs. Constructed about 1935, the building first served as a pharmacy. The tradition of the flower baskets, begun in the 1960s by the shopkeepers' wives, is continued by the city today.

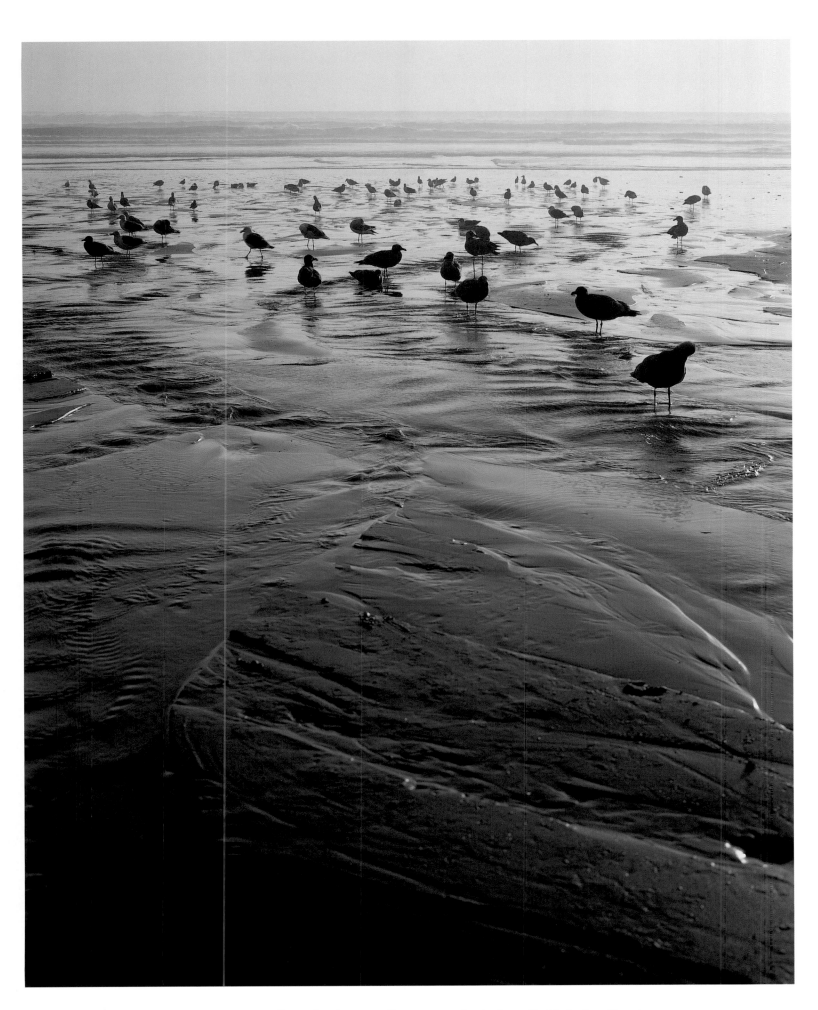

△ At sunset, seagulls gather in a small stream on Ecola State Park's Indian Beach.
▷ ▷ From a height of 205 feet above the ocean, the Heceta Head Lighthouse, completed in 1894 at a cost of $180,000, casts its beam some twenty-one miles out to sea, warning ships to stay away from the dangerous rocks near shore.

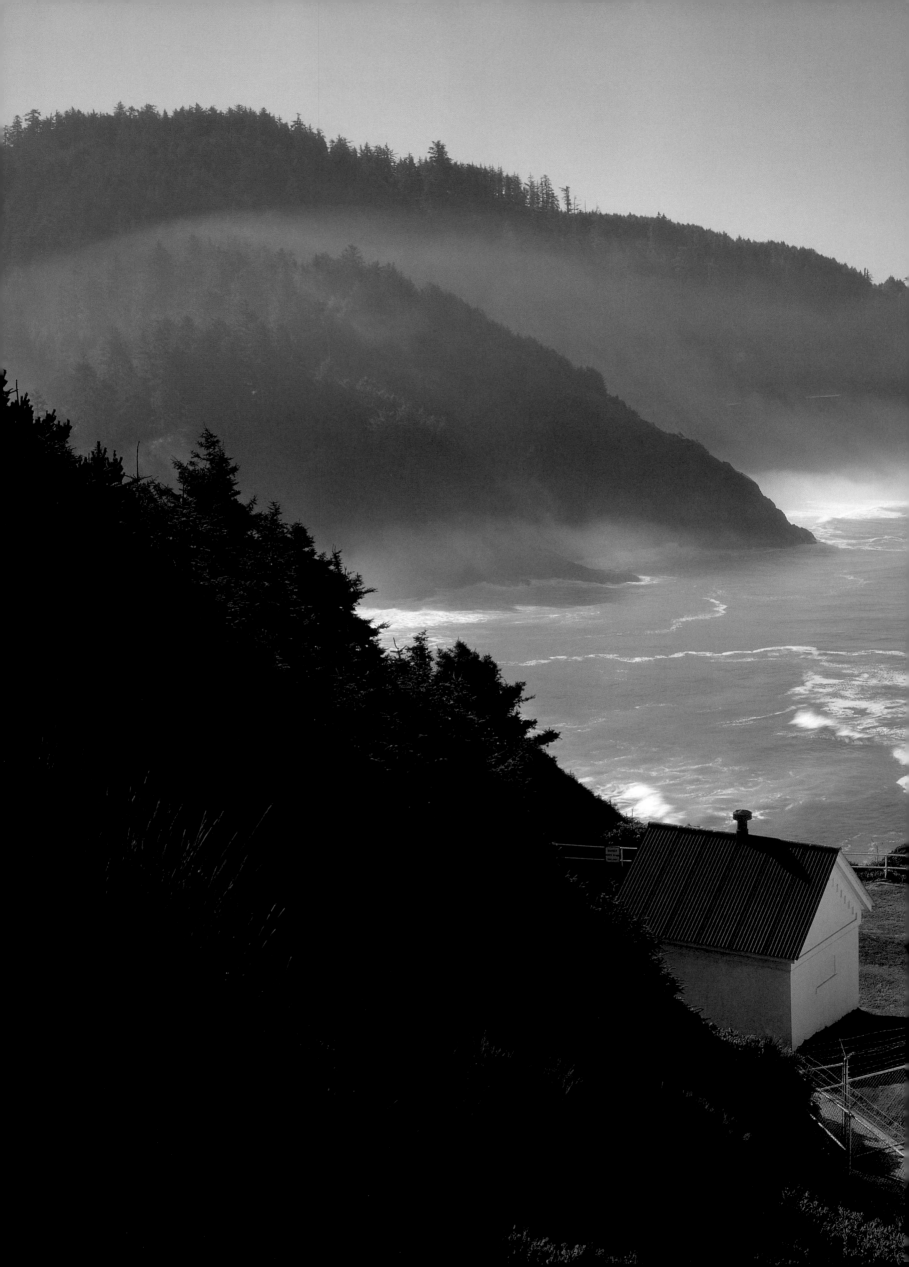

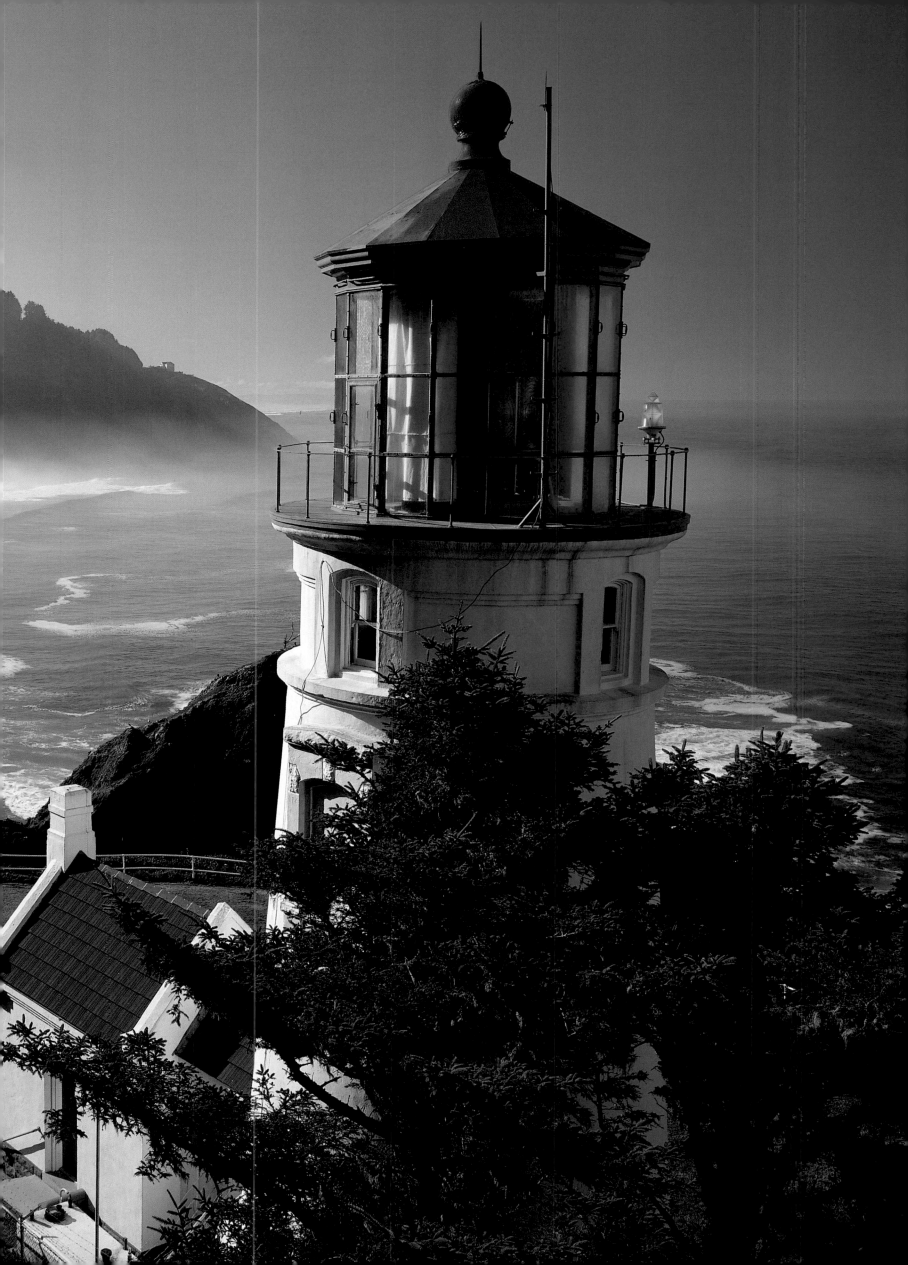

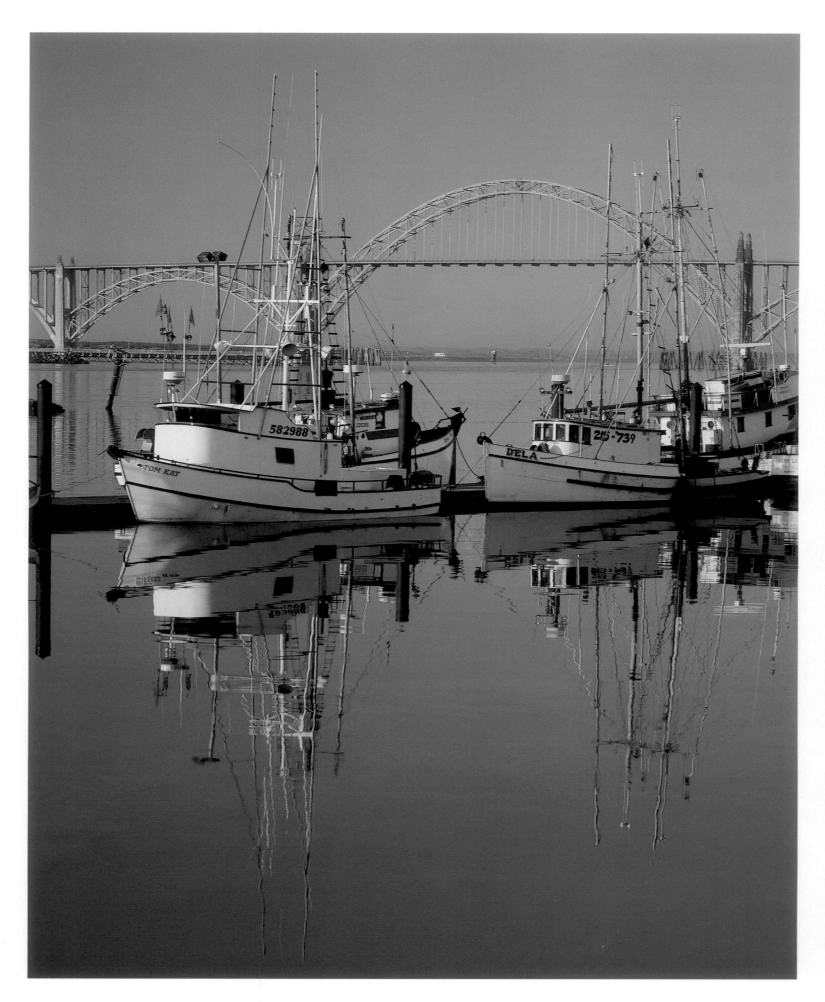

△ Newport Harbor's early morning tranquillity belies the busyness that will be evident later in the day when whale-watching and sightseeing cruises along with commercial and charter fishing boats all conspire to bring the waterfront alive.

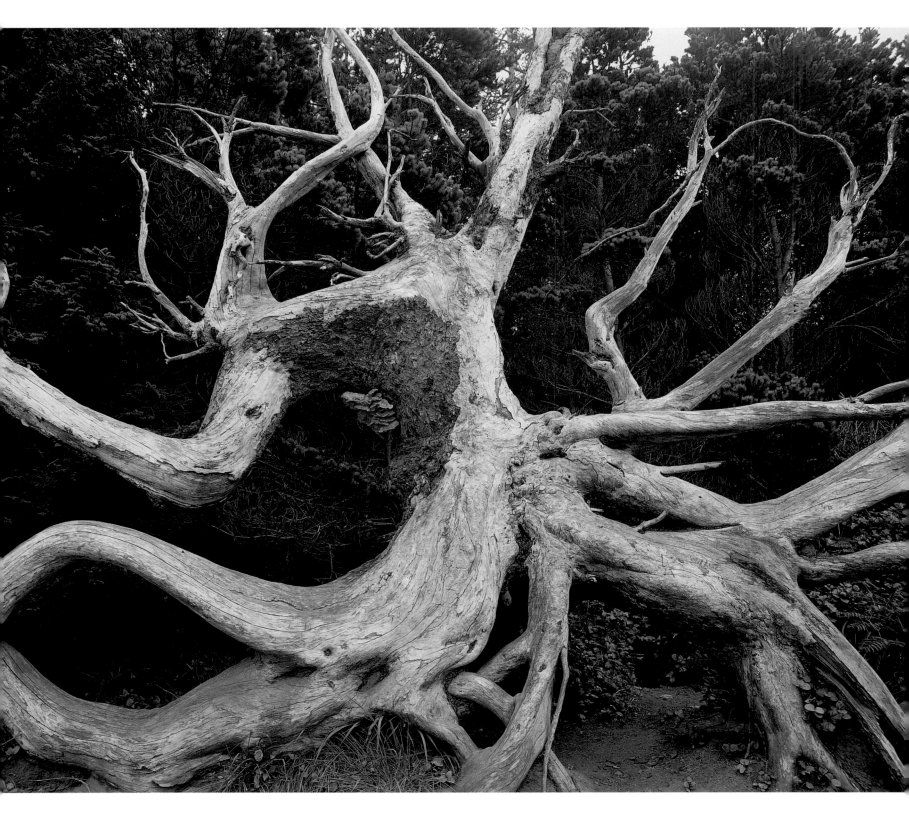

△ An exposed root system creates an interesting pattern at Shore Acres State Park. Once the grand estate of pioneer timber baron Louis Simpson, Shore Acres encompasses a surprising mixture of natural and constructed features, including formal gardens that showcase plants and flowers from around the world.

47

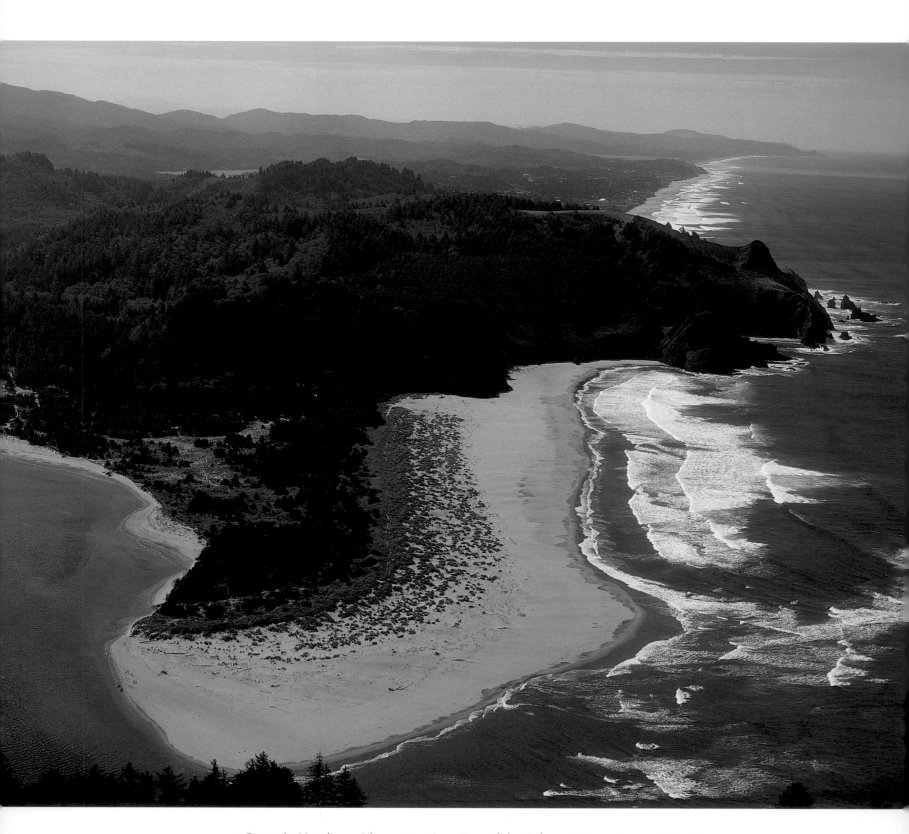

△ Cascade Head provides a stunning view of the Salmon River estuary. Estuaries such as this are a very important ecosystem for marine life. The brackish water, created by the constant flow of tides mixing the fresh and salt waters, furnishes a nutrient-dense environment for a wide variety of sea life and their offspring.

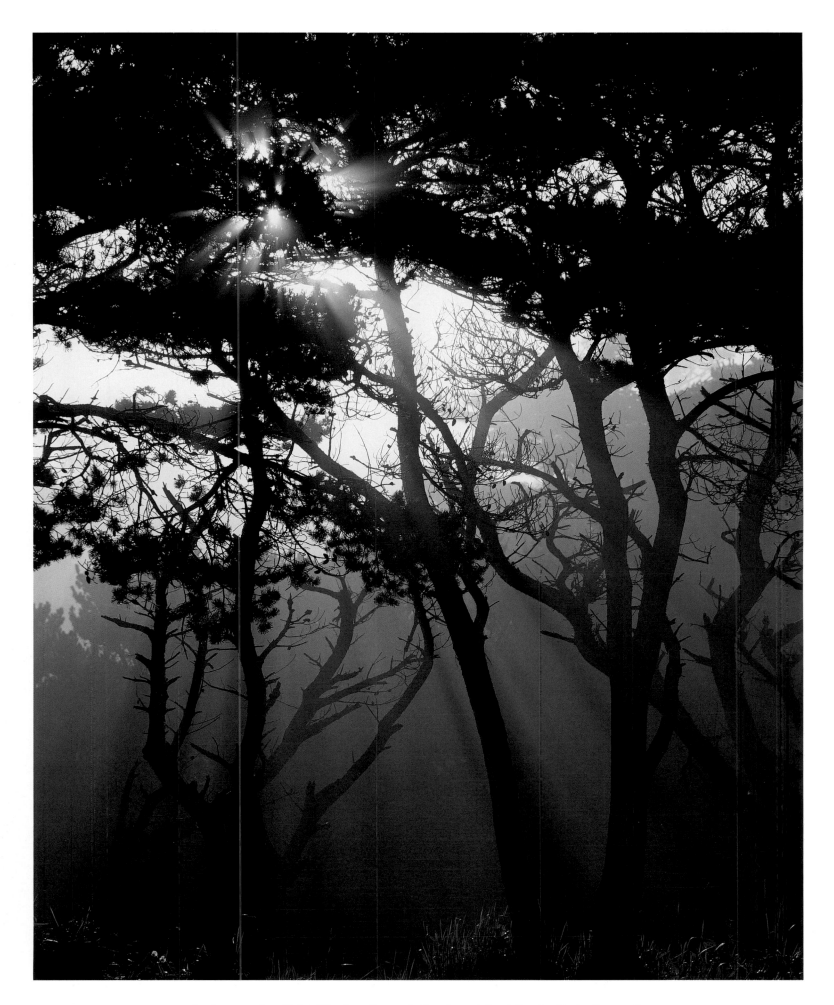

△ Early morning light filtering through the fog at Seal Rocks State Recreation Site adds a ghostly appearance to the weathered trees. A picnic area, shaded by the pleasant stand of shore pine and spruce, also offers respite to tourists.

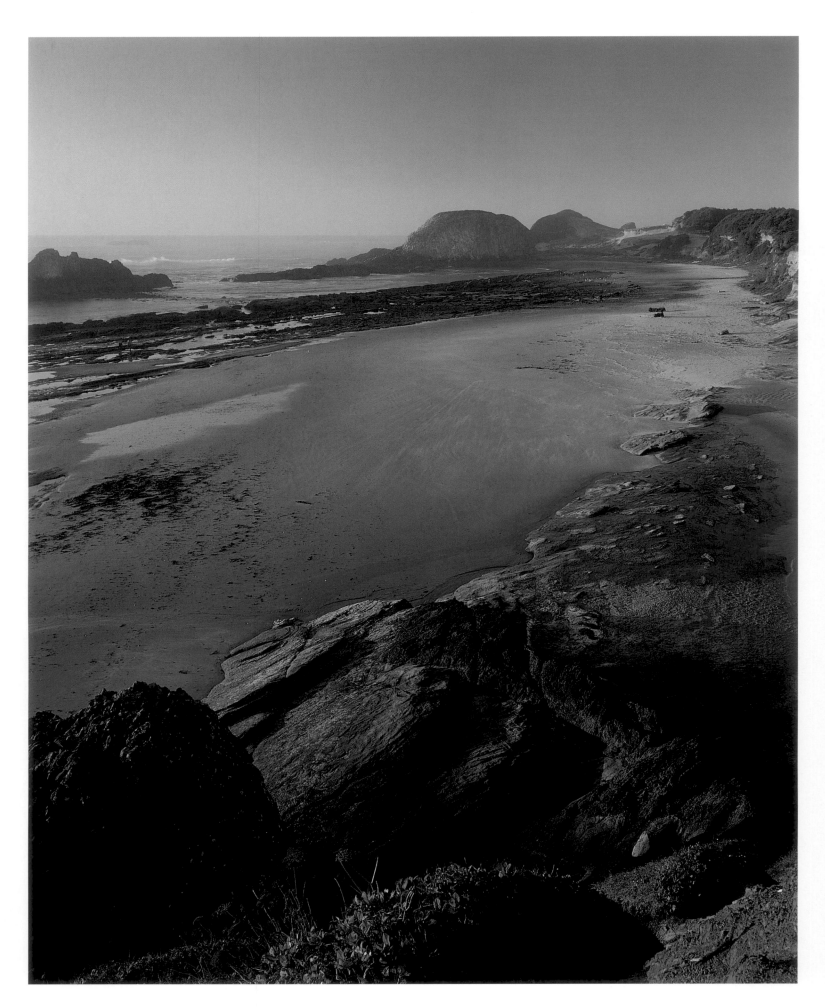

△ In addition to seals, for which the park is named, the offshore rocks at Seal Rocks State Recreation Site host sea lions and various species of sea birds, including cormorants, harlequins, oystercatchers, turnstones, scoters, and surfbirds.

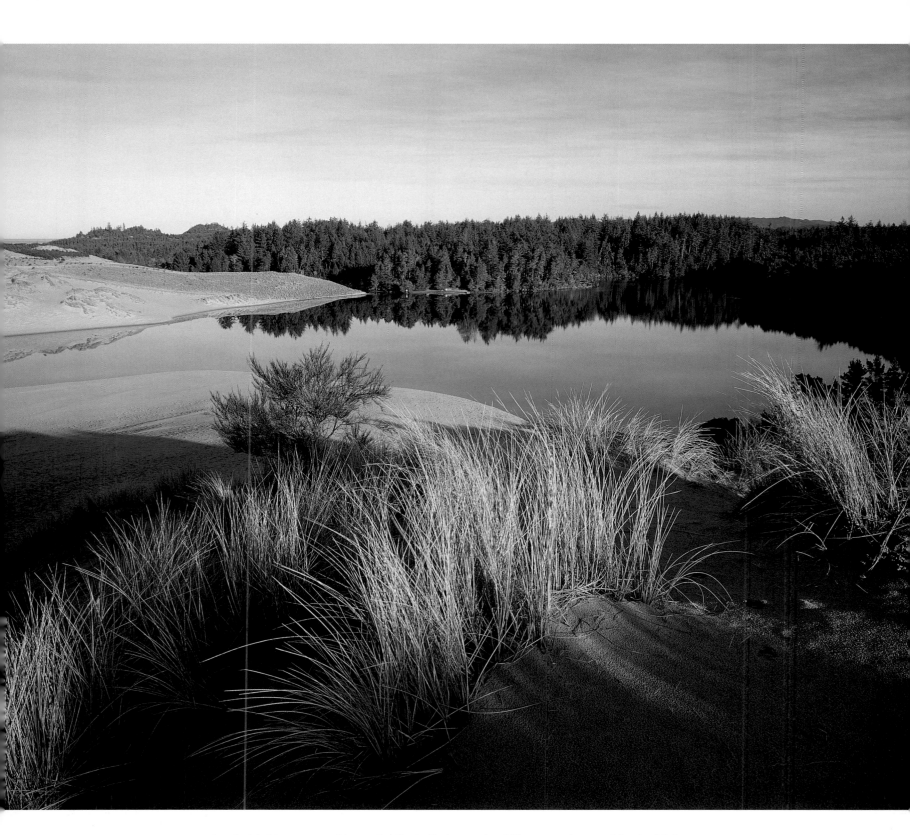

△ Jessie M. Honeyman Memorial State Park, south of Florence, is noted for its high sand dunes and beautiful rhododendron blooms. With two freshwater lakes in the park, day uses include swimming, fishing, and boating. ▷ ▷ Devils Elbow Beach is just one of the attractions in Heceta Head Lighthouse State Scenic Viewpoint.

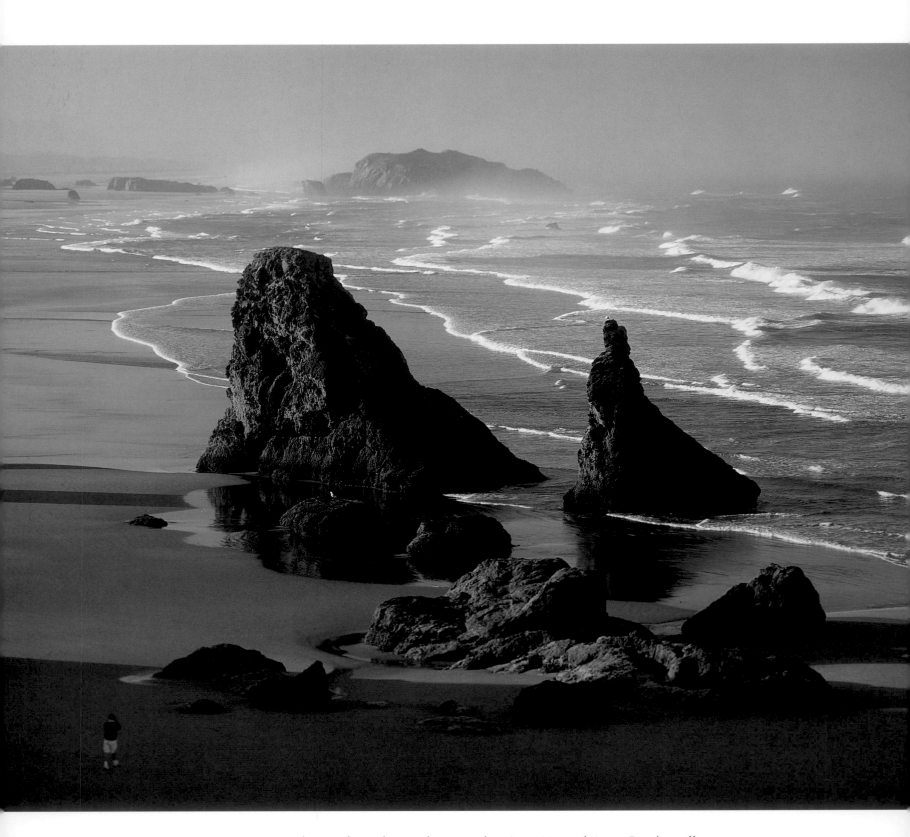

△ Huge rocks rise from the sands at Bandon State Natural Area. Bandon offers
great fossil- and rock-hunting opportunities during winter and spring—but beware
of angry seas! The steamer *Acme,* destroyed offshore in 1924, remains buried here.

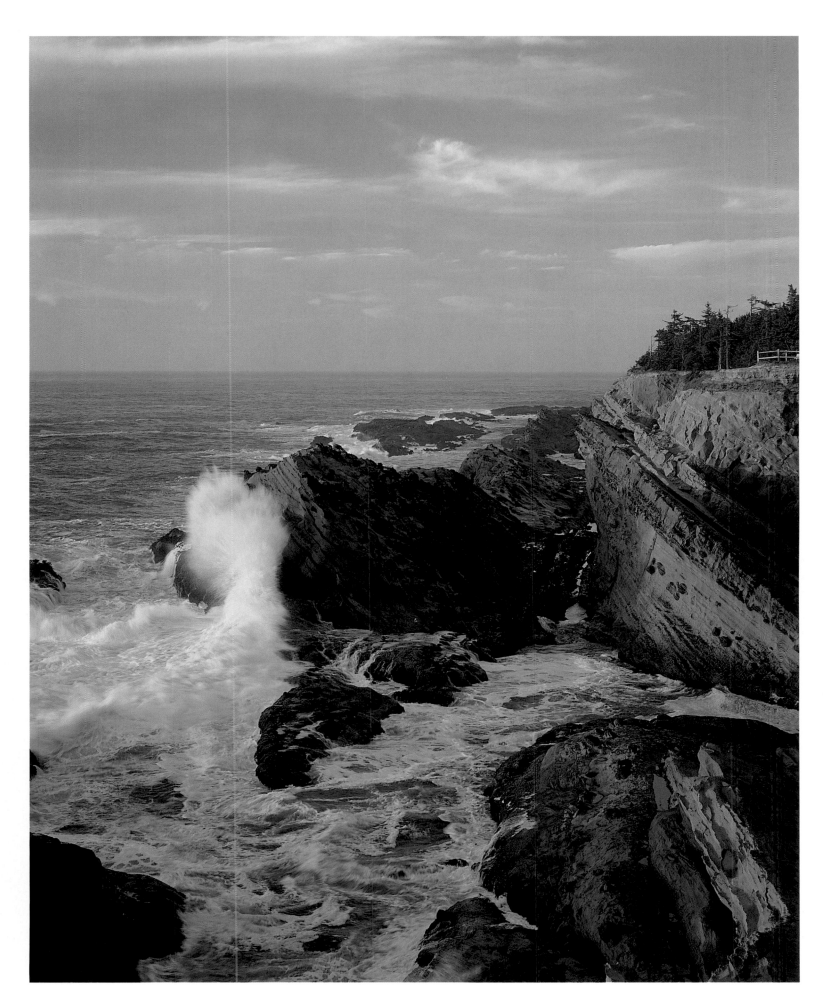

△ & ▷▷ All along the coast, one of the best times for wave-watching is after a storm, when towering waves often crash against rocks near shore. Always in flux, the sea ranges from crashing waves to peaceful sunsets—and the cliffs at Shore Acres State Park offer one of the best places to view the sea in all its varying moods. The views include anything from crashing waves to calm serenity to gray whales.

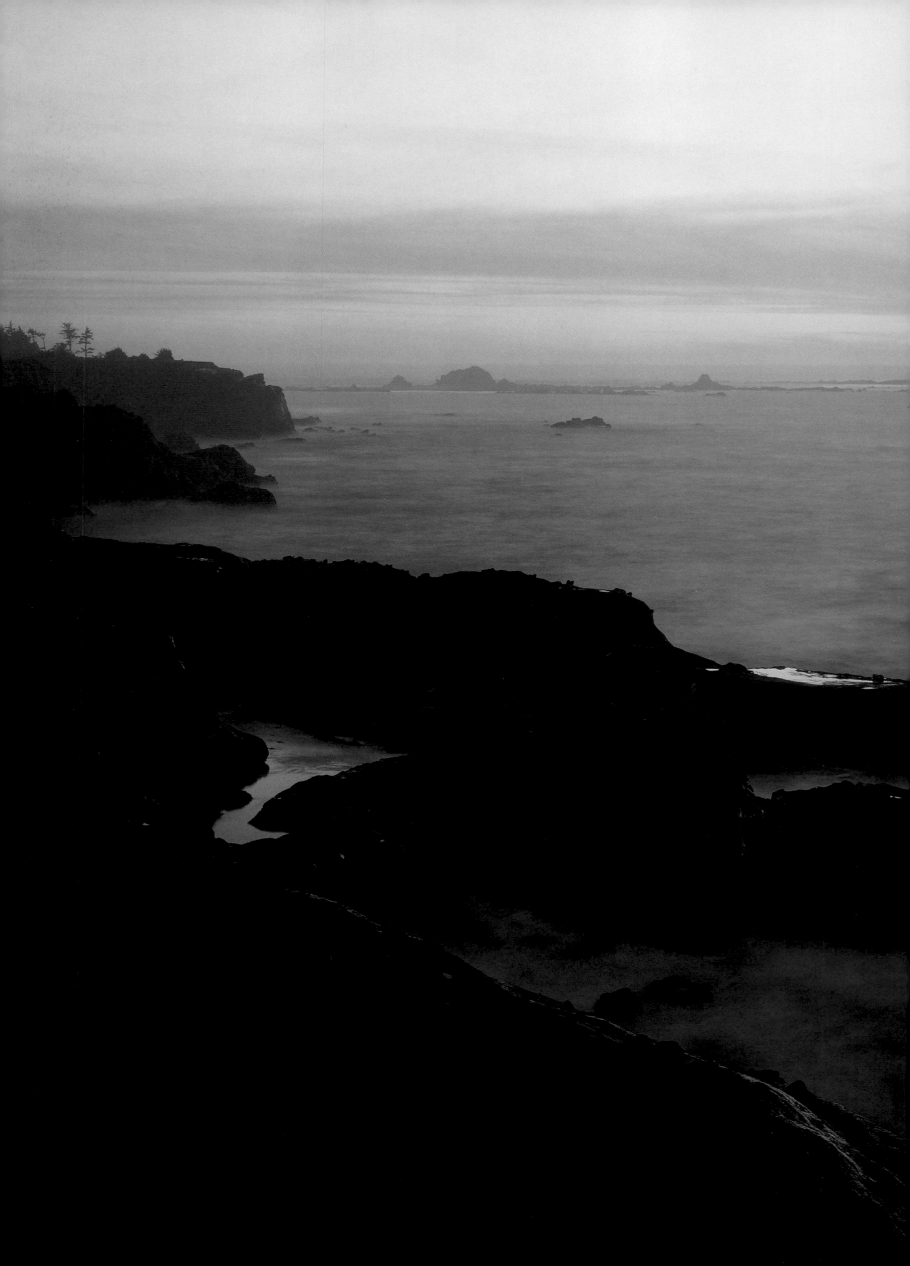

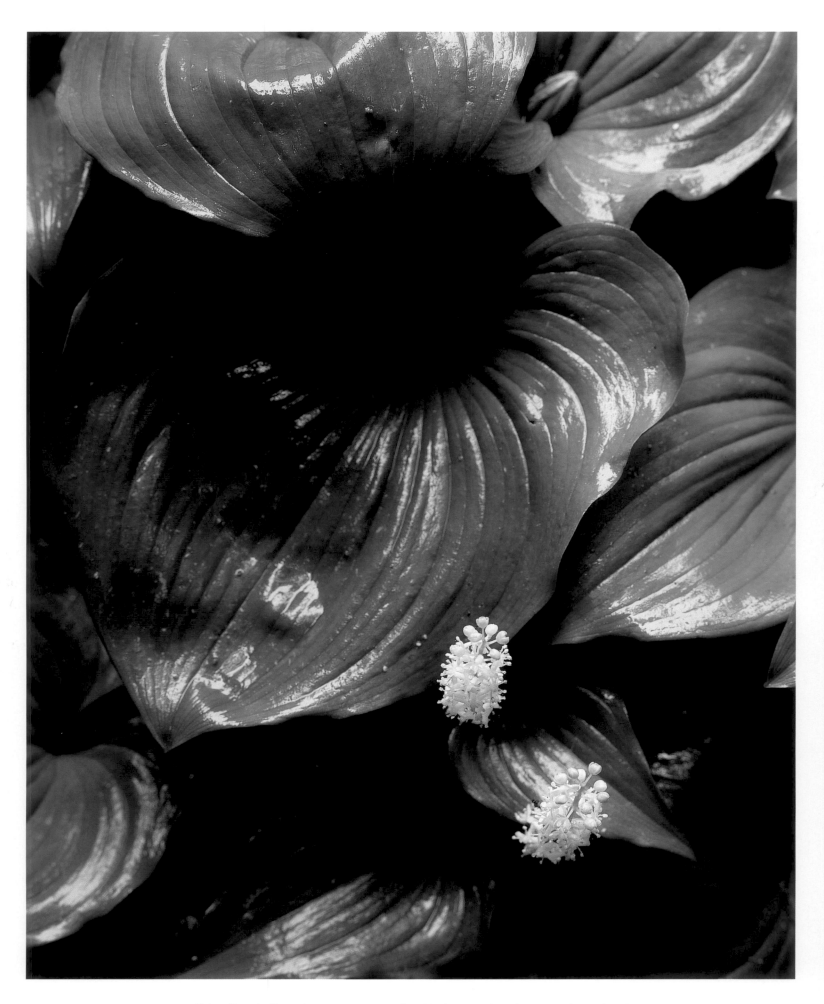

△ Wild calla *(Calla palustris)* grows in the Siuslaw National Forest along the Cape Perpetua Trail system. Also known as the water arum, swamp robin, or water dragon, wild calla flourishes in the cool, damp environment of the coastal forest floor.

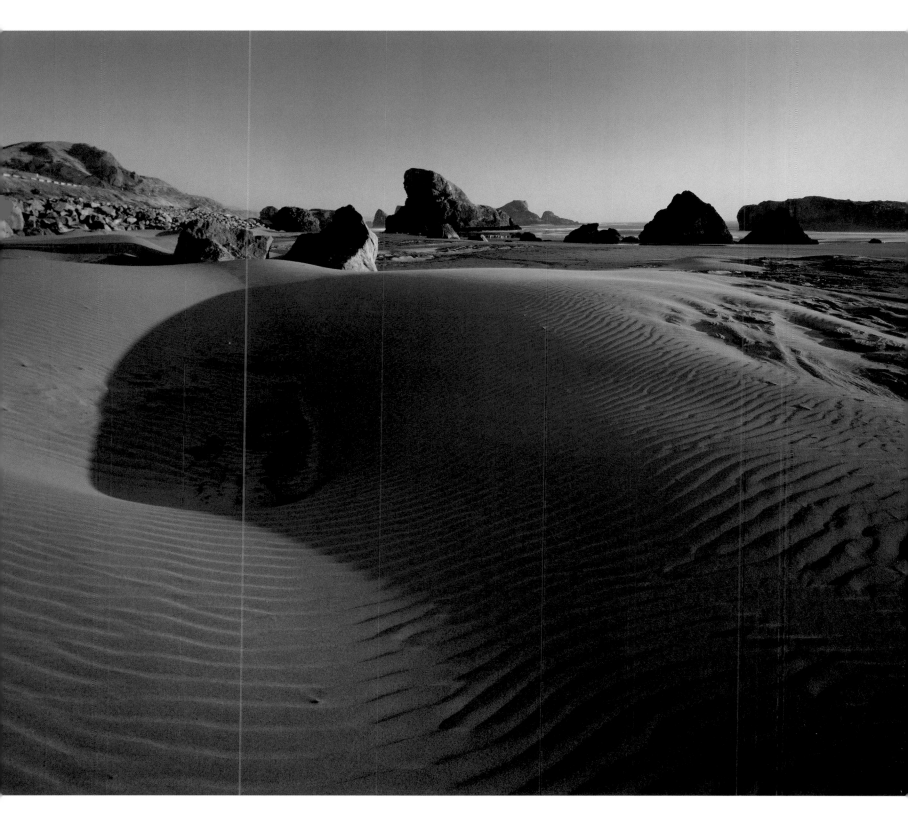

△ In late afternoon, the sun's slant creates intricate designs on the sand dunes at the Pistol River State Scenic Viewpoint, near Cape Sebastian. Wind creates ripples in the sand, and those winds, along with the unique beach and surf, have made this site the National Ocean Windsurfing Championships choice for several years.

WESTERN VALLEYS

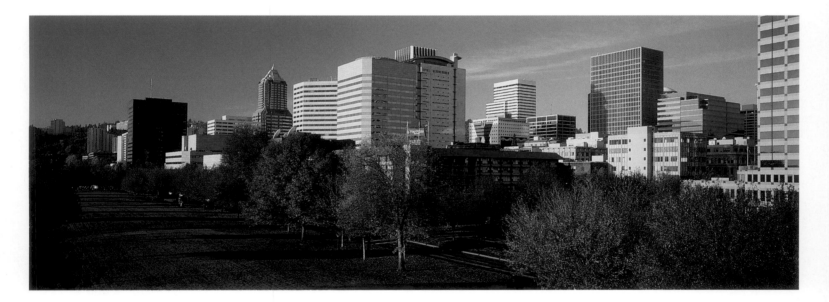

The pioneers did not find in the Willamette Valley

everything that had been promised. The pigs were not

born with knife and fork ready planted in their loins.

The fence posts did not bear fruit. But it was indeed

an uncommon place, this land of rainbows.

—Jonathan Nicholas

△ Portland's Waterfront Park
▷ Hot air balloon, between Newberg and St. Paul

◁ Mount Angel Abbey, located in the Willamette Valley, was founded in 1882 by monks from a seven-hundred-year-old Benedictine monastery in Engelberg, Switzerland. △ In Oregon's lush Willamette Valley, cool evenings in summer and early fall translate into deliciously high acid levels in ripening winegrapes.

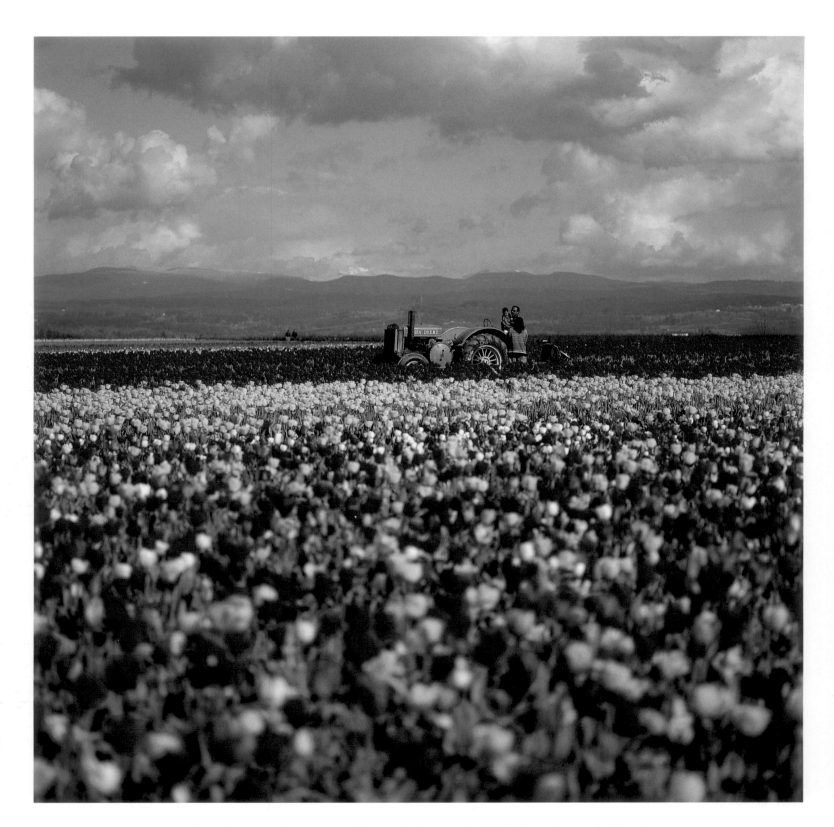

△ A family rests by a tractor in a multicolored tulip field at Iverson's Wooden Shoe Bulb Company in Woodburn. Each year from March 20 through April 21, the Wooden Shoe opens its thirty acres of brilliant color for the Tulip Festival.

△ Retired logging equipment rests among ferns at the Merten Sawmill Site in the Opal Creek Scenic Recreation Area. The steam engine from the battleship USS *Oregon* once powered logging operations here in the Willamette National Forest.

△ Blueberries flourish in the Iowa Hills area of the Willamette Valley. Oregon ranks third in the nation in the production of blueberries. ▷ Near Medford, a pear orchard in bloom shares space with mustard plants, also in bloom.

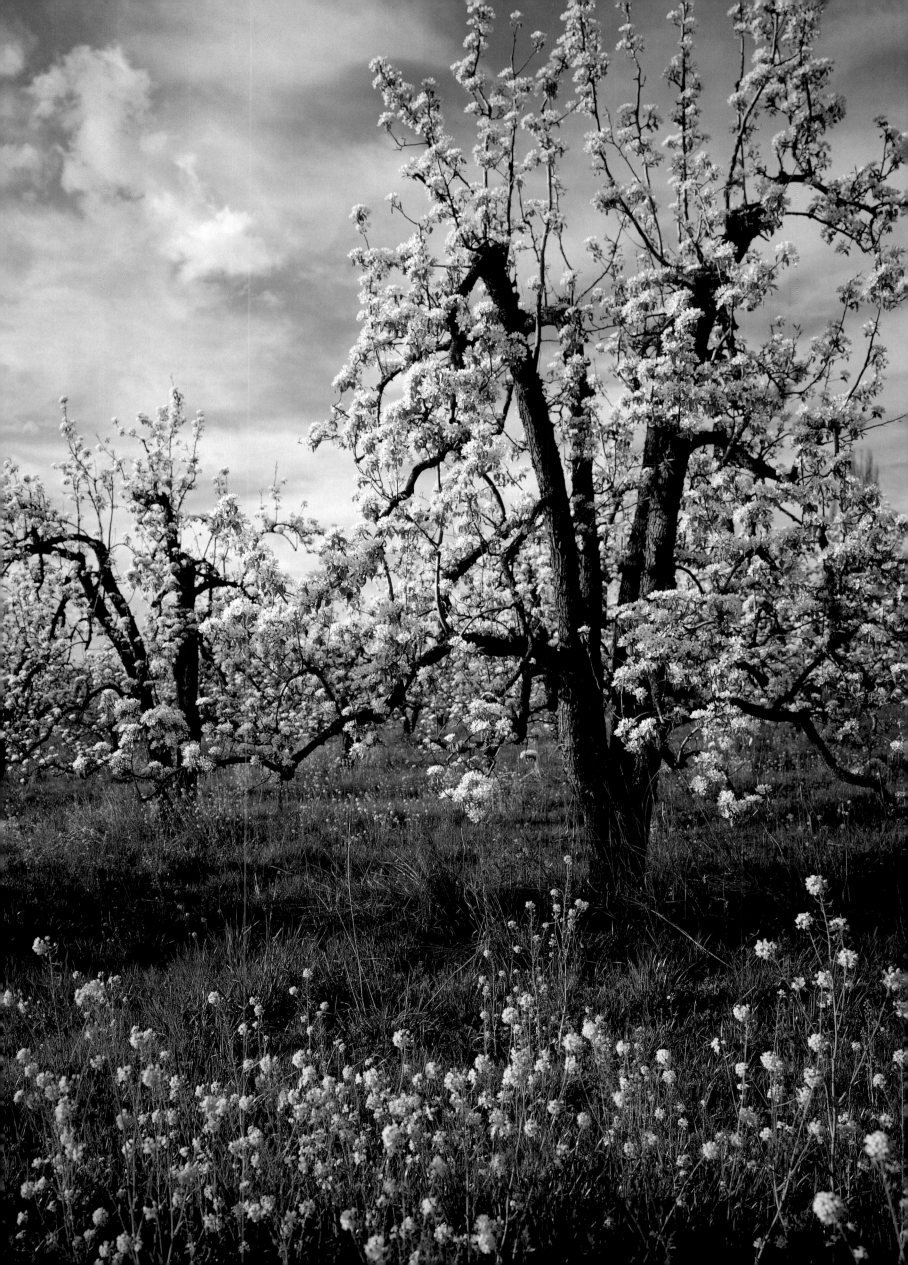

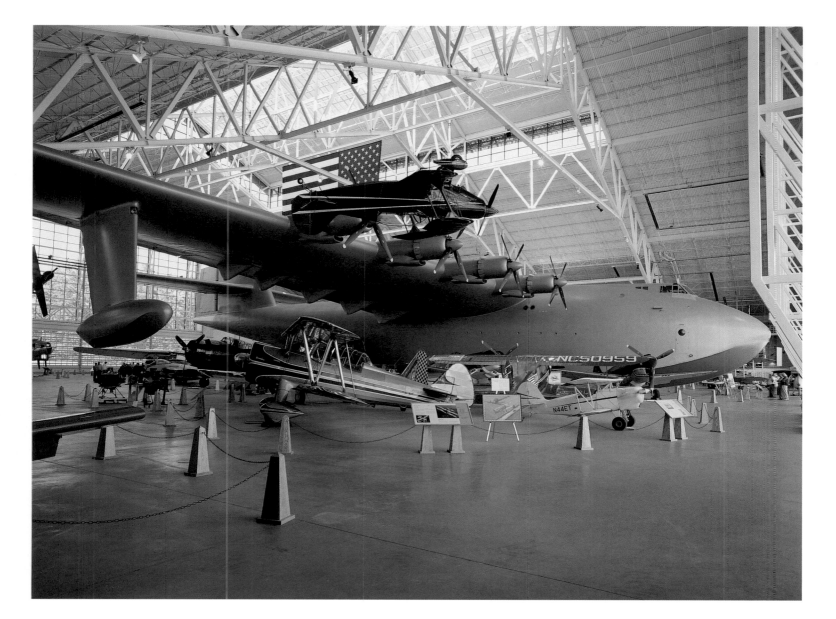

◁ A beautifully decorated saddle typifies the St. Paul Rodeo, first held July 4, 1936.
St. Paul is a town of 322 people, but the rodeo fills the arena's 10,500 seats.
△ The Hughes Flying Boat, or "Spruce Goose," flew its maiden—and only—flight
in 1947. More than 218 feet long with a wingspan of 320 feet, the largest plane
ever built is now displayed at the Evergreen Aviation Museum in McMinnville.

△ Situated at Sunny Valley in southwestern Oregon's Josephine County, Grave Creek Covered Bridge was built in 1920 and incorporates Gothic-style windows. ▷ The Jacksonville Museum now occupies the historic Jackson County Courthouse, which was constructed in 1883. The two-story red brick building served as the courthouse until 1927, when the county government moved to Medford.

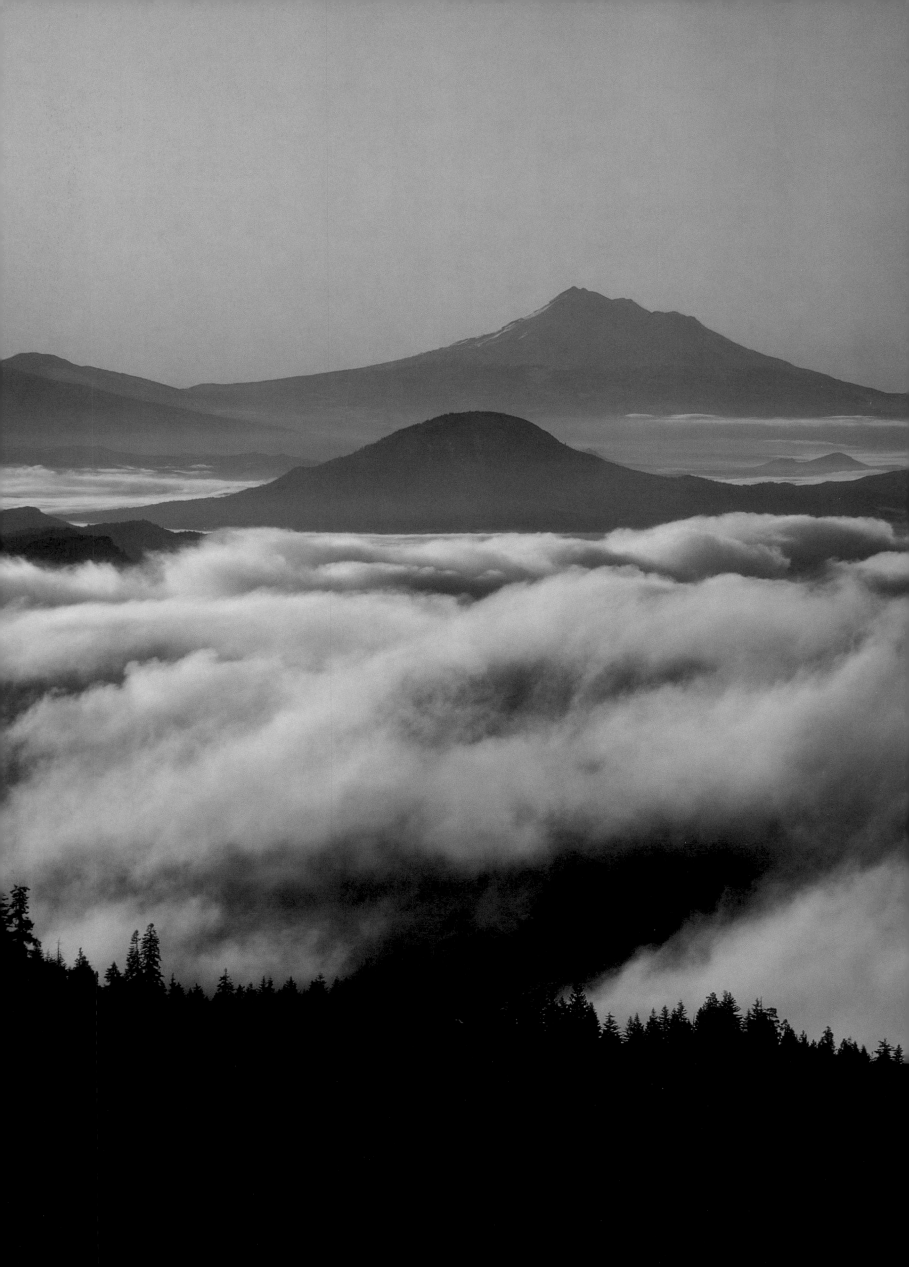

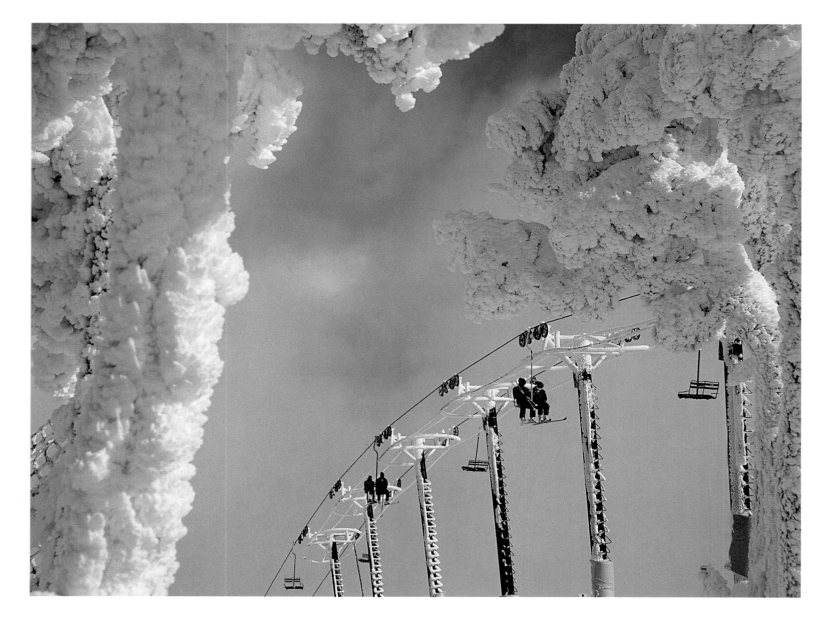

◁ Mount Shasta, towering 14,162 feet in the distance, is visible from Oregon's Mount Ashland at the intersection of the Siskiyou Mountains and the Cascades. △ With an annual snowfall of about two hundred inches. the Mount Ashland Ski Area provides opportunity for plenty of good skiing and snowboarding.

COLUMBIA

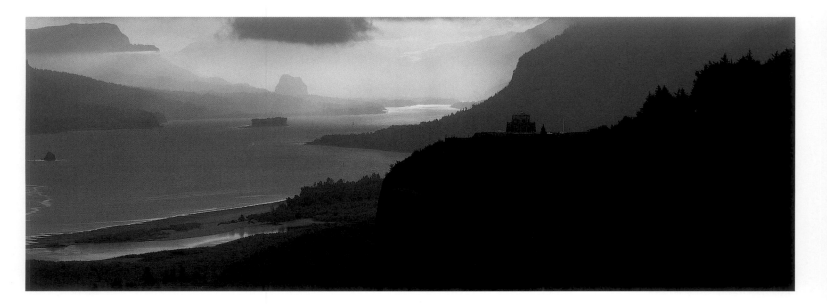

The scenery all along the Columbia both above

and below the Cascades is said to be the most beautiful

of any on the Continent, which cannot be fully

described by other than an artist's pen.

—Harriet A. Loughary, 1864

△ Vista House and Crown Point, Columbia River Gorge
▷ Columbia River Gorge in autumn

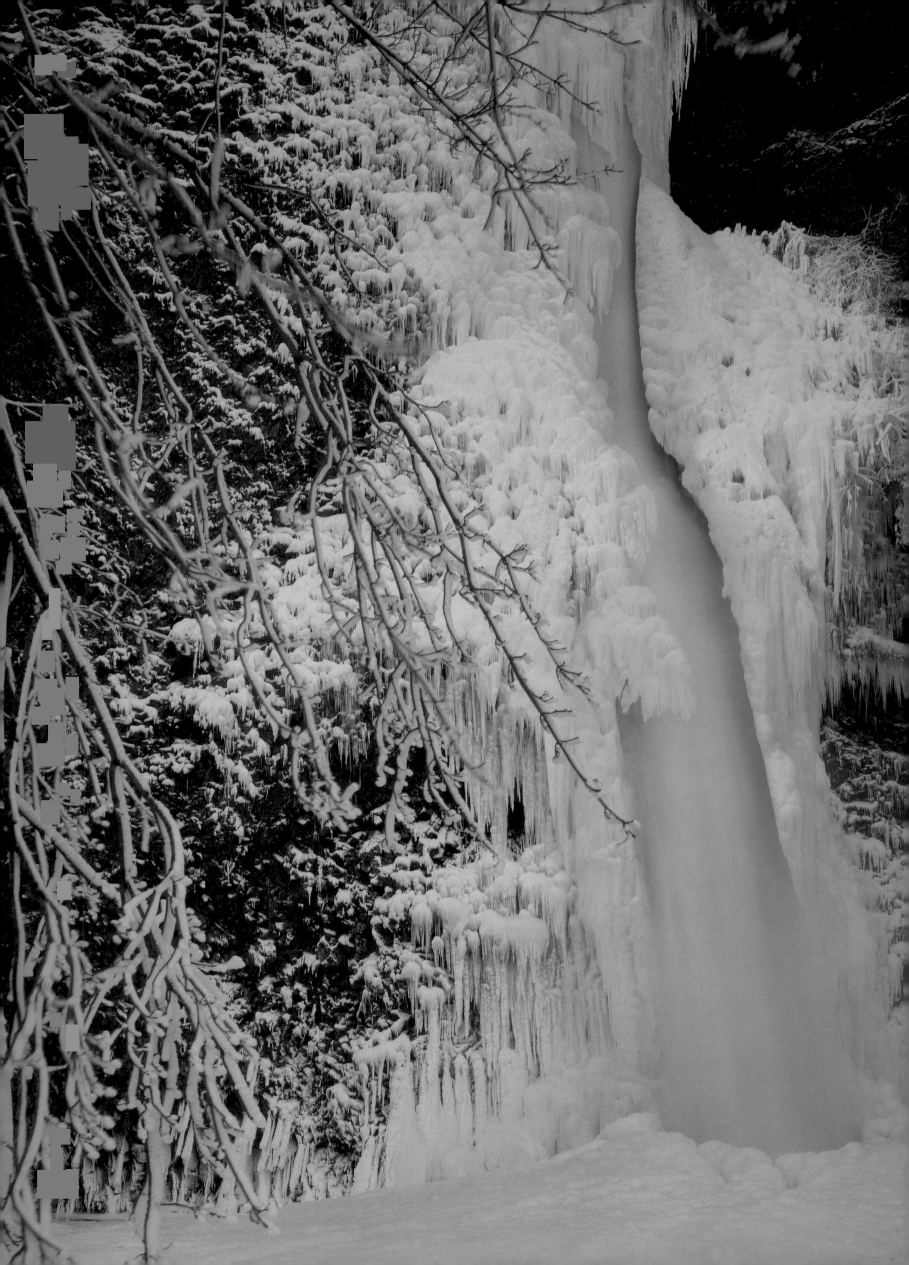

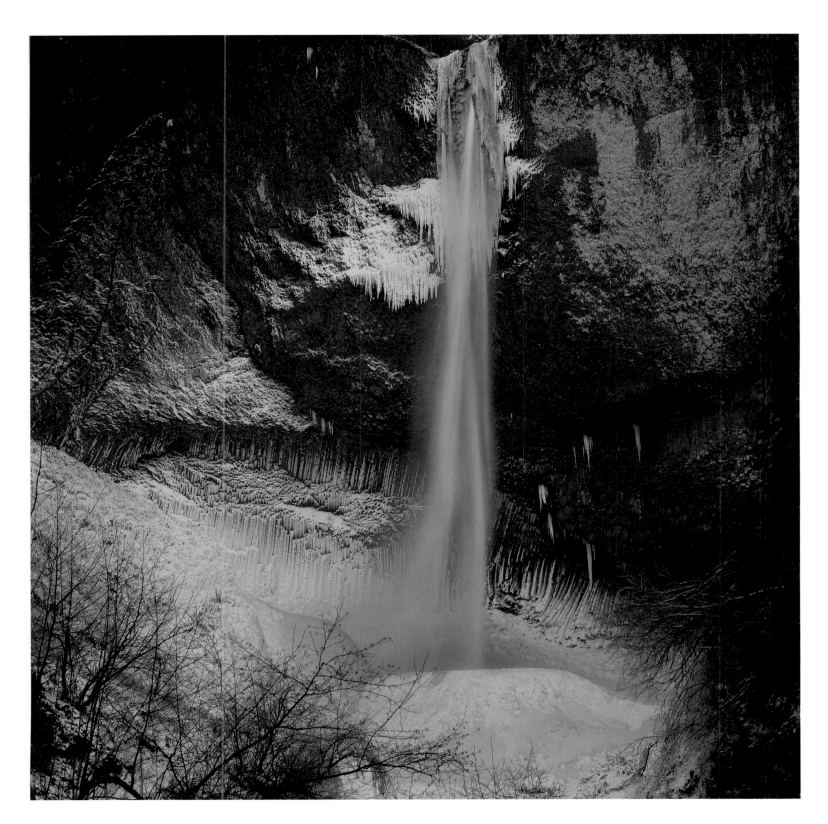

◁ Winter in the Columbia Gorge is sometimes harsh—but always beautiful—
as demonstrated here by 176-foot Horsetail Falls in the National Scenic Area.
△ Countless falls, from unnamed seasonal trickles to year-round cascades,
accent the Columbia River Gorge National Scenic Area. One of the permanent
ones, 224-foot Latourell Falls, is highlighted by snow, icicles, and yellow lichen.

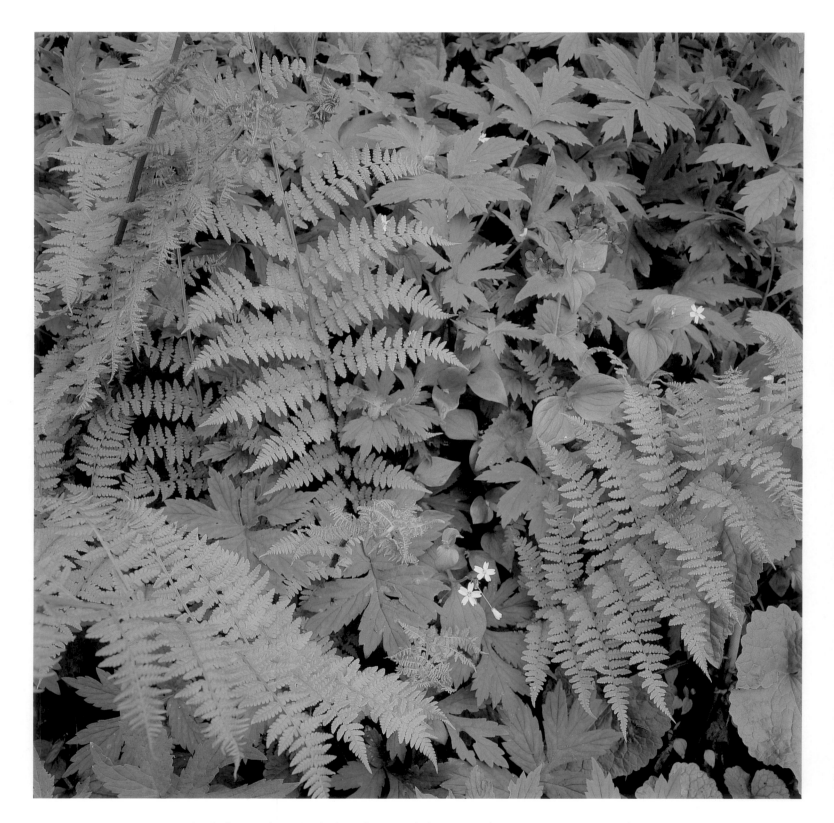

△ Lush flora—here including ferns and dame's rocket *(Hesperis matronalis)*—shows why, in 1986, the U.S. Congress enacted a law designating the Columbia Gorge as a national scenic area. The Columbia River Gorge National Scenic Area Act is a continuing mandate "to protect and provide for the enhancement of the scenic, cultural, recreational, and natural resources of the Columbia River Gorge."

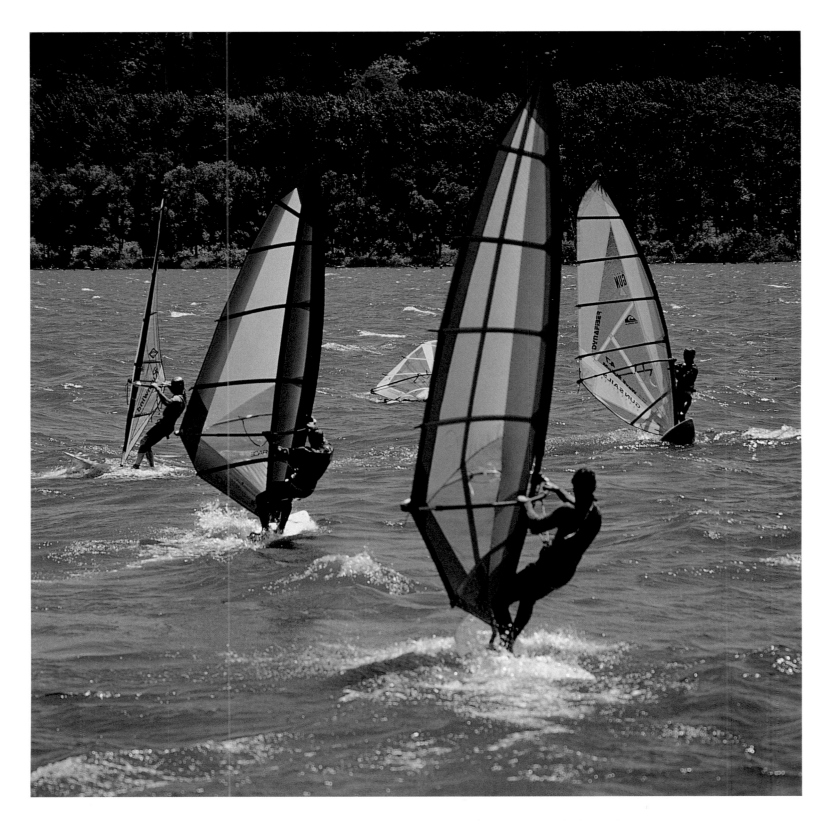

△ The Columbia River Gorge is known for its world-class windsurfing. Flowing from the east, the river current is counterbalanced during much of spring and summer by strong winds from the west—creating ideal windsurfing conditions. With its north canyon walls in Washington and its south canyon walls in Oregon, the gorge is some eighty miles long and up to four thousand feet deep.

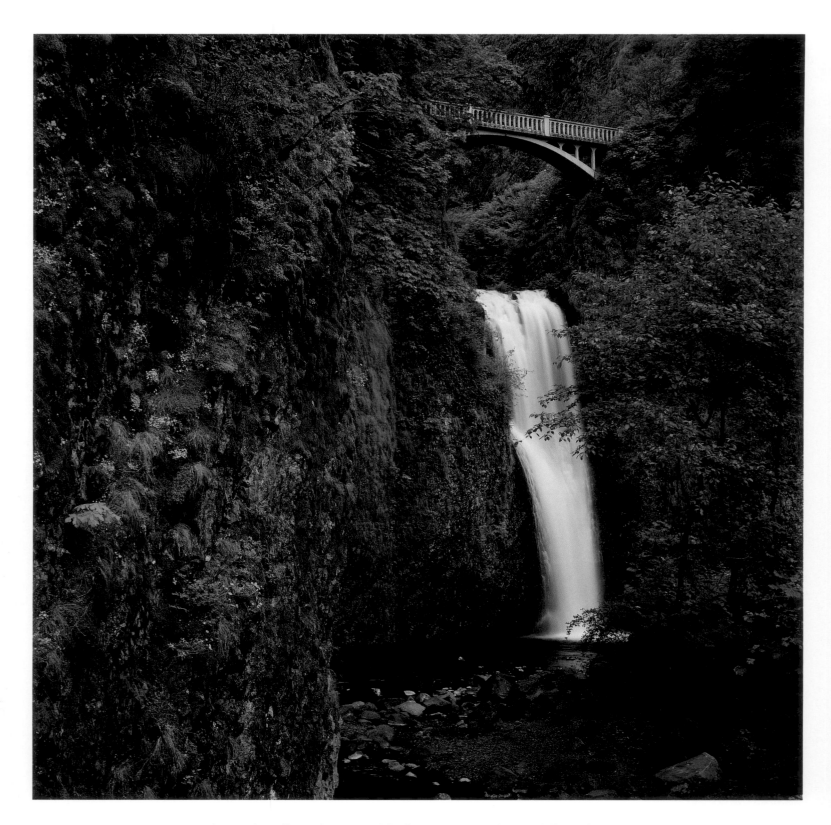

△ Multnomah Falls is the second-highest year-round waterfall in the nation—a total drop of 620 feet for the combined upper and lower falls. The lower falls, shown here, make up only 69 feet of that total. The waterfall attracts nearly two million visitors each year from around the world. ▷ Bigleaf maple leaves transform the Historic Columbia River Highway into an artist's palette.

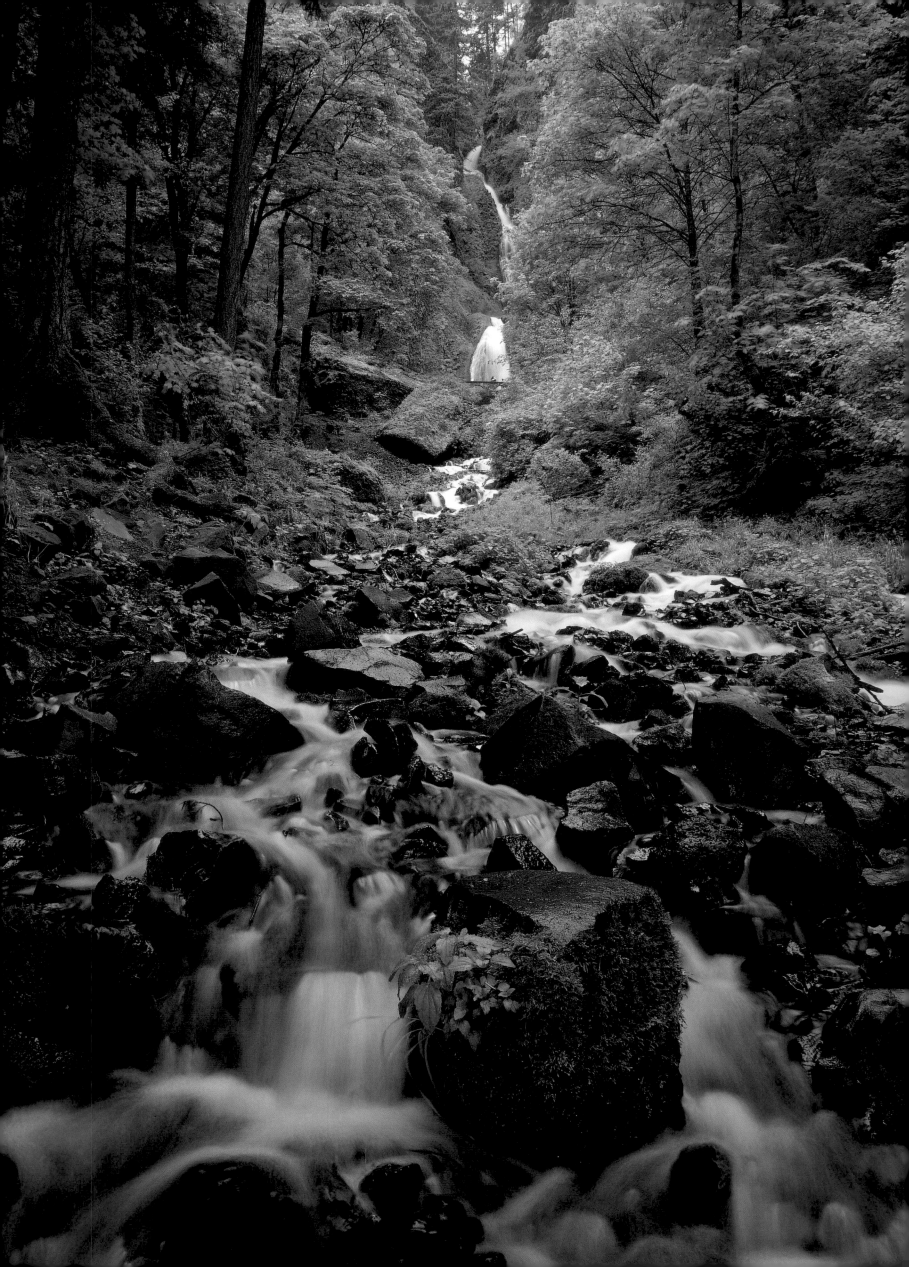

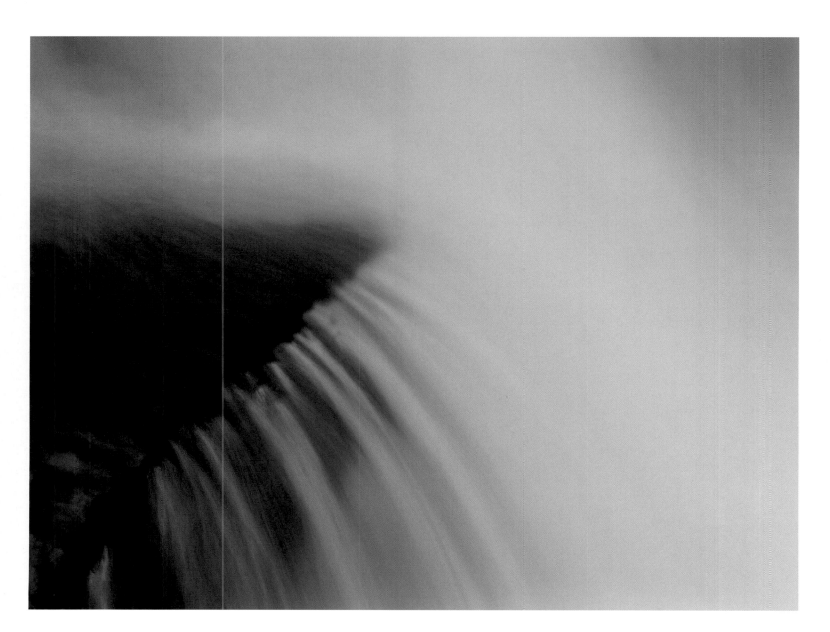

◁ The waters of Wahkeena Falls twist and turn as they tumble over the rocks. Some historians say that the falls were named for the daughter of an Indian chief; others believe that *wahkeena* is a Yakima Indian word meaning "most beautiful." △ A small, unnamed stream rushes over rocks on its way to join the mighty Columbia. ▷ ▷ Mount Hood, Oregon's highest peak at 11,237 feet, towers above fruit orchards.

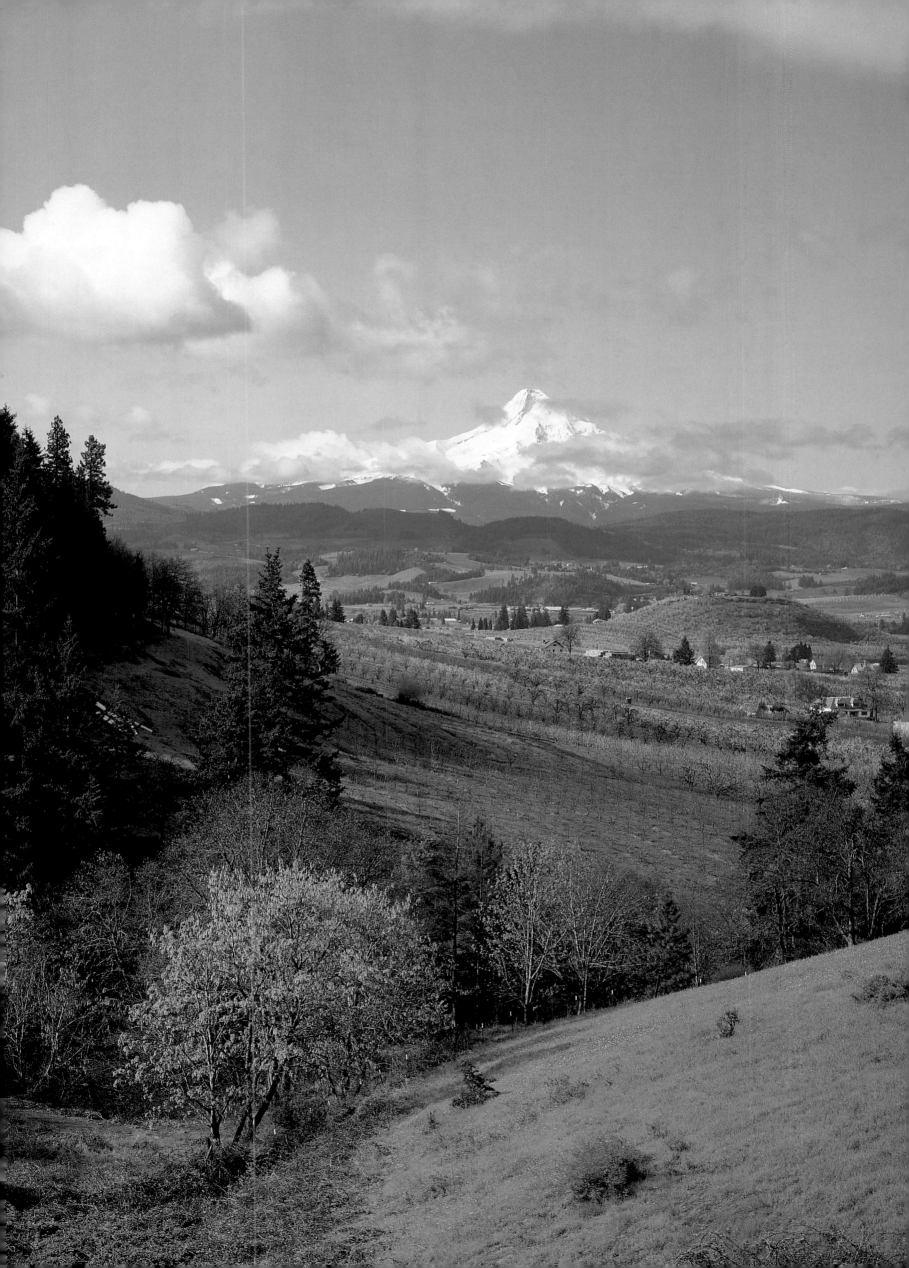

△ In this exposed area of the Columbia River Gorge, near Rowena, poplar trees *(Populus nigra)* are planted along the edges of orchards to protect the fragile fruit-bearing trees from the fierce winds that funnel through the gorge region.
▷ Colorful rocks line the East Fork of Hood River, which provides water to the fruit orchards of Hood River Valley on its way from Mount Hood to the Columbia River.

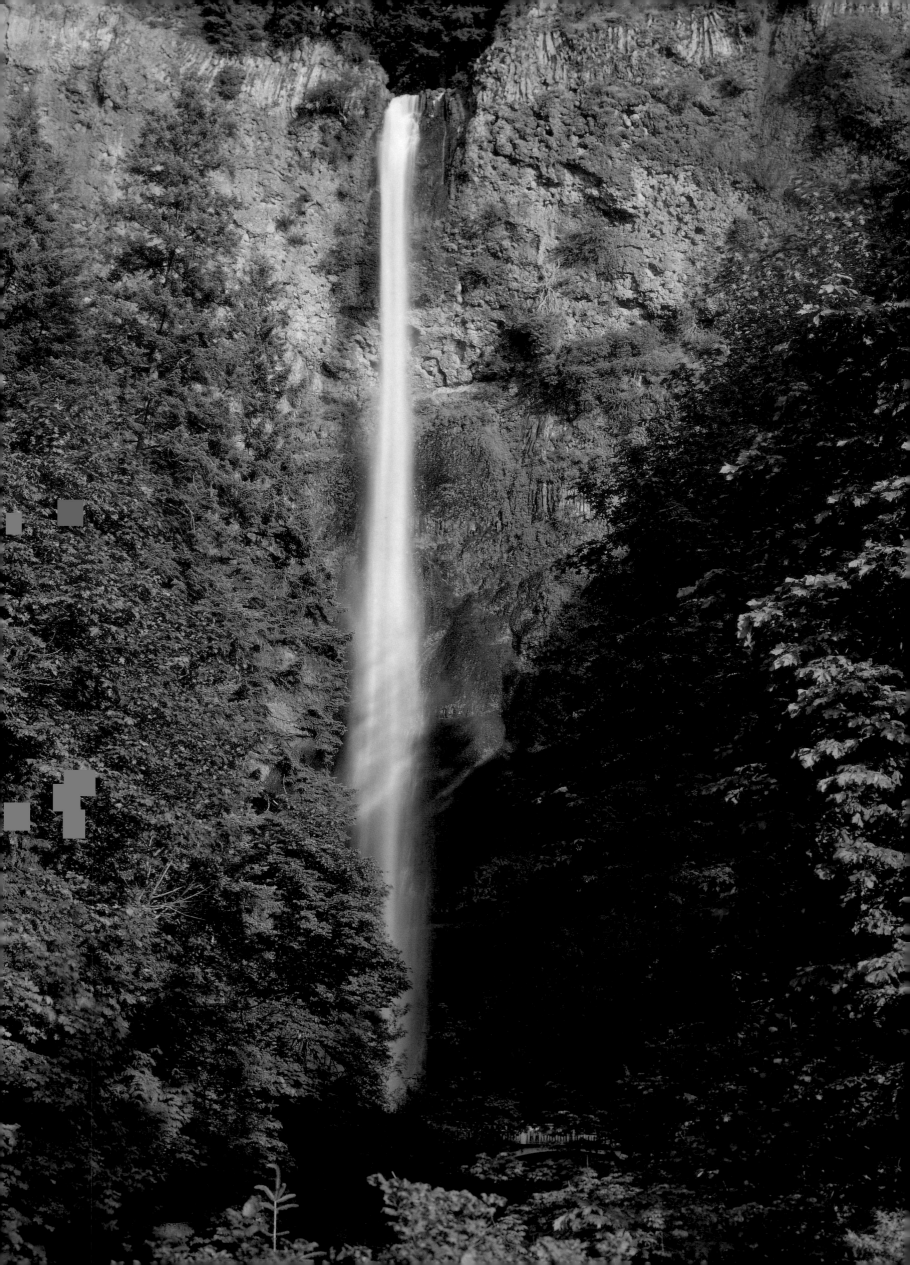

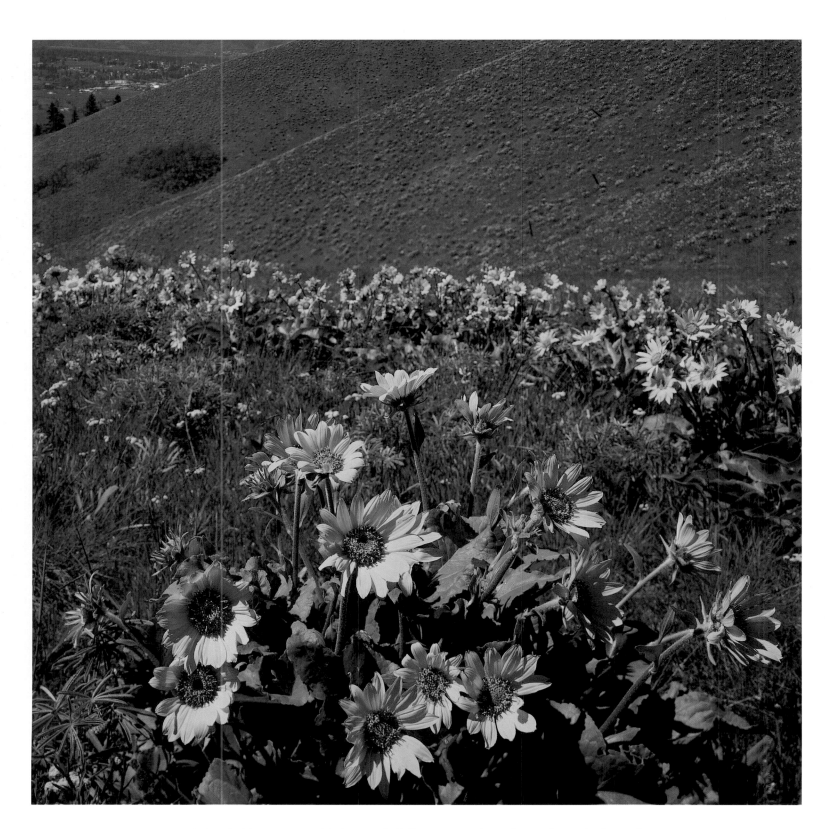

◁ A footbridge crosses Multnomah Falls seventy feet above the splash pool at the base of the 542-foot upper falls. The falls' source is near the summit of Larch Mountain, four thousand feet above the Columbia River Highway. △ Balsam root *(Balsamorhize deltoidea)* adds brilliance to a hillside in the foothills of the Cascades.

CASCADES

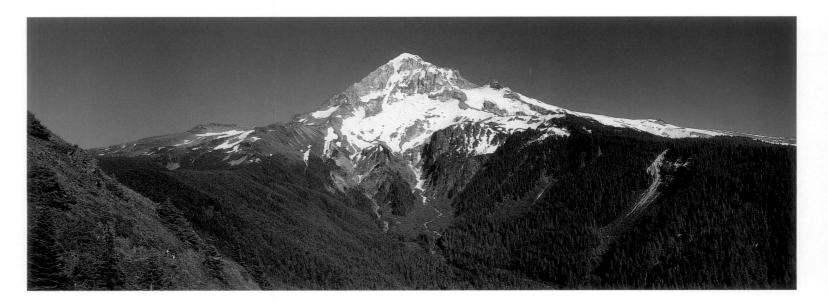

Sparkling with snow, the ice-capped summits

of the Cascades ride above a green base

of coniferous forest. The peaks are linked like

a great wall built inland from the Pacific Ocean.

—Fred Beckey

△ Mount Hood
▷ Timberline Ski Area on Mount Hood

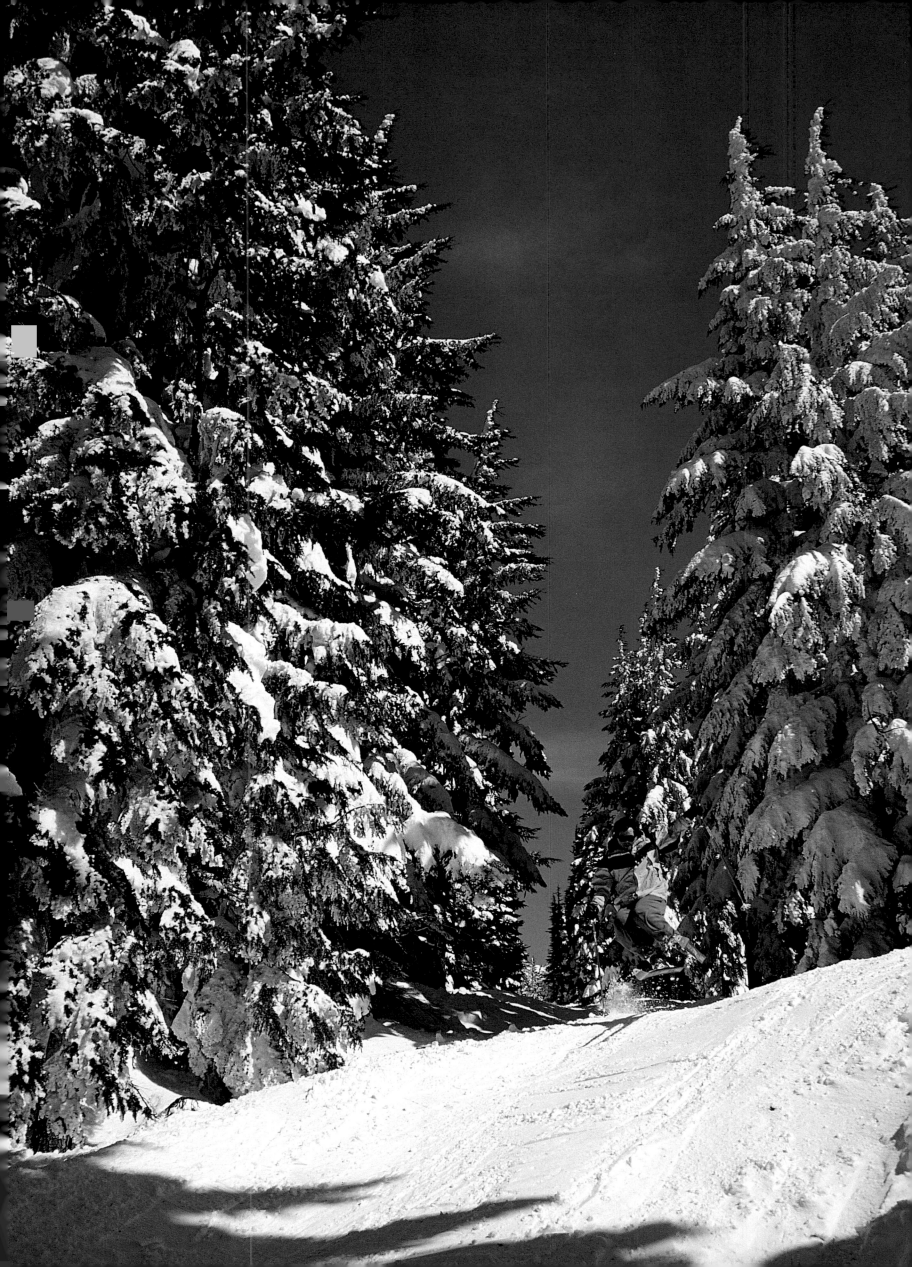

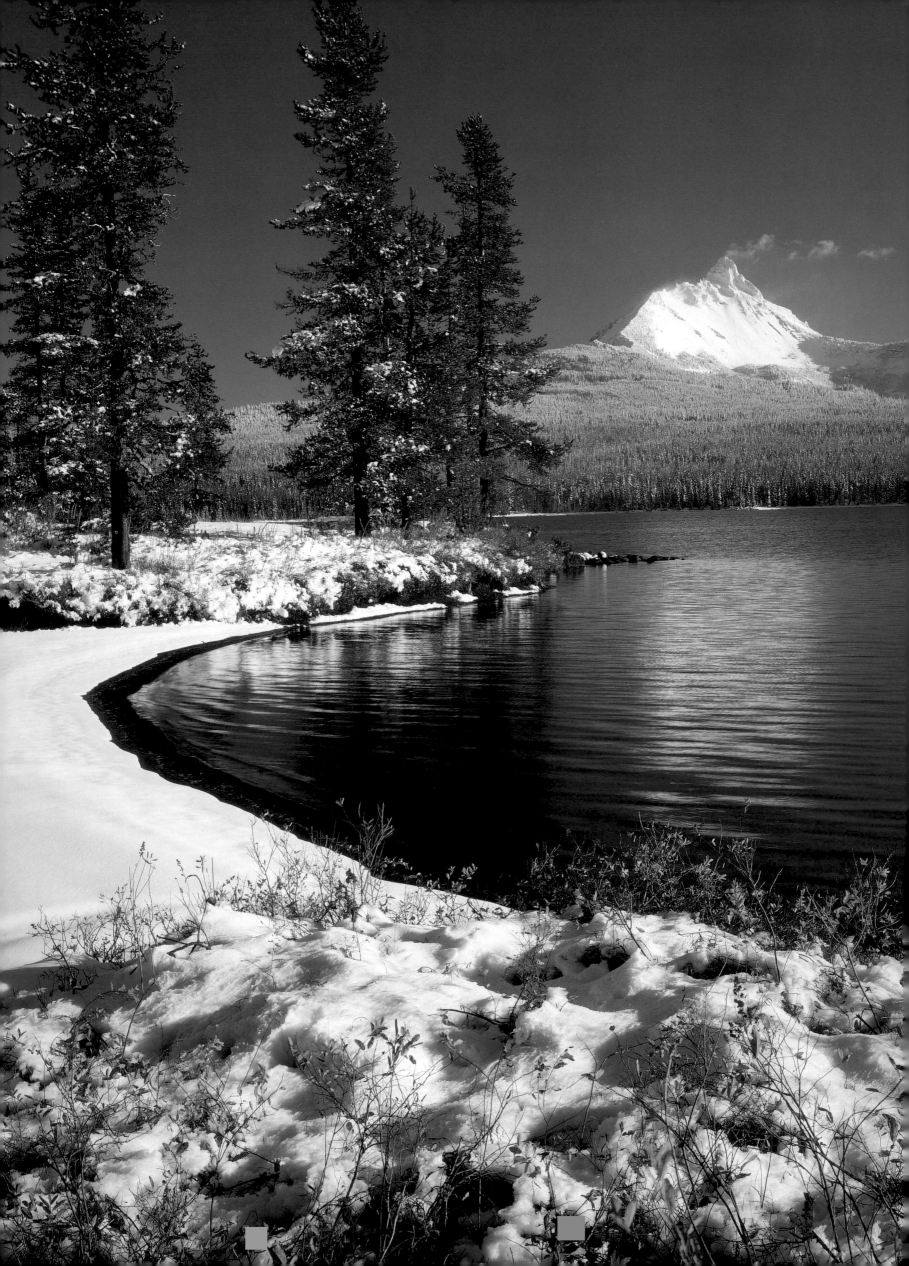

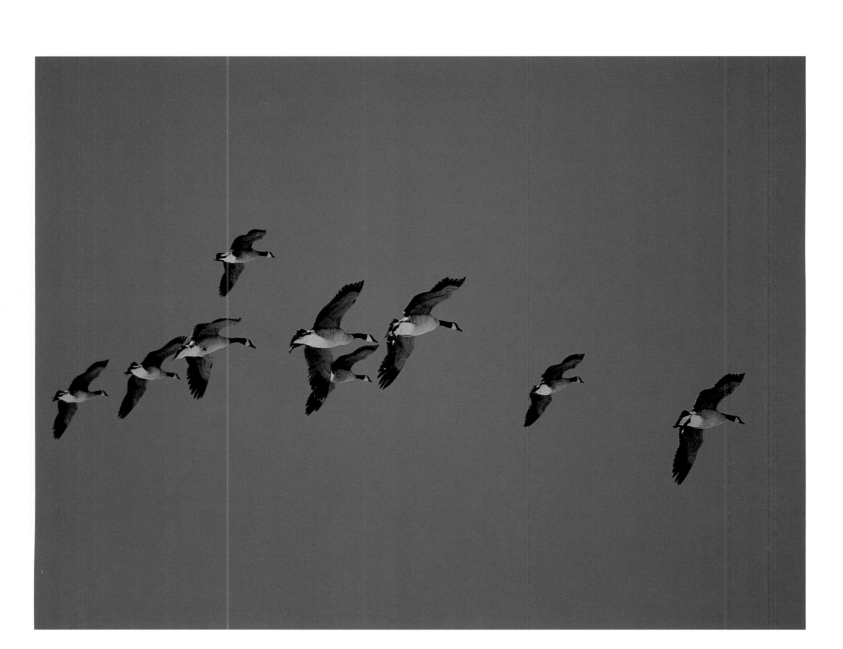

◁ Mount Washington, near Big Lake in the Central Cascades, rises 7,794 feet above sea level. Big Lake, situated at an elevation of 4,644 feet, is one of the highest in the Cascades. △ Canada geese *(Branta canadensis)* soar in a crisp blue winter sky. Several subspecies of Canada geese winter in the western states, including Oregon, returning north each spring to nest and raise their young.

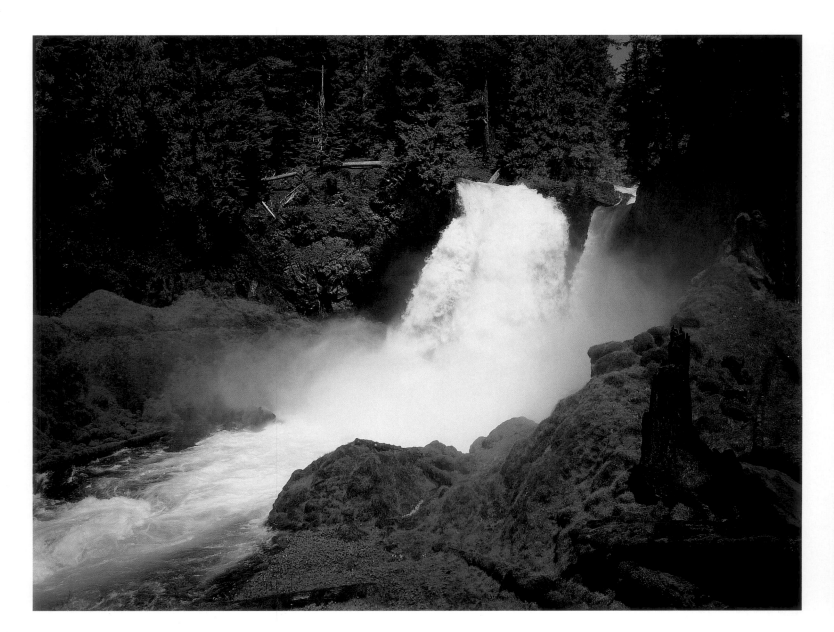

△ A heavy snowpack and a quick snowmelt send the waters of the McKenzie
River rushing furiously over the edge of Sahalie Falls for a drop totaling 140 feet.
▷ Situated along the Marion Lake Trail in the Mount Jefferson Wilderness, Ann
Lake, elevation 3,940 feet, is home to a modest population of native brook trout.

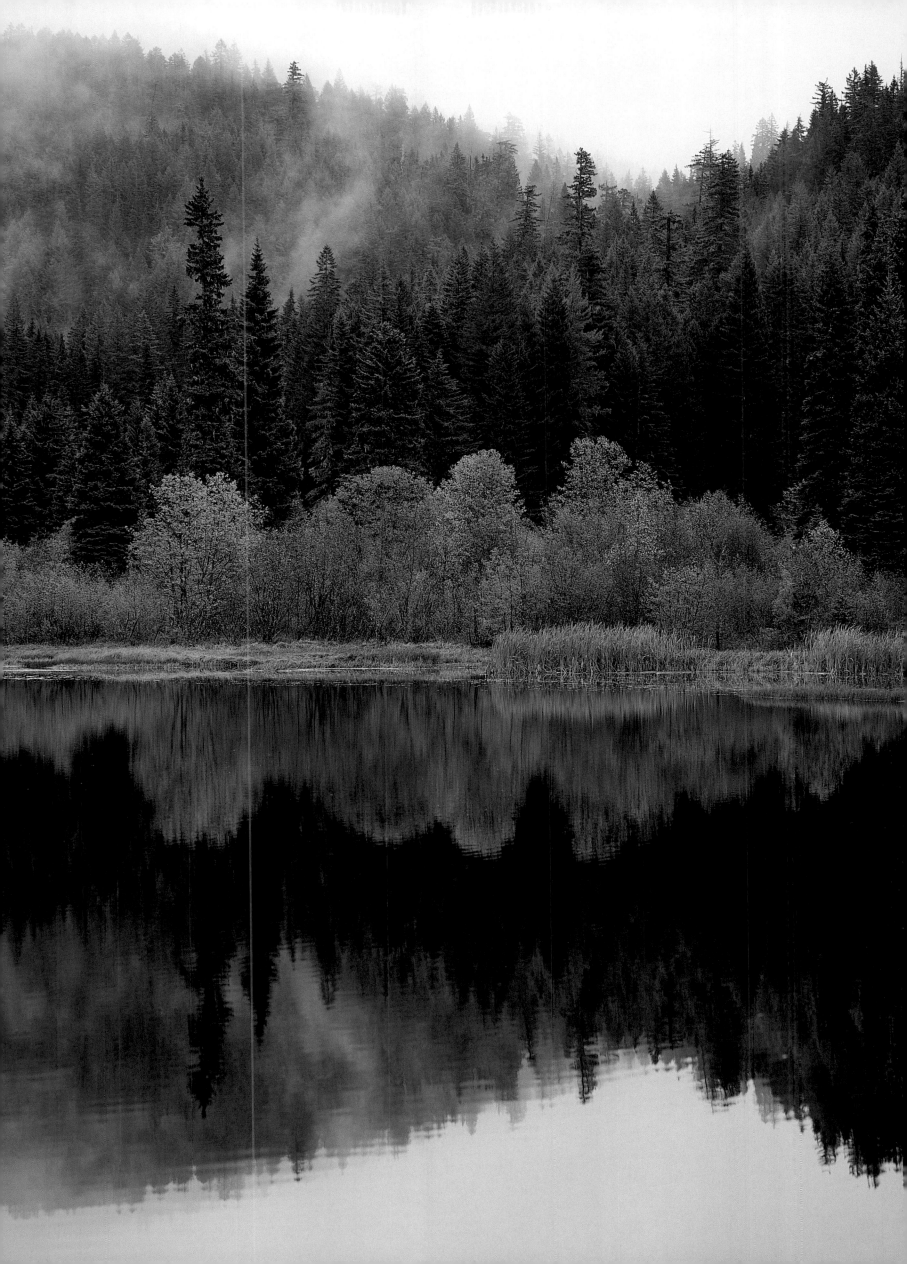

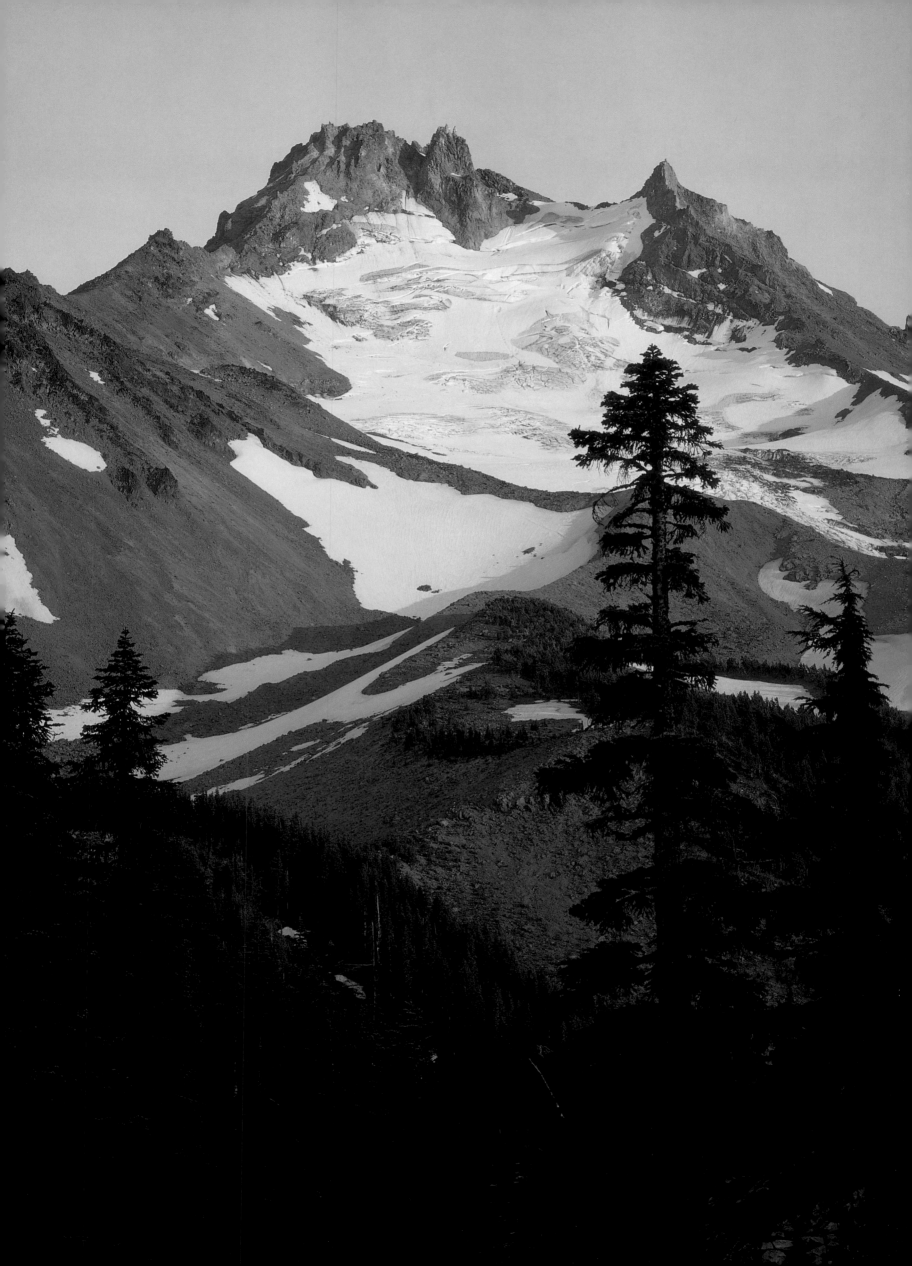

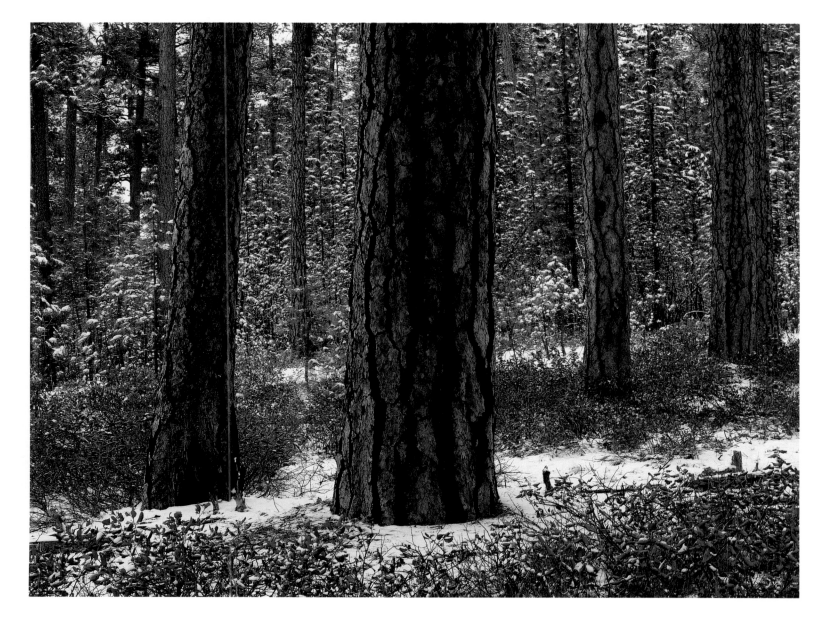

◁ Sunset lends the blush of alpenglow to 10,495-foot Mount Jefferson in the Central Cascades. △ Ponderosa pine *(Pinus ponderosa)* is just one of the attractions enjoyed by more than eight million people who visit the Deschutes National Forest each year. The national forest also offers opportunity for numerous recreational activities, including hiking, camping, fishing, hunting, and skiing.

△ Mount Thielson, 9,182 feet high, is one of the most remarkable in the state because of the great pinnacle or spire that forms its summit. Diamond Lake, in the heart of the Umpqua National Forest, lies between Mount Thielsen and Mount Bailey at an elevation of 5,182 feet. ▷ Sparks Lake, in Deschutes County, reflects the South Sister, the highest of the Three Sisters at 10,358 feet.

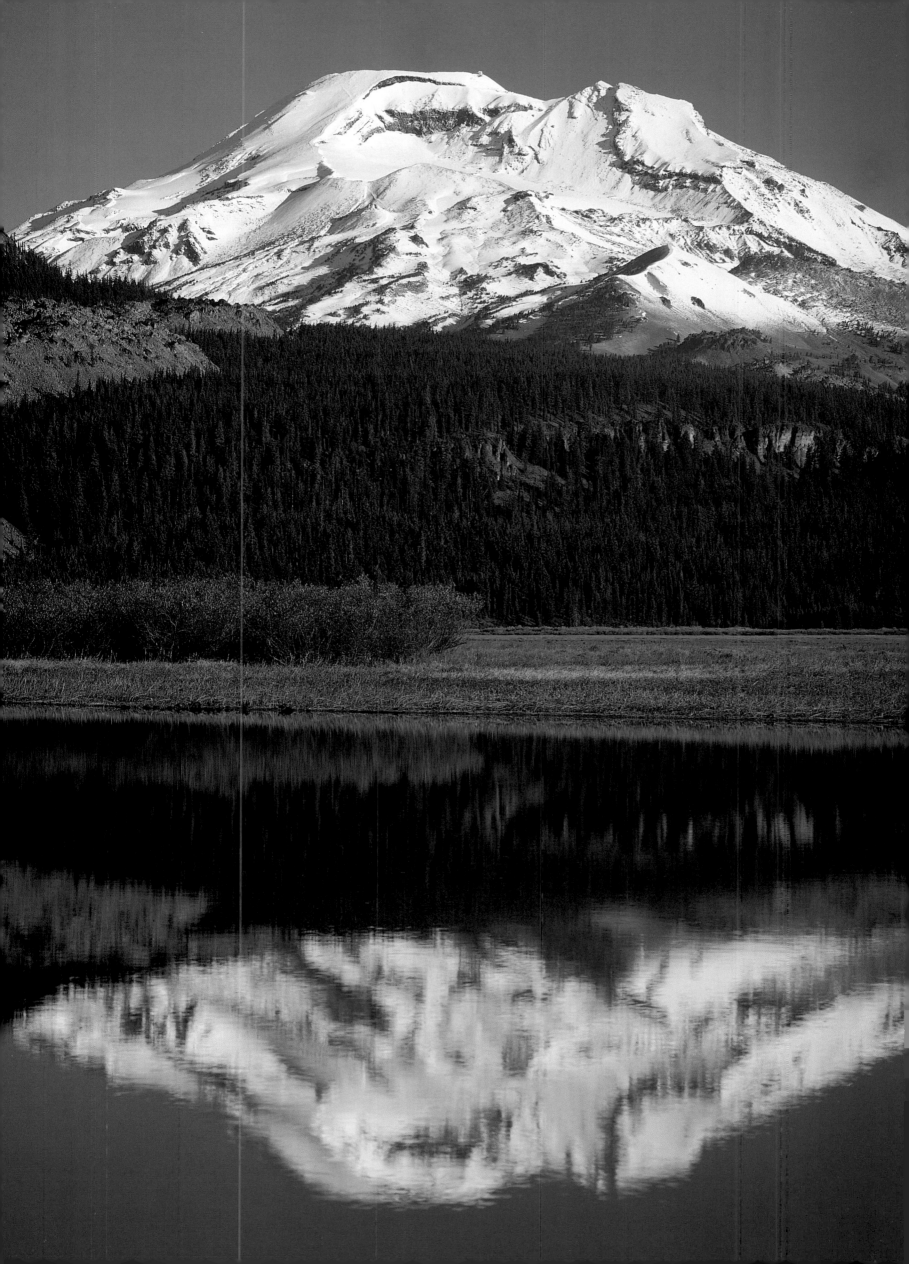

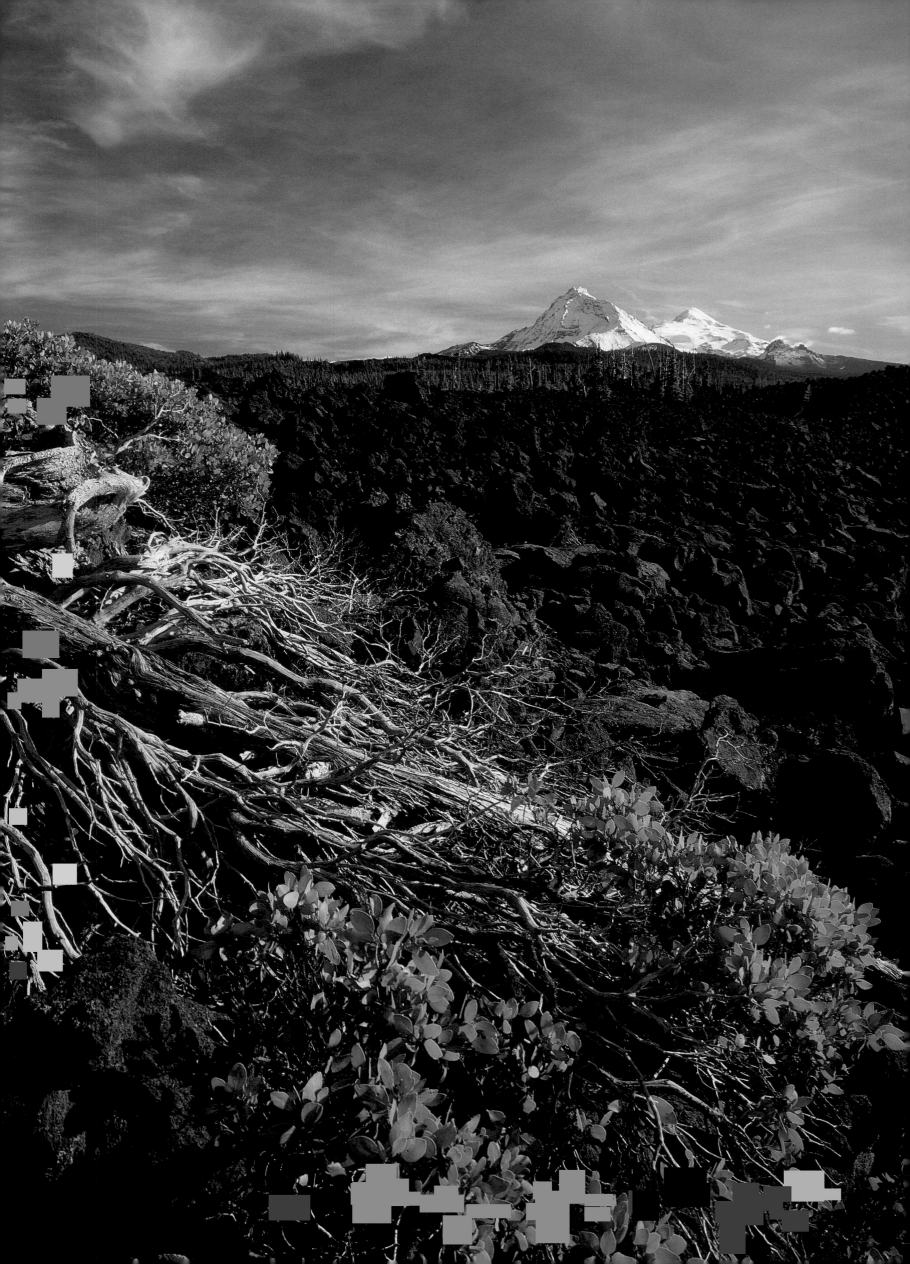

◁ The Middle Sister (10,050 feet) and North Sister (10,090 feet) rise above McKenzie Pass lava flows. Affording views of the flows, today's highway follows the route of a toll road constructed by pioneer citizens—which followed an old Indian trail. The highway, running between Blue River and Sisters, reaches 5,325 feet in elevation. △ Vine maple *(Acer circinatium)* glows red in the Mount Hood National Forest.

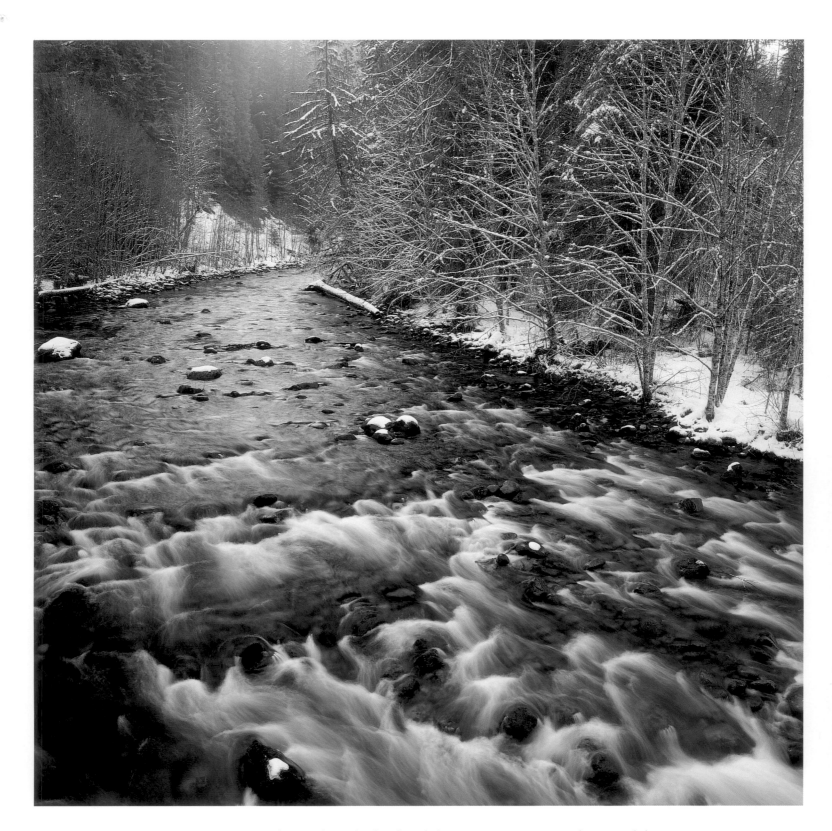

△ Snow-covered trees line the banks of the Santiam River. A tributary of the Willamette River, the Santiam begins in the Central Cascades and joins the Willamette just north of Albany. ▷ The Metolius River tumbles over Wizard Falls on its way to join the Deschutes. ▷▷ One of the best rainbow trout fishing rivers in the West, the Metolius flows from an underground spring at the base of Black Butte.

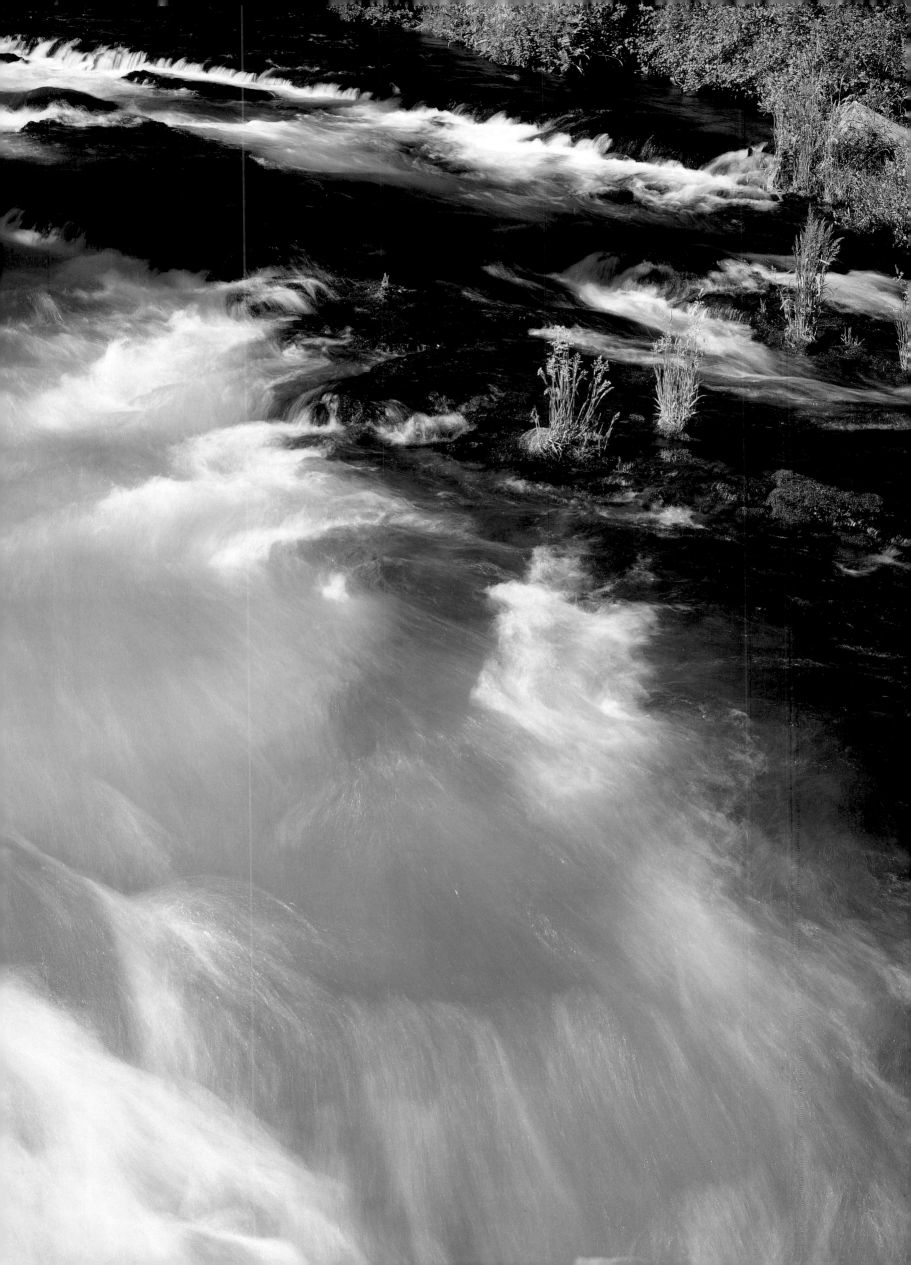

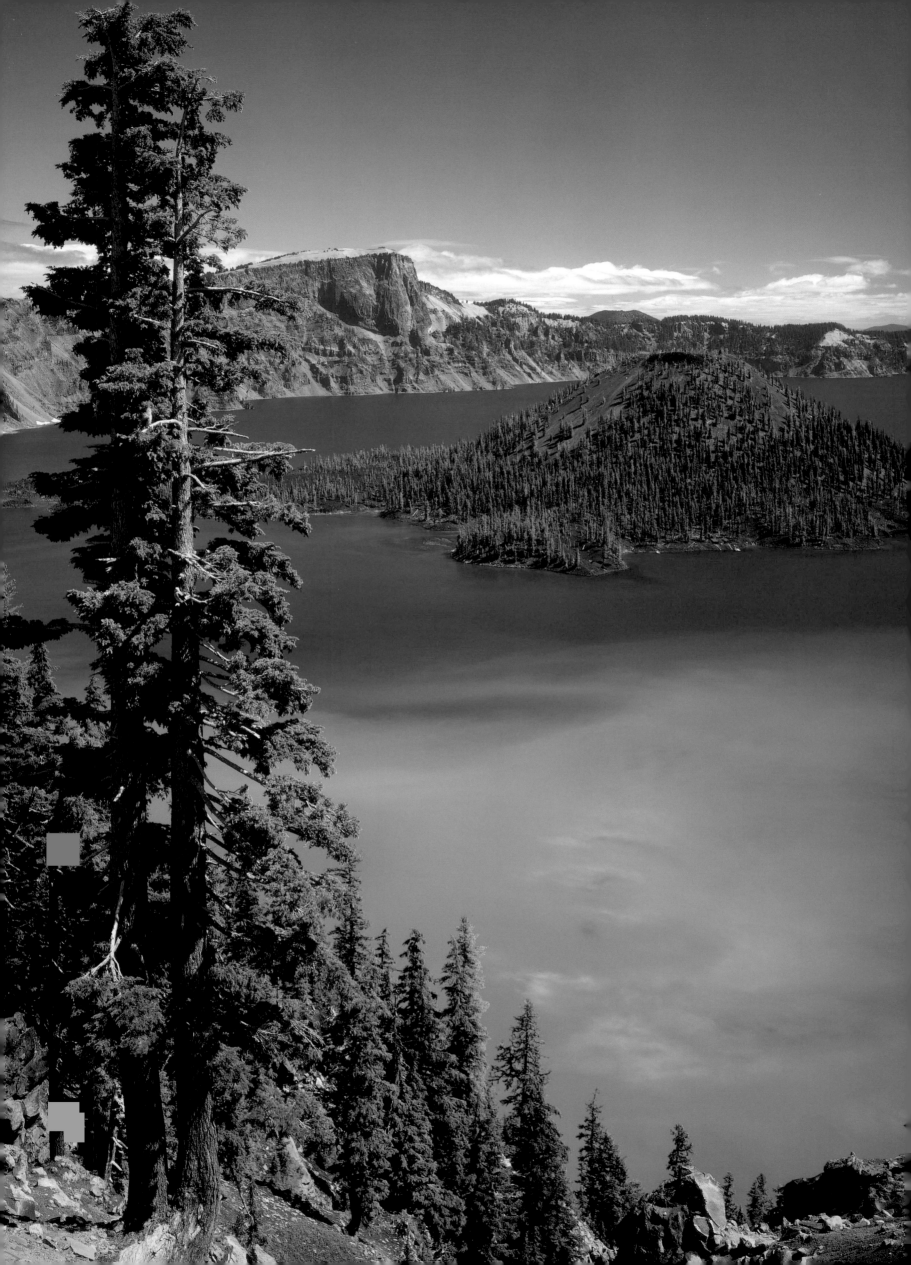

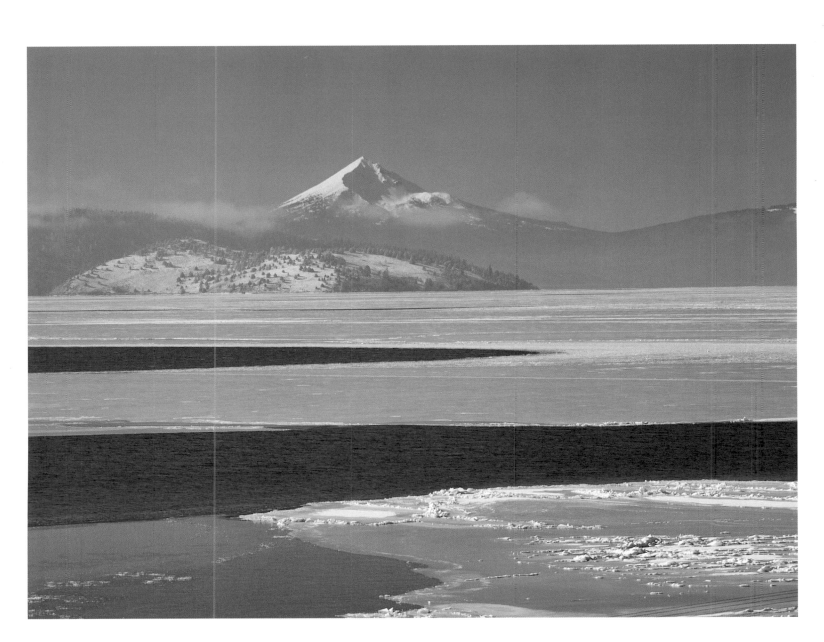

◁ A summer storm leaves Crater Lake turquoise in color. The world's seventh-deepest lake (1,932 feet deep), Crater Lake was formed after the collapse of the top five thousand feet of Mount Mazama in an eruption that was forty-two times more powerful than the 1980 eruption of Mount St. Helens. △ Clouds partly obscure 9,495-foot Mount McLoughlin, seen from across an icy Upper Klamath Lake.

CENTRAL

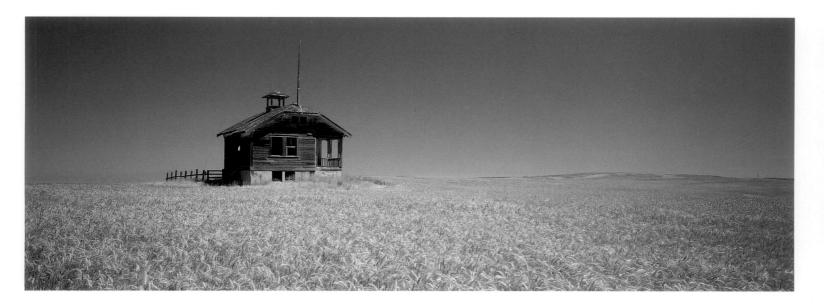

At length the old familiar scenes

A checkerboard of browns and greens,

Retire behind us, giving place

To undulating seas of space.

—Edwin T. Reed

△ Abandoned schoolhouse and wheat, Wasco County
▷ Wheat harvest, Wasco County

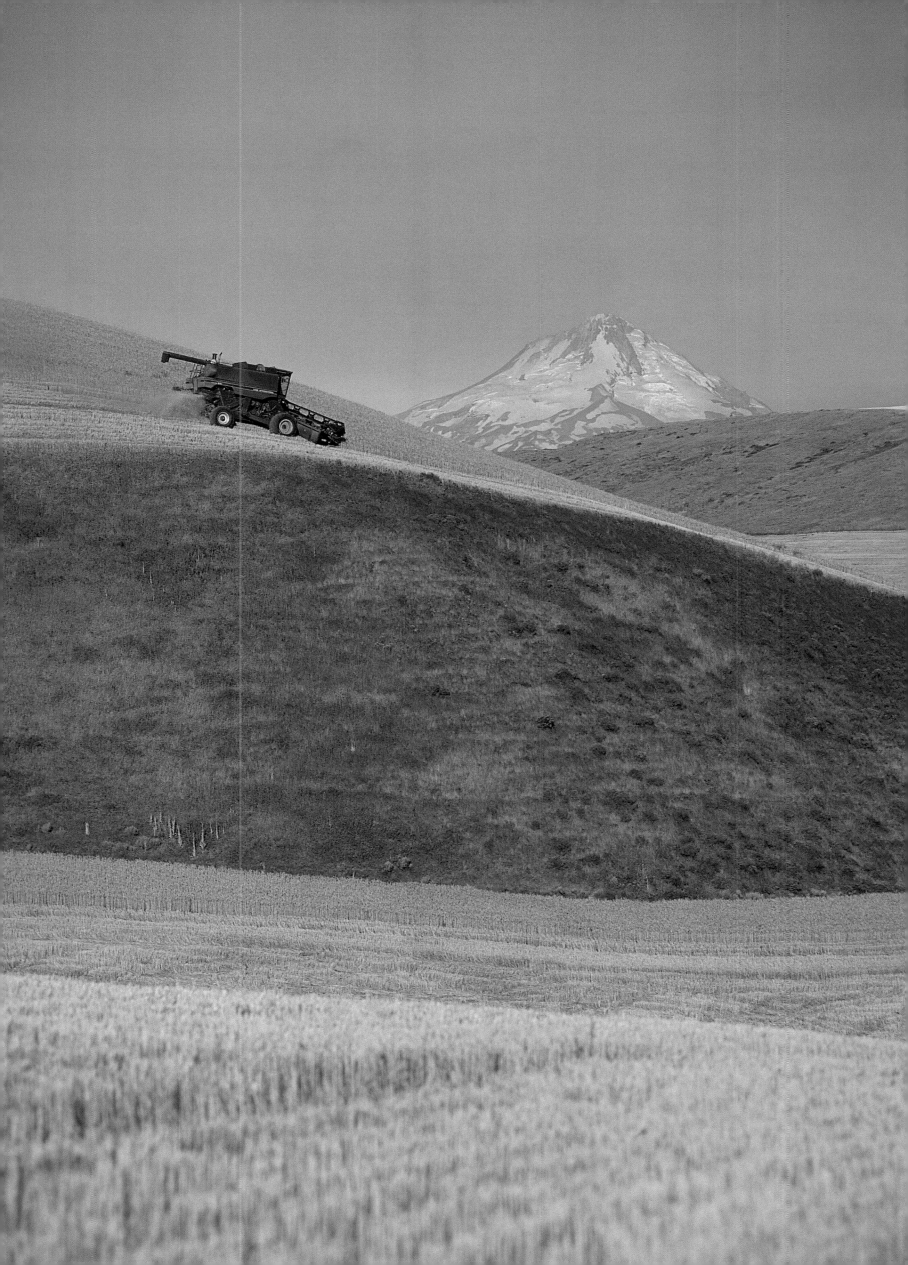

◁ Hosmere Lake, designated "fly-fishing-only," is one of many on the Cascade Lakes Highway. △ A branch of ponderosa pine *(Pinus ponderosa)* sparkles with morning dew in Deschutes National Forest. The national forest provides a variety of commodities, including timber, mushroom gathering, mining, and grazing.

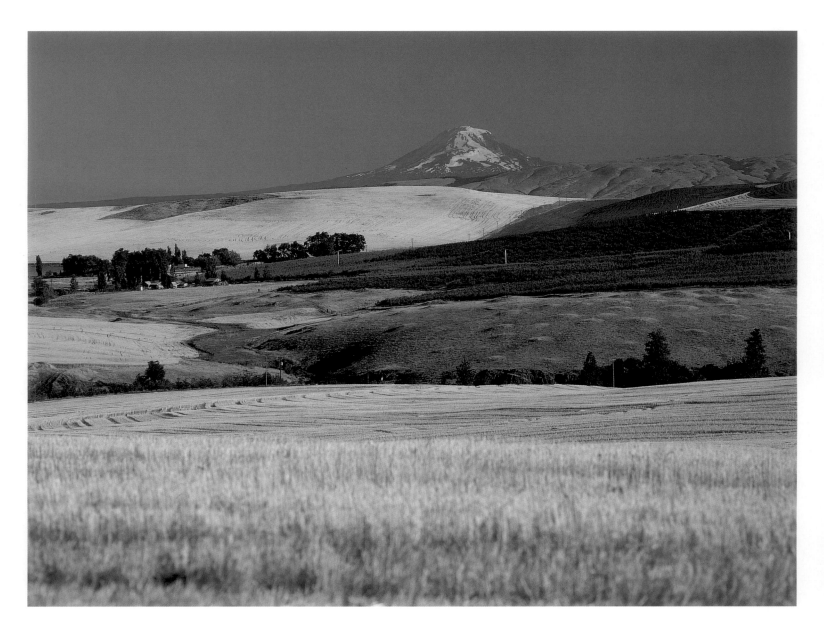

△ Waving gold in the breeze, wheat thrives in the rich soil of north-central Oregon. In the background, situated approximately thirty miles north of the Columbia River in Washington, 12,276-foot Mount Adams dominates the horizon.
▷ Seen from the viewpoint at the Ray Atkeson Memorial at Sparks Lake, 9,065-foot Bachelor Butte hovers over Goose Creek as it meanders through a golden meadow.

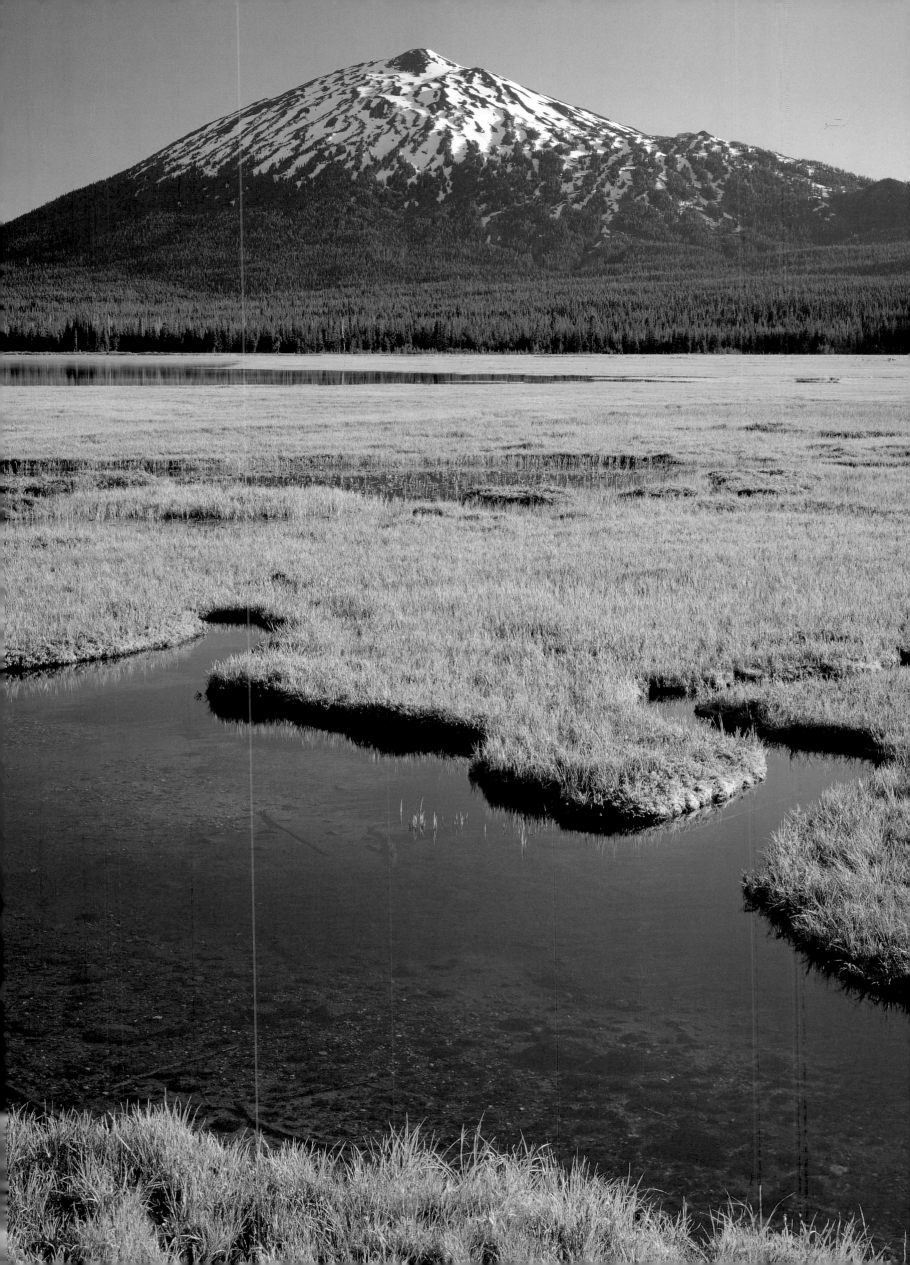

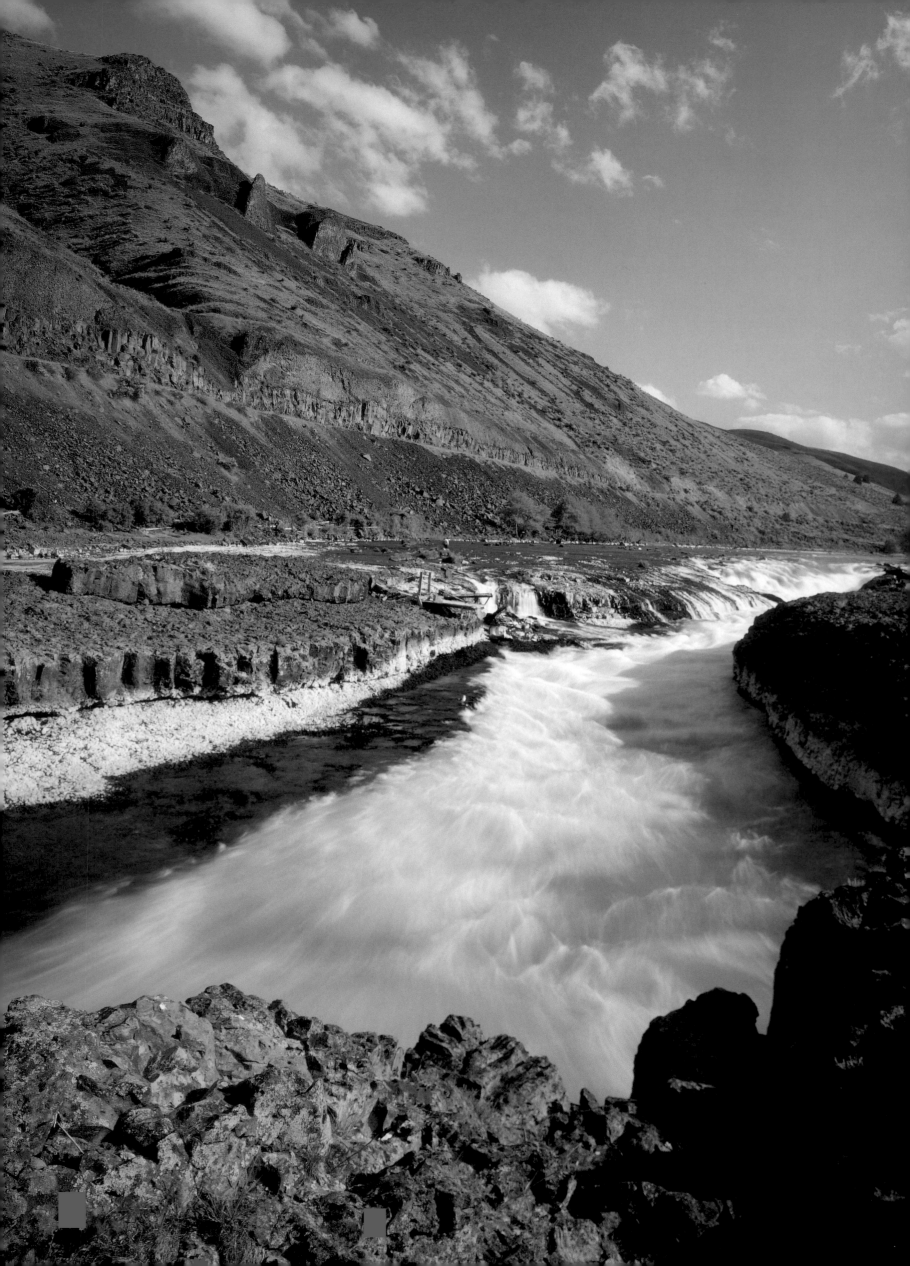

◁ Starting from Lava Lake high in the Cascade Mountains, the Deschutes River flows for fifty-six miles before cascading down Shears Falls. △ A wooden logging wheel waits at Historic Collier Memorial State Park, which features an outdoor museum of historic logging equipment. ▷▷ Backdropped by the South and Middle Sisters, aspens shimmer along the shore of Phalarope Lake at Black Butte Ranch.

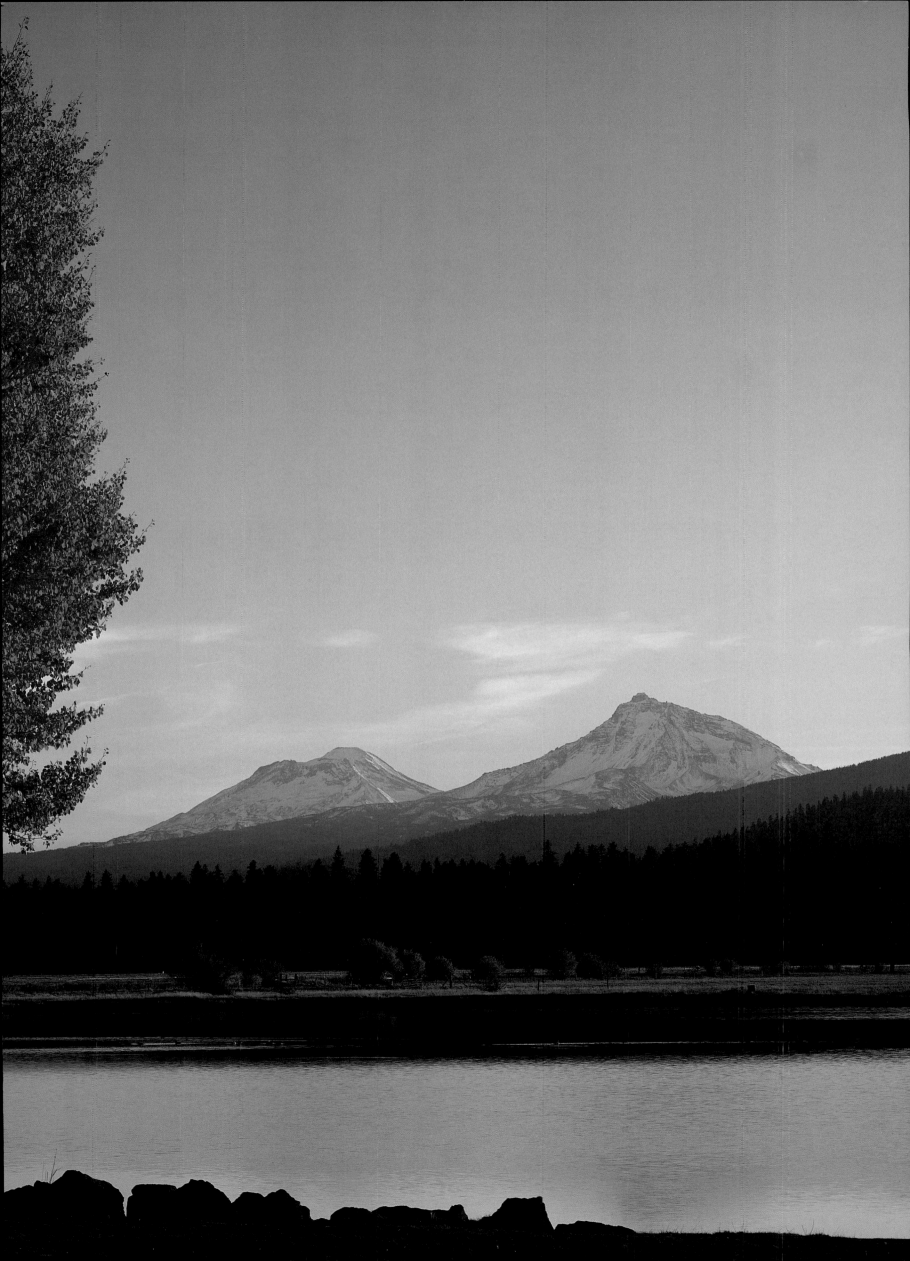

△ The Fall River gets its name from a series of small falls and cascades about halfway down its eight- to ten-mile length before it meets the Deschutes River. ▷ The Deschutes affords numerous opportunities for boating, fishing, rafting, and camping along its hundred-mile length. ▷▷ Central Oregon's wheat lends beauty to nature's rolling hills. The state ranks fifteenth in the nation for wheat production.

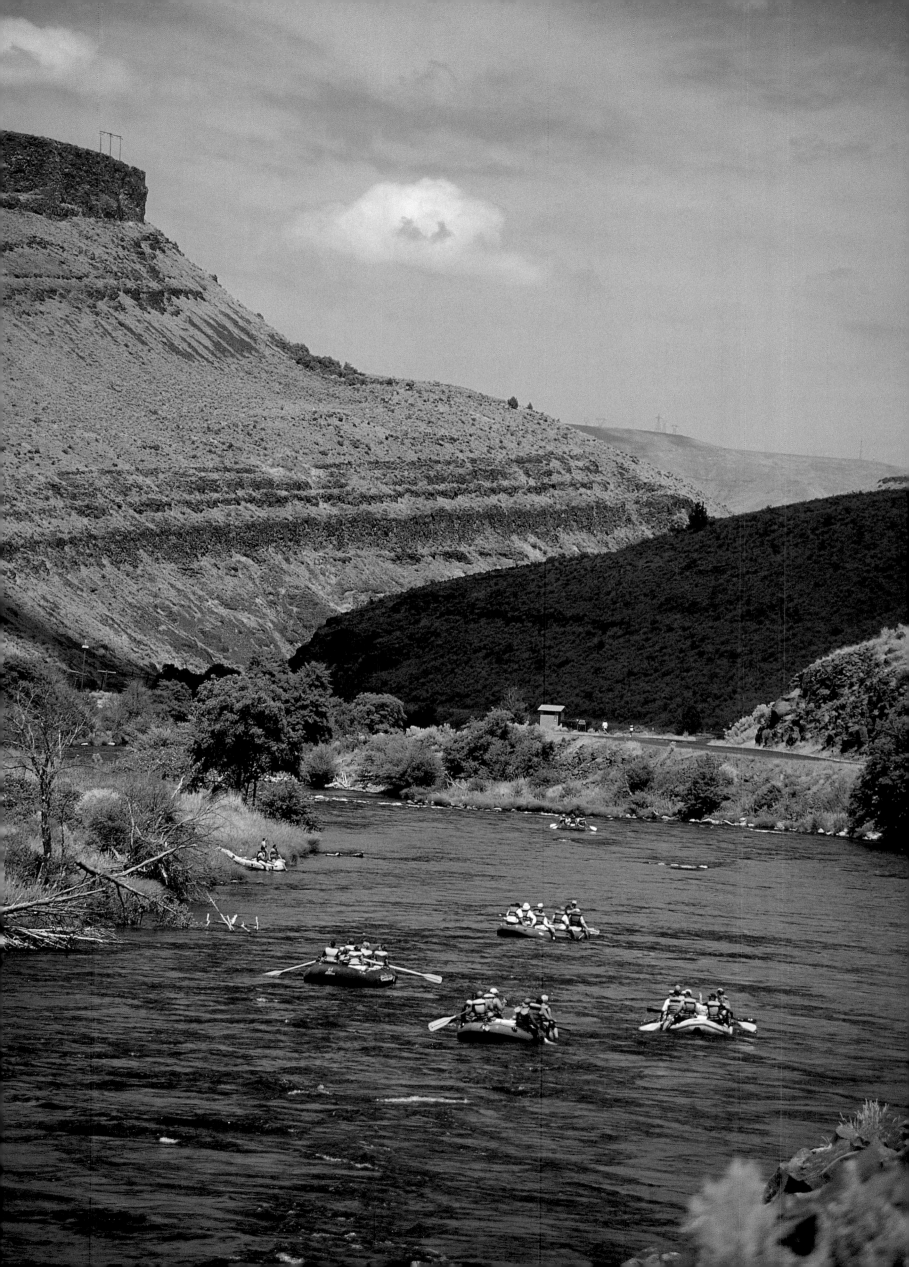

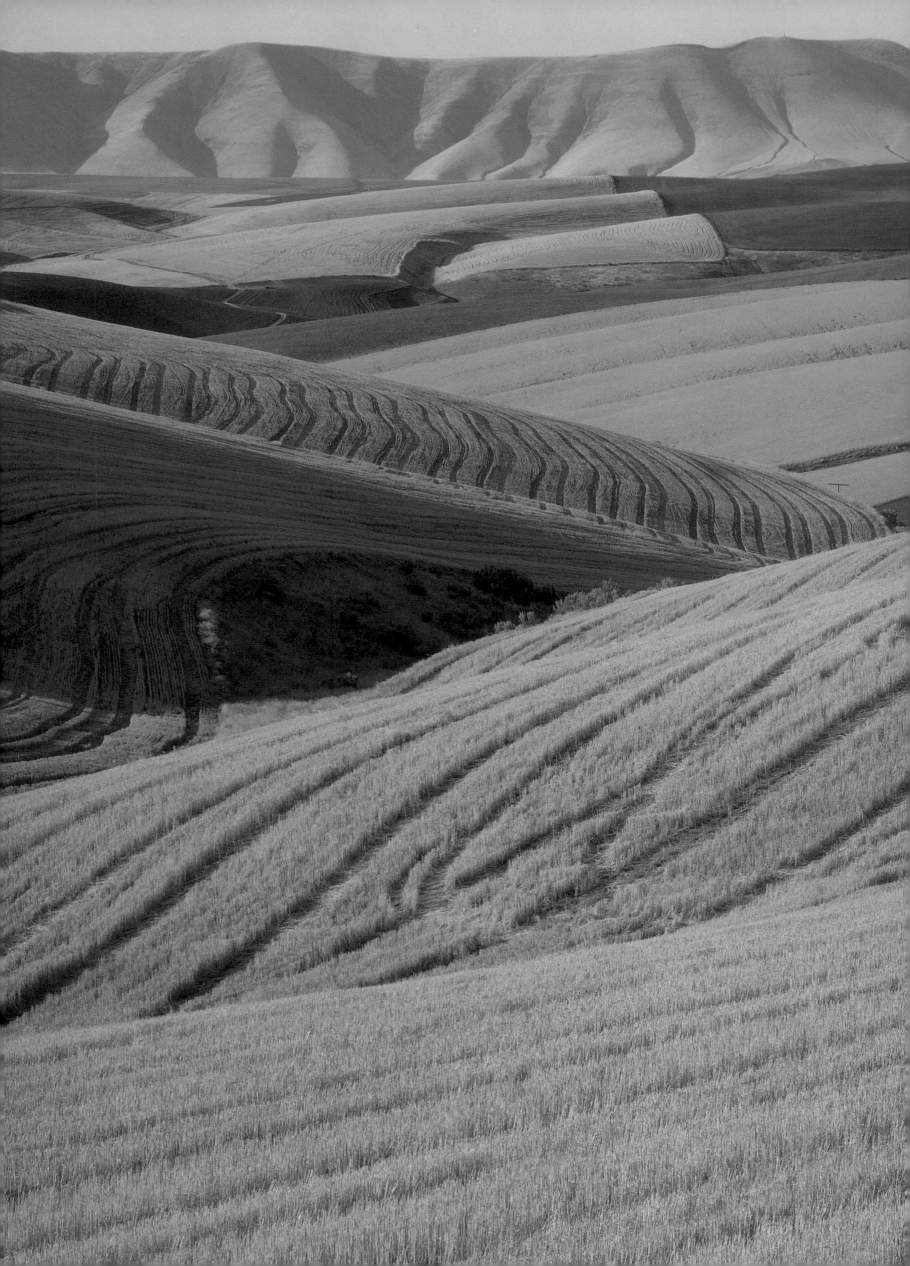

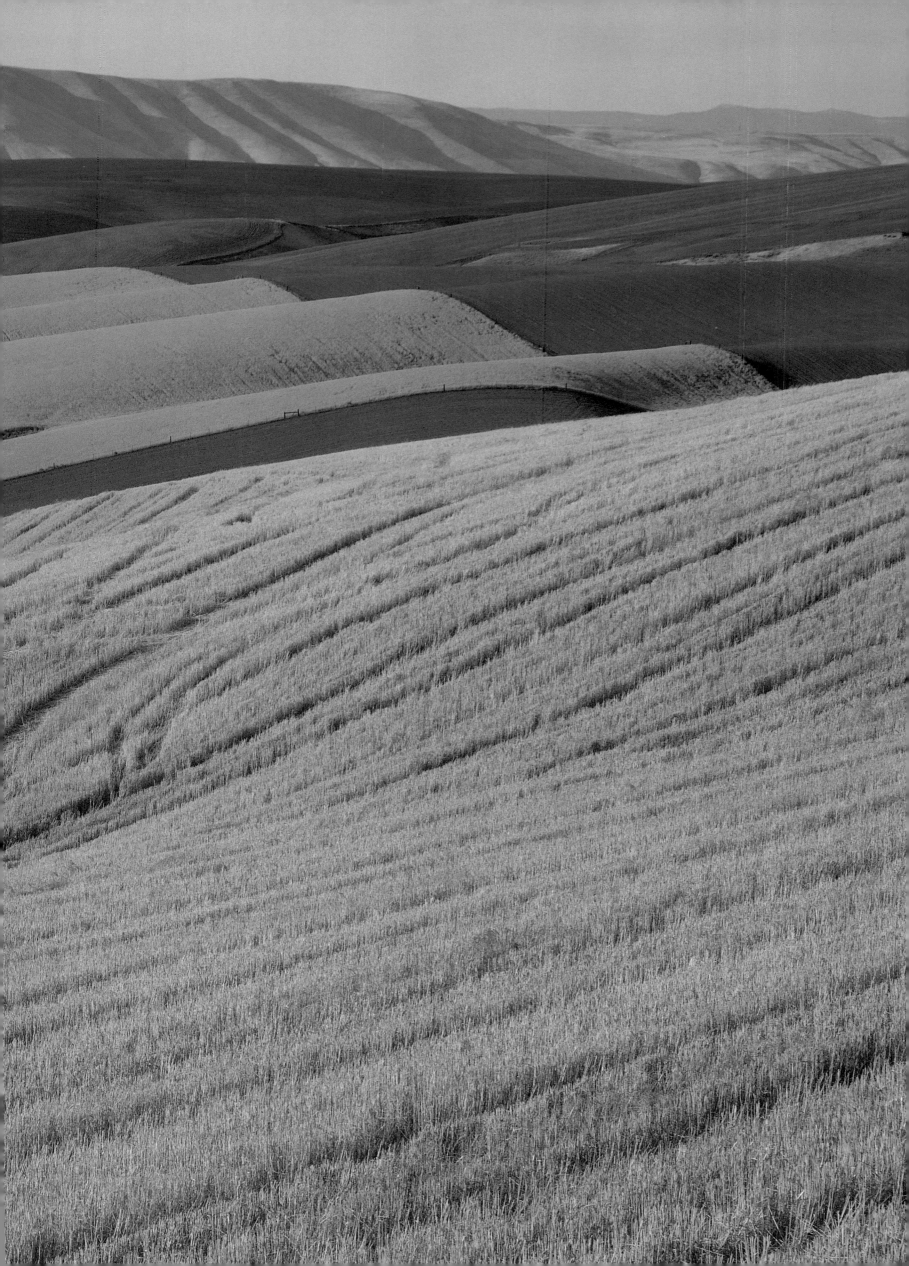

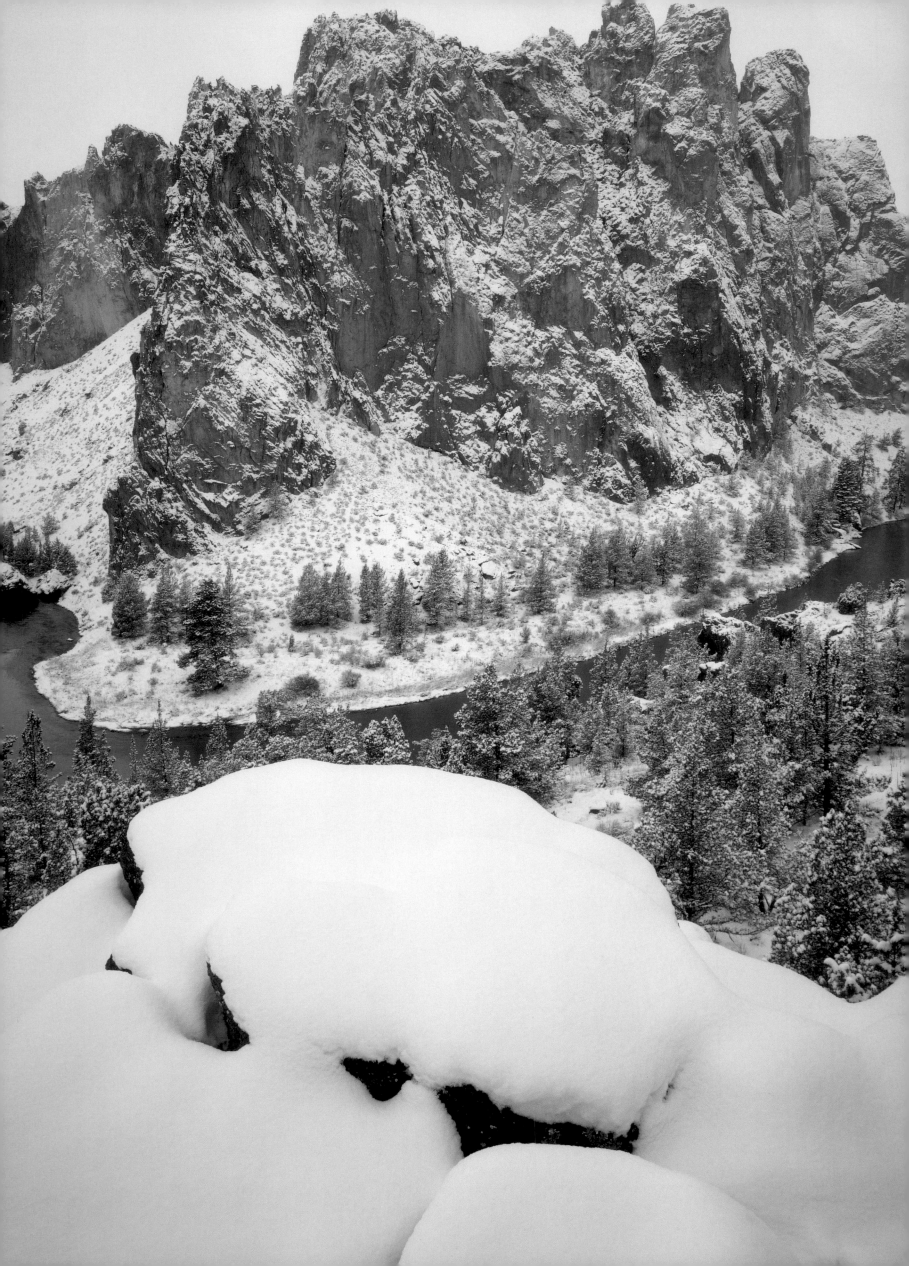

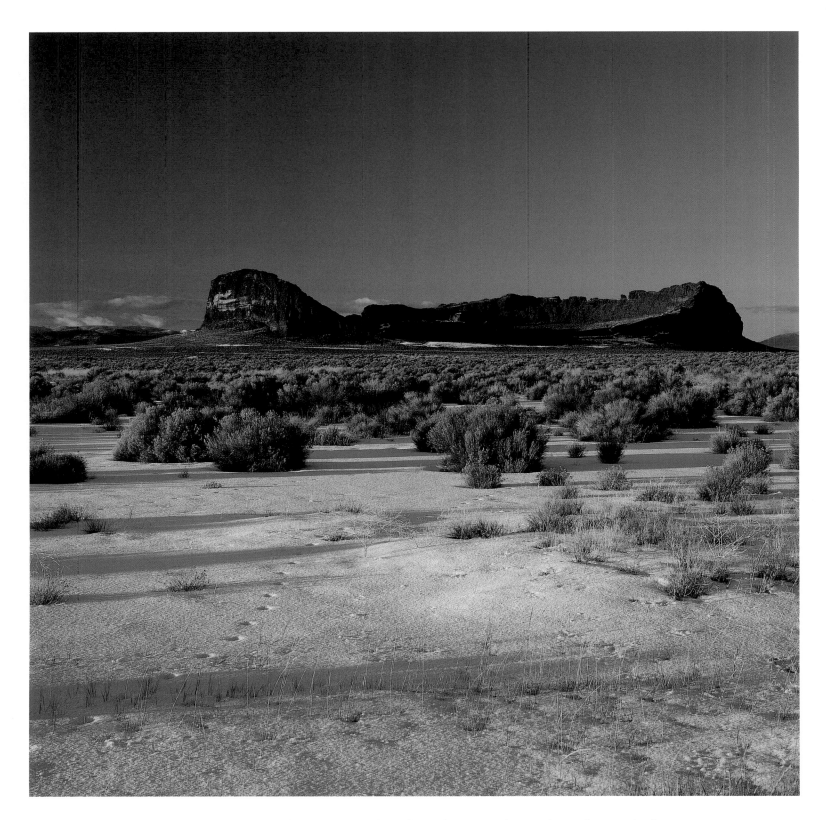

◁ The dramatic cliffs and spires of Smith Rock State Park rise above the Crooked River. Rock climbers from all over the nation enjoy challenging the sheer walls. △ Animal tracks can be seen in the snow covering the ground near Fort Rock State Natural Area. Fort Rock, whose walls rise 325 feet above the surrounding countryside, is an old shield volcano set in what at one time was a shallow sea.

EASTERN

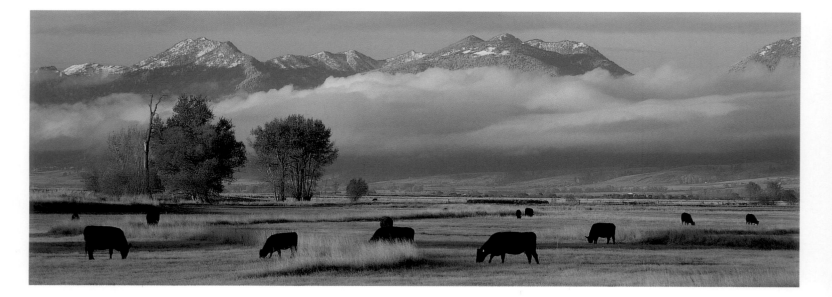

Eastern Oregon is . . . space, a clear sky,

an unclocked way where

time is the length of one's shadow.

—Carl Gohs

△ Elkhorn Mountains
▷ Aspens on Steens Mountain

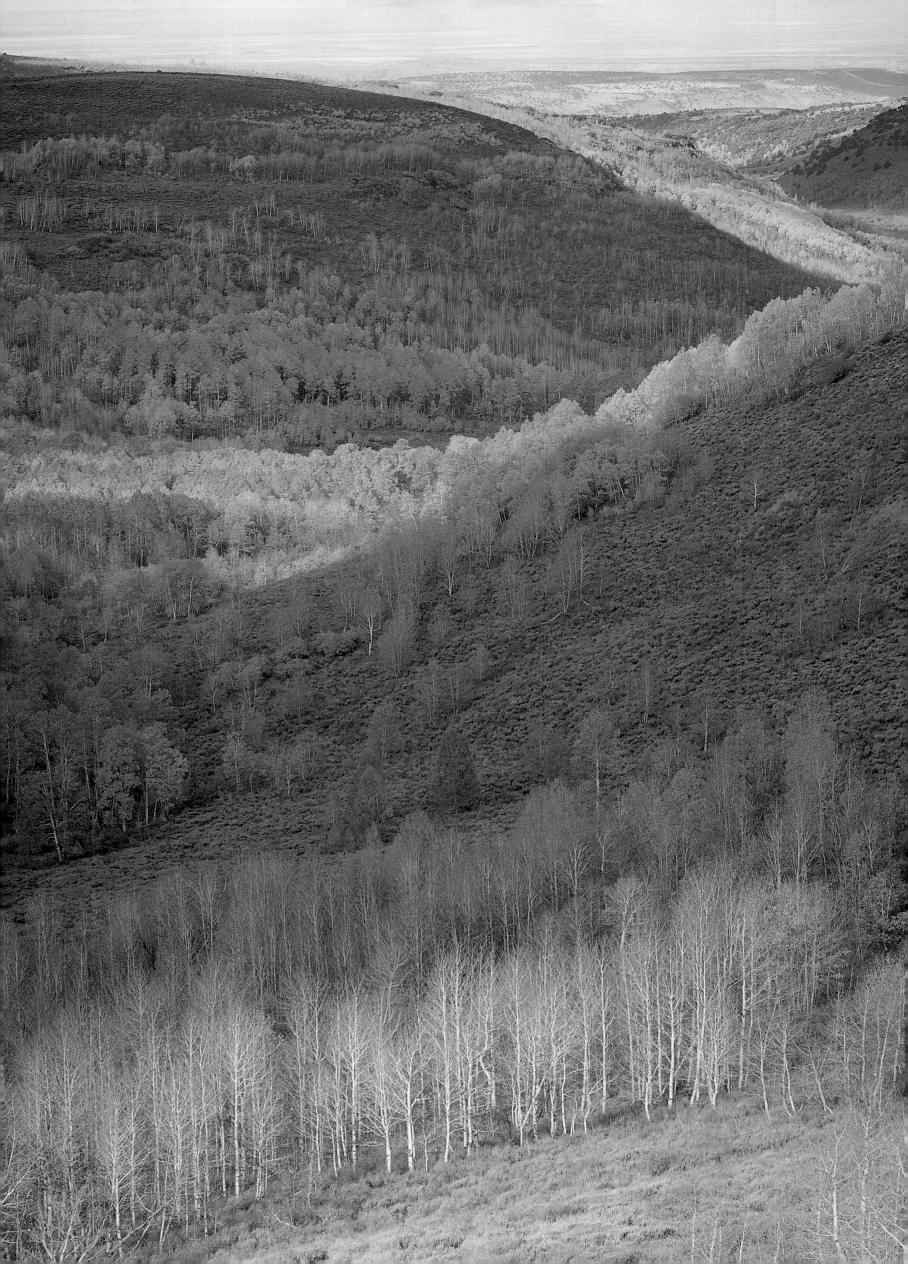

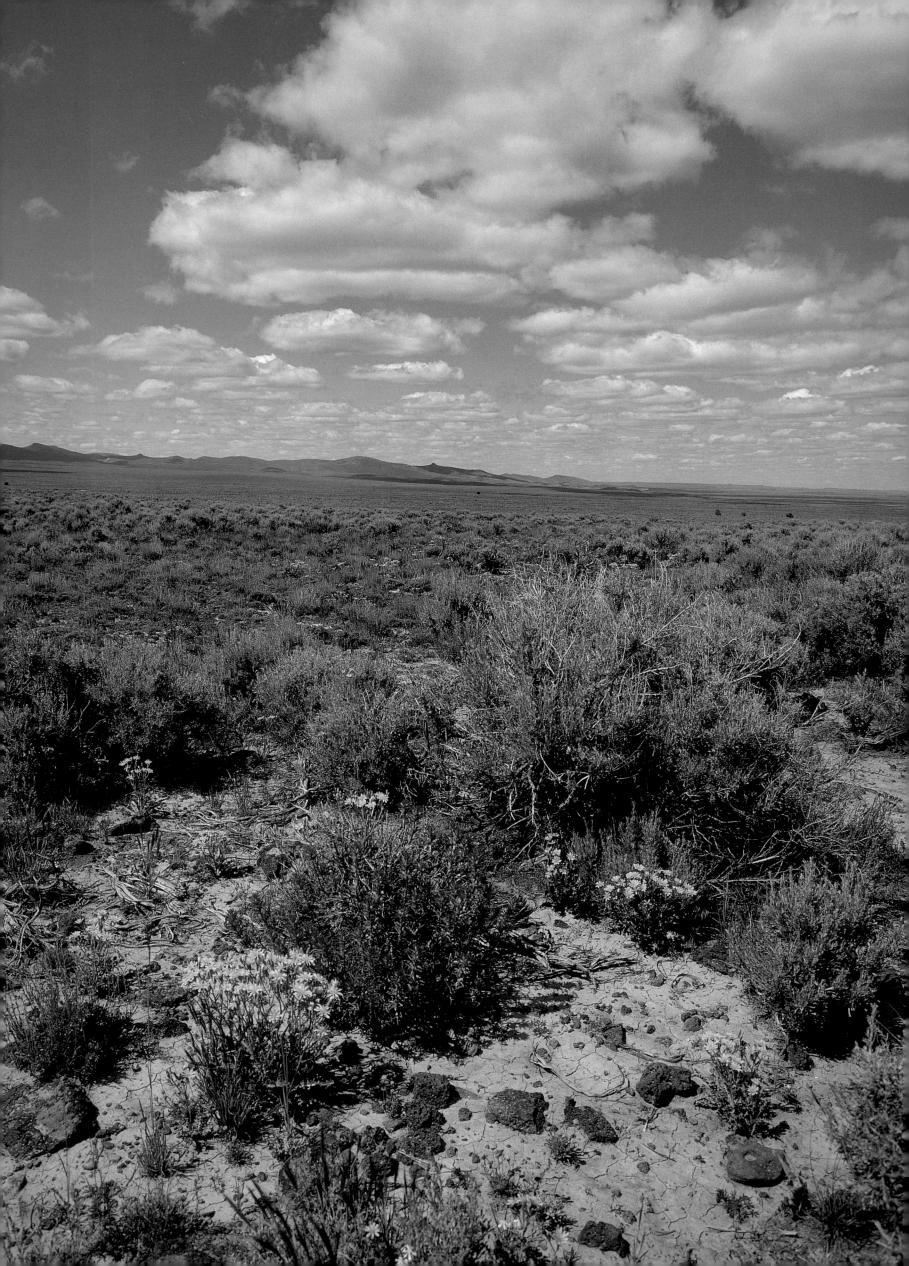

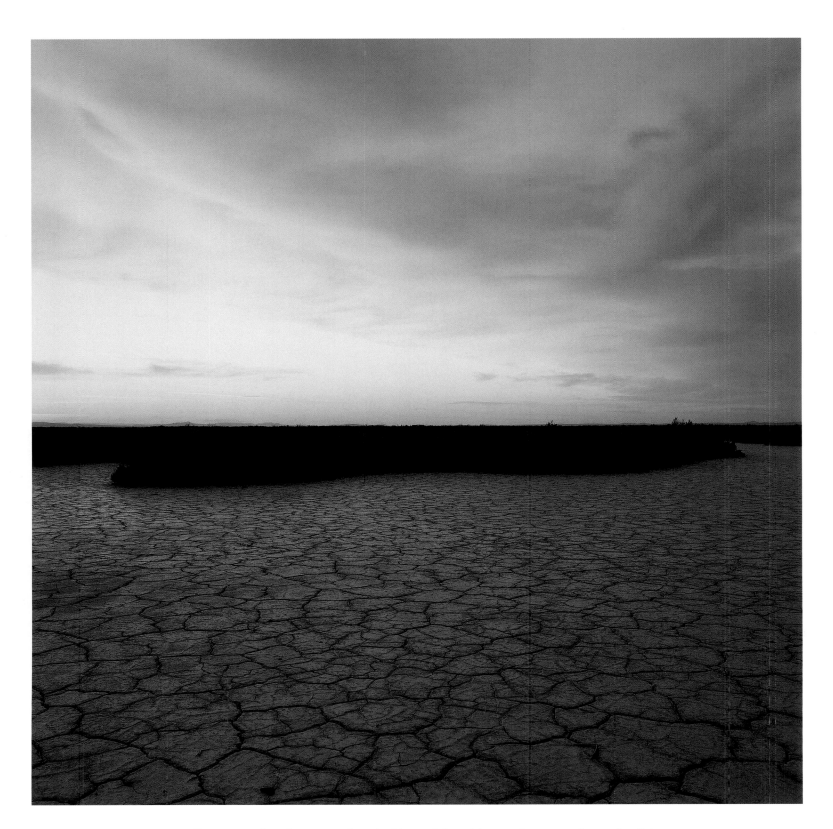

◁ Flora, ranging from sagebrush *(Artemisia tridentata)* to a variety of wild-flowers, dots the high desert near the town of Plush in southeastern Oregon. △ Sunrise lends a pastel wash to the parched floor of the Alvord Desert. Located in the southeast corner of the state, the desert encompasses approximately twenty-five thousand acres and receives only about eight to ten inches of rain annually.

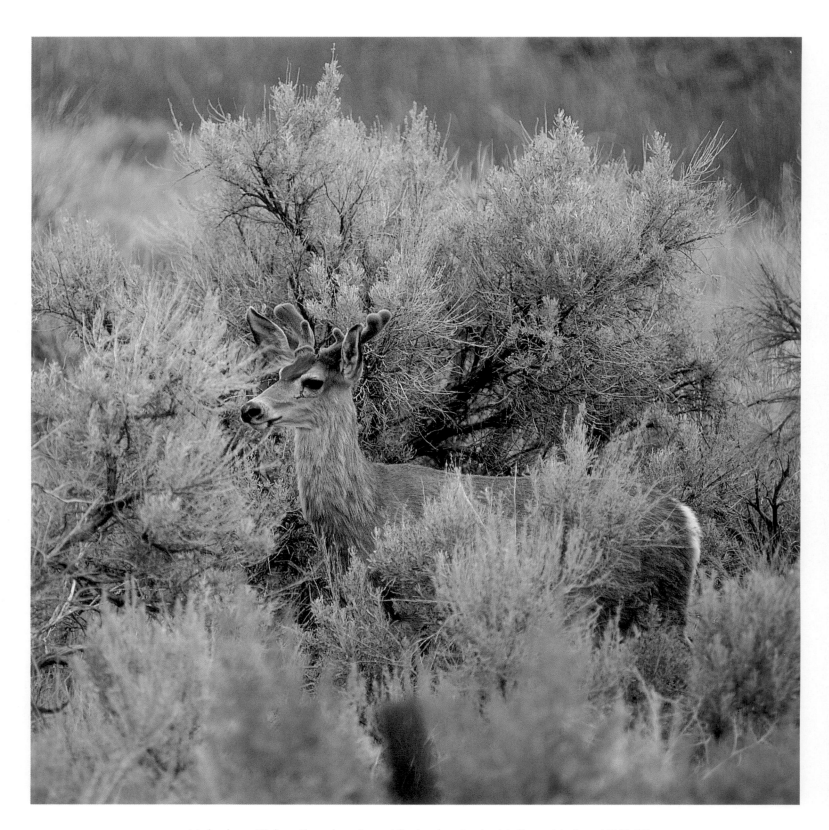

△ Mule deer *(Odocoileus hemionus)* find safety in the Malheur National Wildlife Refuge. Stretching from the base of Steens Mountain to the north shore of Malheur and Harney Lakes, the refuge is managed by the U.S. Fish and Wildlife Service. ▷ A petroglyph (artwork carved or painted onto the surface of a rock) gives compelling evidence of the past presence of Native Americans near the town of Adel.

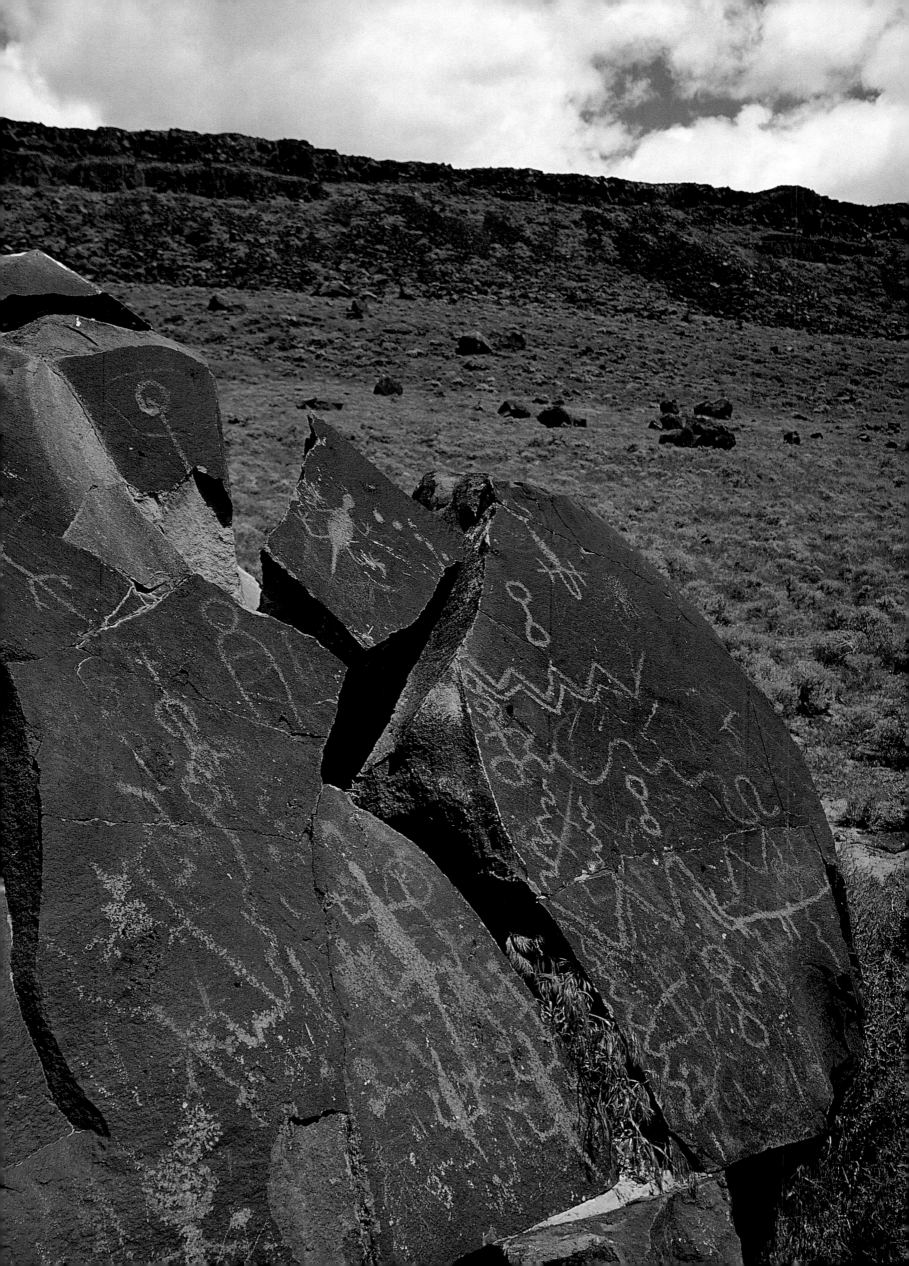

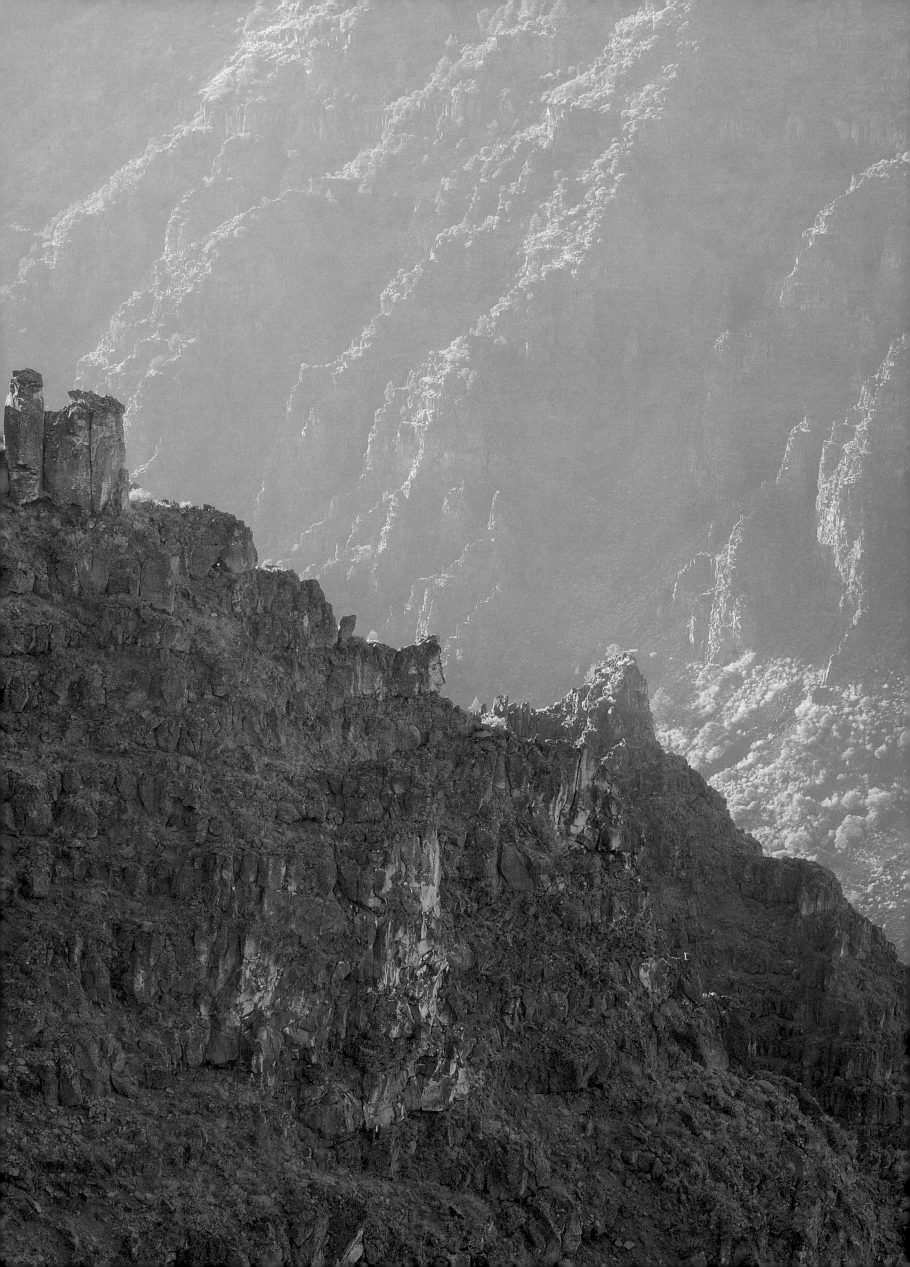

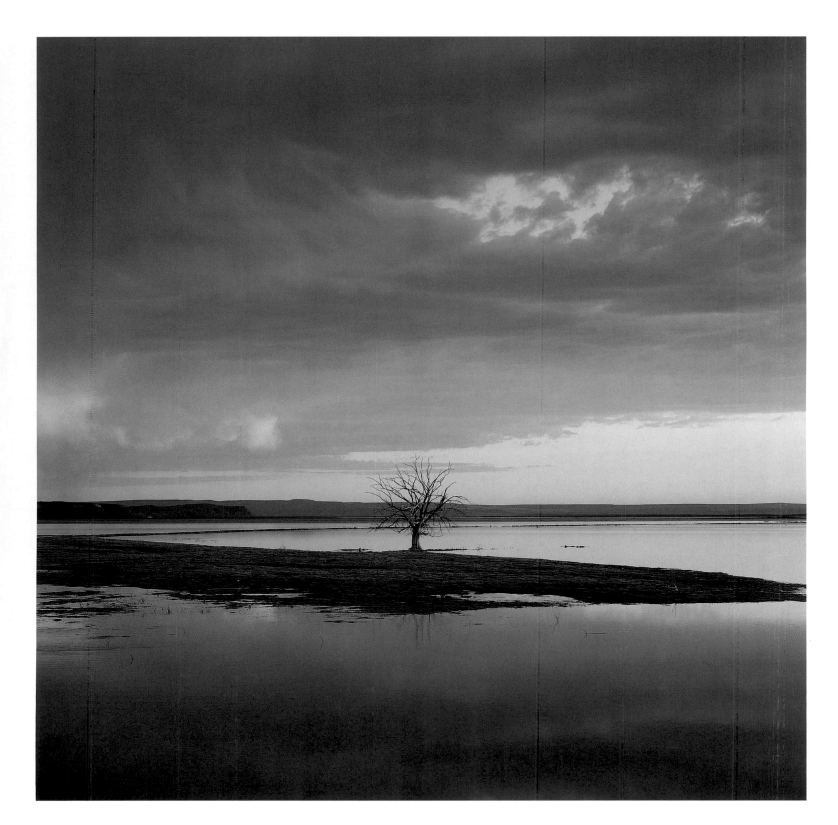

◁ The rocky landscape of a canyon of Steens Mountain offers a desolate look. Formed by faulting rather than volcanic action, Steens Mountain rises 9,670 feet. △ Situated in the Malheur National Wildlife Refuge, The Narrows, a channel connecting Harney Lake to Malheur Lake, have flooded so extensively some years that both of the lakes have run together to become a single body of water.

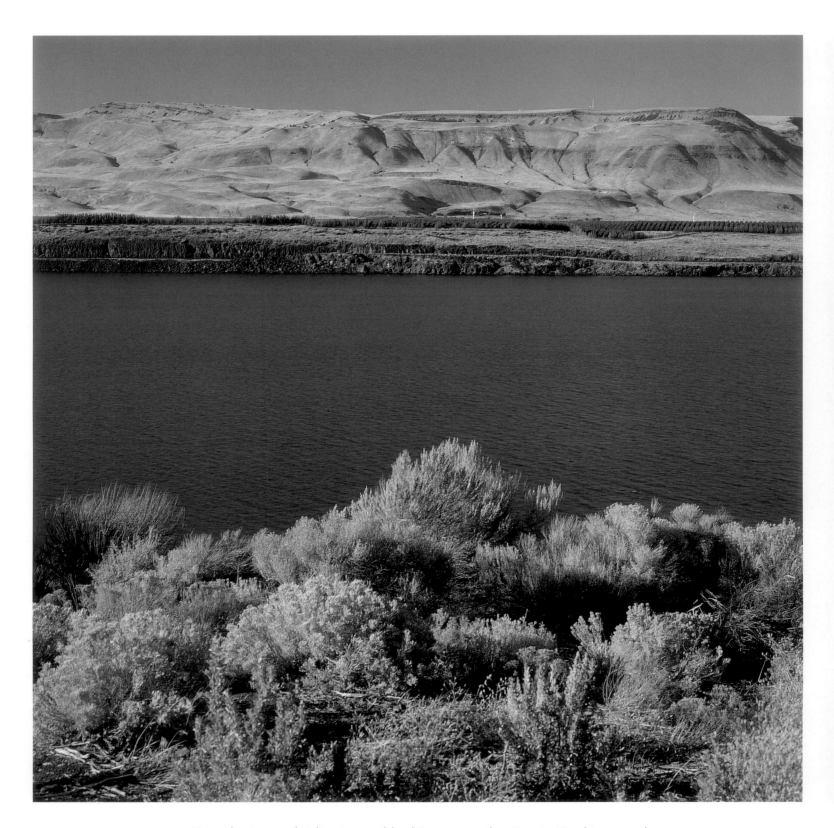

△ Near the town of Arlington and looking across the river to Washington, the Columbia River may seem quiet and peaceful. But as the pioneers learned to their sorrow, that tranquil appearance sometimes hid a dangerous enemy. Rising in Columbia Lake, in southeast British Columbia, the river flows 1,210 miles before entering the Pacific Ocean through an estuary west of Portland.

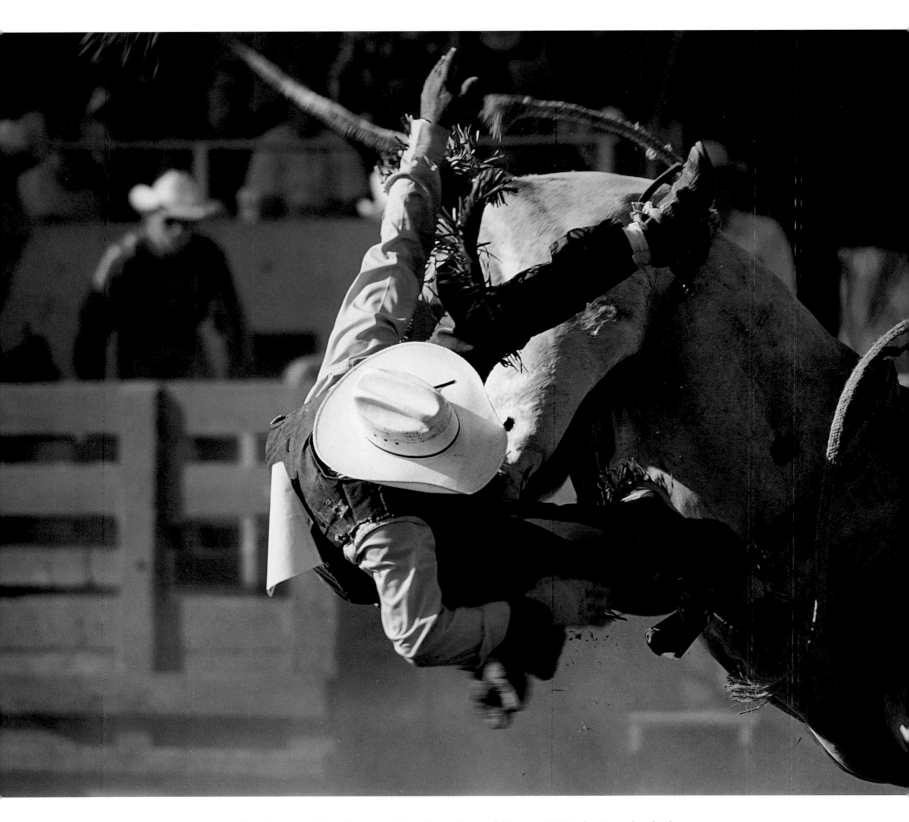

△ A bull-rider loses his grip at the Pendleton Round-Up. In 1909, the Fourth of July celebration in Pendleton included bronc riding and horse racing, and the idea was conceived that a round-up should be held each year. Numerous events are scheduled, from Bareback Riding to Indian Dances to Wild Cow Milking. The event attracts some fifty thousand visitors from around the world each year.

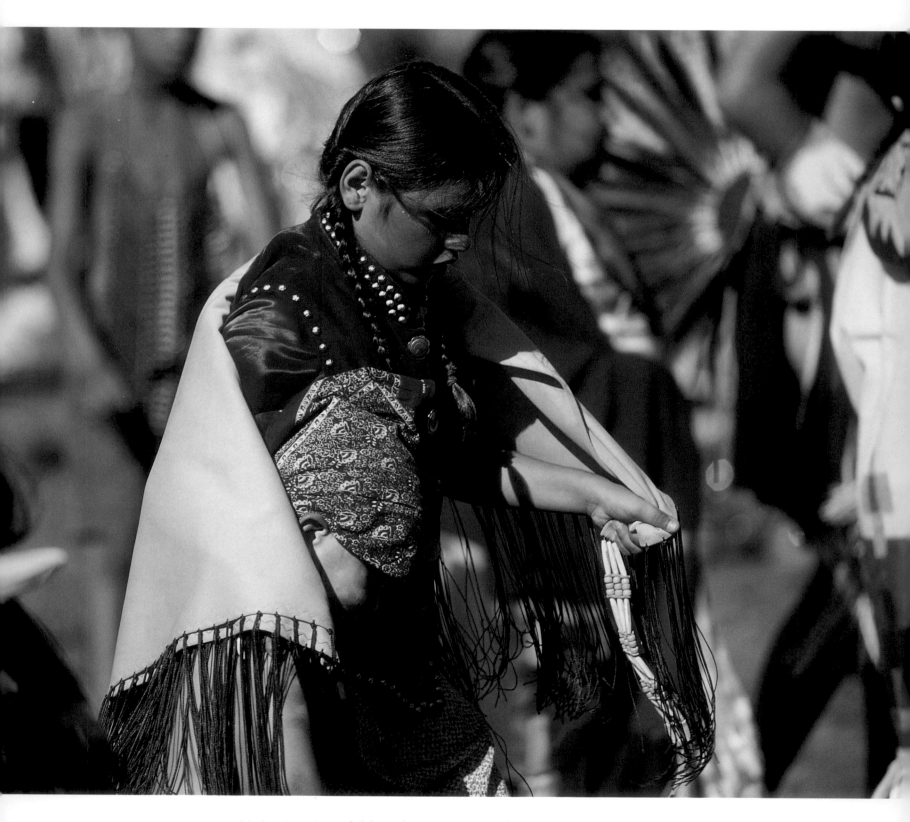

△ Native American children also participate at the Pendleton Round-Up. From the beginning, Indians have been an important factor in the success of the Round-Up, thanks originally to excellent relations between Major Lee Moorehouse, the superintendent of the Umatilla Reservation Agency; Roy Bishop, the Round-Up Indian Director; and Poker Jim, an Indian chief and nephew of Chief Joseph.

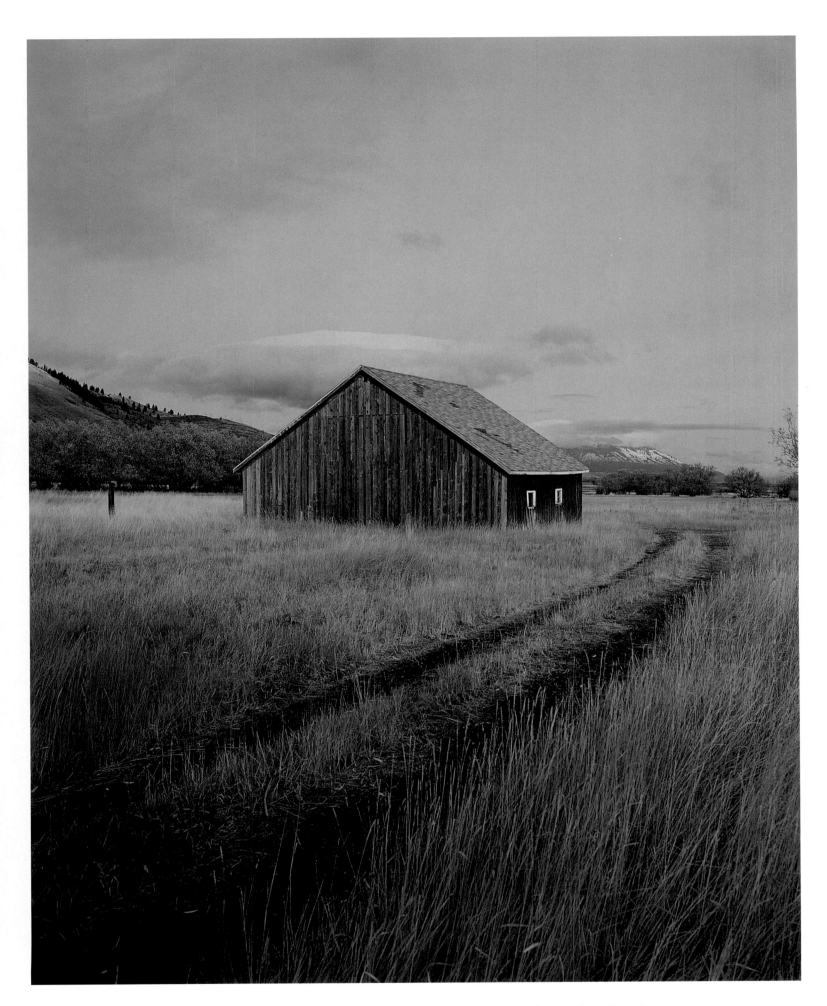

△ Located in the southwest corner of Union County's Grande Ronde Valley, the Ladd Marsh Wildlife Refuge comprises a little more than three thousand acres. ▷ ▷ The Painted Hills are part of John Day Fossil Beds National Monument. The weathering of volcanic ash has created rock layers of red, p nk, bronze, tan, and black. In spring, bee plant *(Cleome lutea)* adds bright yellow and green to the mix.

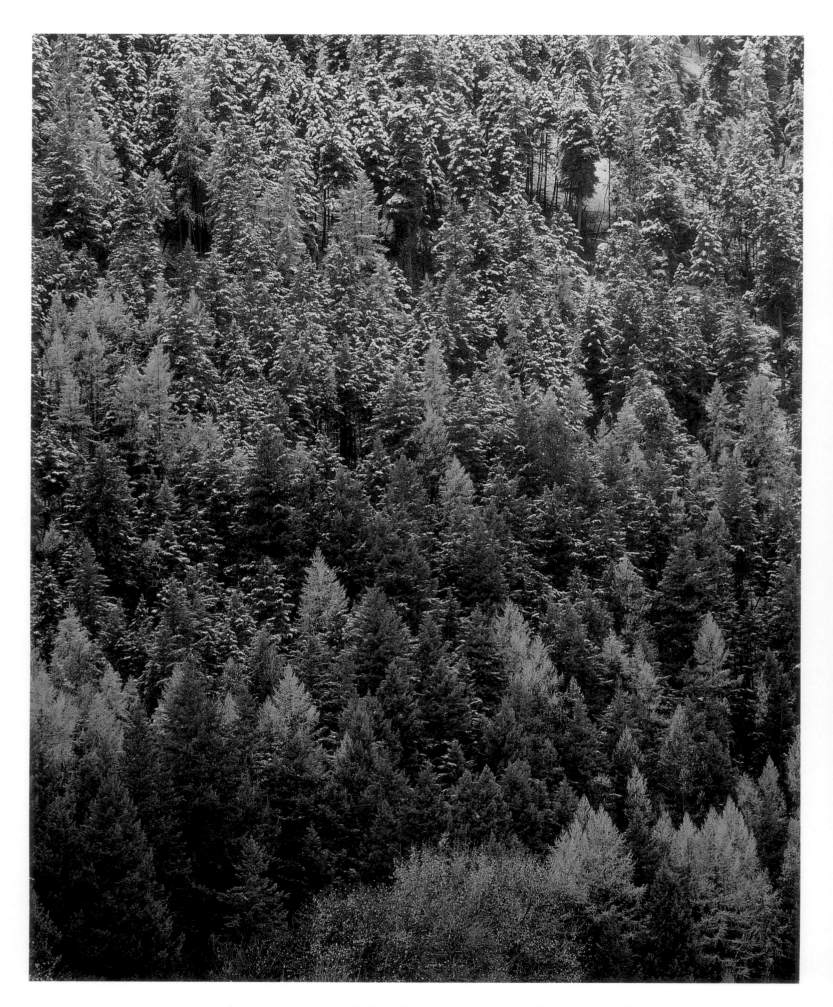

△ An early winter snow highlights fall colors in the 2.3-million-acre Wallowa Whitman National Forest. Elevations range from 875 feet in Hells Canyon to 9,845 feet in the Eagle Cap Wilderness, creating a diversity of landscapes and ecosystems.

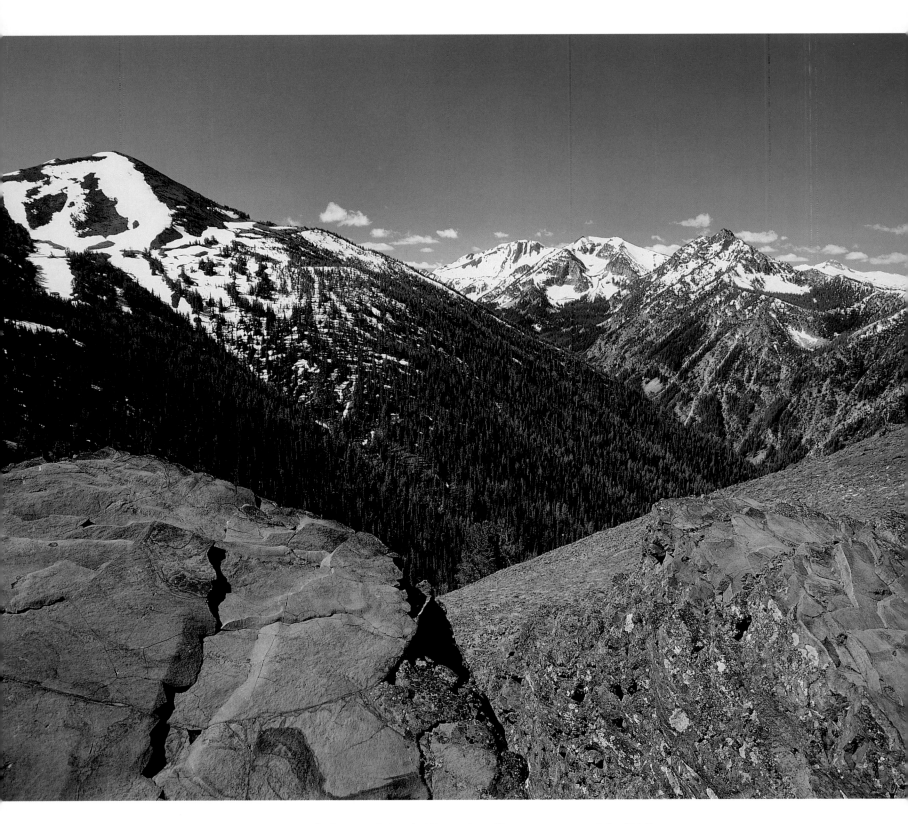

△ On Mount Howard, the Royal Purple Viewpoint offers panoramas of the Wallowa Mountains and Eagle Cap Wilderness. The Wallowas are unique in the state: they are granitic in composition rather than of volcanic origin or the result of lava flows.
▷ ▷ A typical winter scene in northeastern Oregon's Wallowa Valley includes a barn and newly harvested wheat field, all backdropped by the Wallowa Mountains.

139

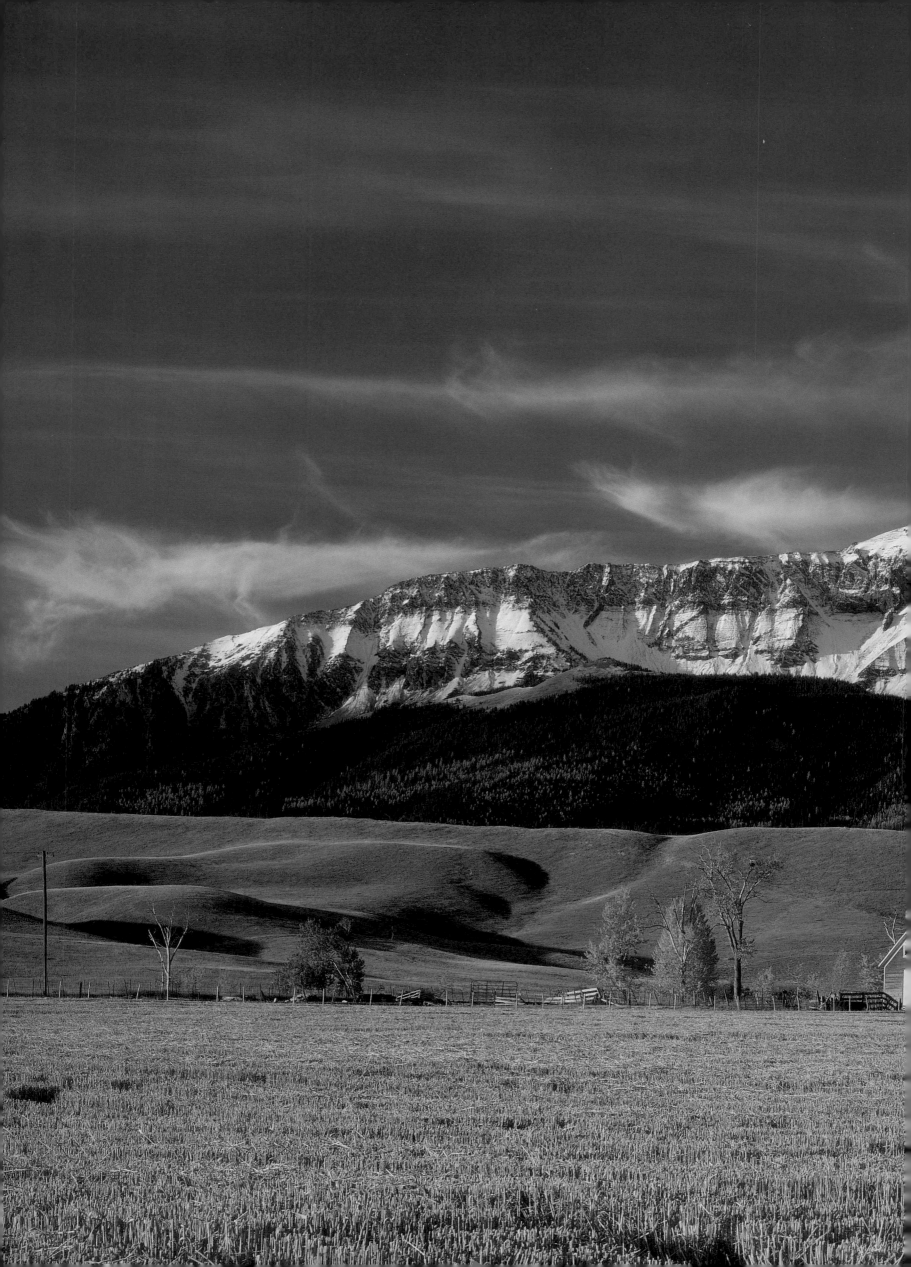

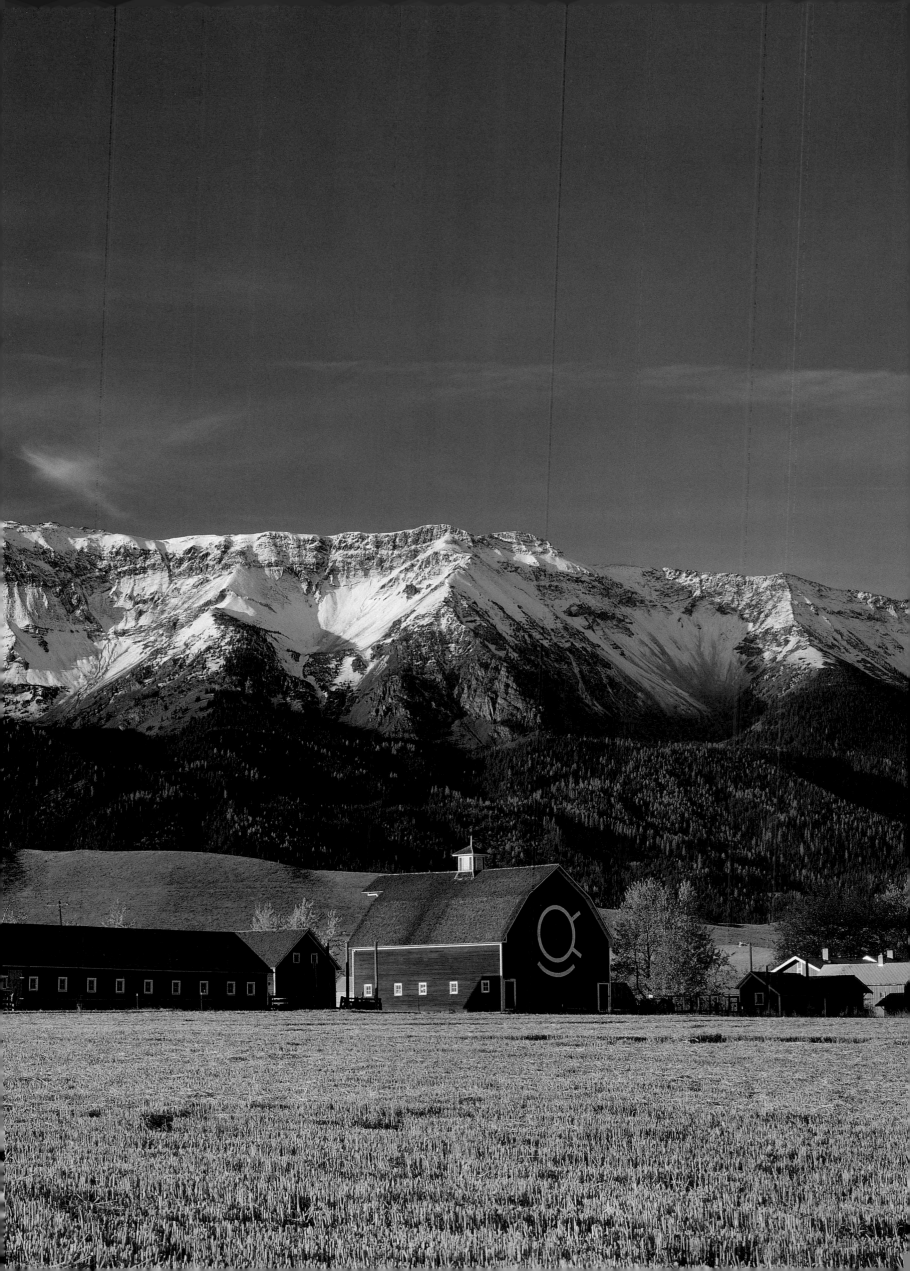

△ The lush green hillsides of Imnaha Canyon were once the hunting grounds of the Nez Perce Indians. Located not far from this vista, near the town of Wallowa, was the actual home ground of the Nez Perce tribe and their leader, Chief Joseph. In the summer of 1877, the tribe was chased from their homelands and eventually surrendered to the U.S. Army near Chinook, Montana.

142

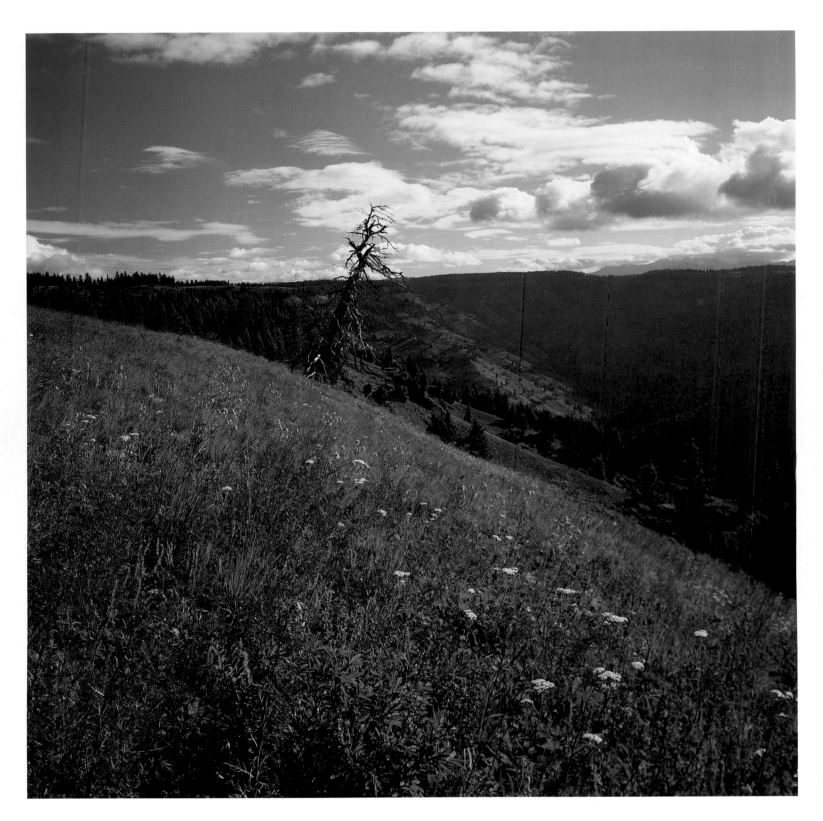

△ Lupine and Indian paintbrush brighten the hillsides of Hells Canyon National Recreation Area. Managed by the U.S. Forest Service, the national recreation area encompasses 652,488 acres and at its deepest point is eight thousand feet deep. Hells Canyon is the deepest river-carved canyon in North America.

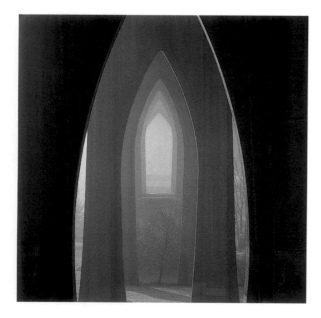

△ Cathedral Park, beside and under the St. John's Bridge, got its name from the bridge supports, which remind one of the beams of a cathedral.

ACKNOWLEDGMENTS

Oregon has been my home now for more than forty years, half of which have been spent exploring and photographing the beauty and diversity of this wonderful place. *Oregon IV* represents my most recent photographic perspectives of the various geographic and geological regions of our state. I would like to thank Graphic Arts Center Publishing® for this opportunity to preserve and share these images so others can enjoy them.

In 1967, Charles Belding of Graphic Arts Center, designer Robert Reynolds, and photographer Ray Atkeson combined their expertise and vision to produce a coffee-table book titled *Oregon*. No one knew at the time the important role this book would play in the economic development of this state. *Oregon* represented state-of-the-art offset printing technology and helped Portland's printing industry to be nationally recognized. This book also shared with the world the natural beauty of Oregon, and began a new publishing endeavor, Graphic Arts Center Publishing Company. *Oregon II* and *Oregon III* followed. Now, with the publication of *Oregon IV*, I want to acknowledge that this title is the last book designed by Robert Reynolds.

My stepfather and mentor Ray Atkeson shared with me his vast knowledge of Oregon and its geologic diversity and the unique atmospheric conditions created by our location in the Pacific Northwest. He taught me to appreciate beauty and simplicity in nature. In travels with Ray, I learned that patience and persistence are crucial to success. I will always be grateful for the opportunities he provided me.

This book would not have been possible without the help and encouragement of many people, each of whom deserves recognition and thanks. Although space does not permit me to list each one, I would like to name a few: I want to thank my wife, Teresa, for her love and support; in caring for our family and sharing responsibilities in our business, she has made great sacrifices to allow the pursuit of my chosen profession. My friends Jack McGowan and Bruce Wold, with their passion for and intimate knowledge of the back roads and wildlife of Oregon, have been very inspirational in my career.

With its agriculture and industry set in a landscape of snow-capped peaks, magnificent rivers, cool forests, delicate deserts, and ever-changing ocean vistas, Oregon is a diverse land, providing both beauty and sustenance to its residents. I hope the images in this book help to remind us of how important our natural resources are and how precious our land is.

—R.S.